ART AND ANARCHY

Art and Anarchy

EDGAR WIND

Third Edition

With an Introduction
by John Bayley

NORTHWESTERN UNIVERSITY PRESS

New reset edition with new Introduction 1985

First published in UK by Faber & Faber 1963
First published in USA by Knopf 1964
Second edition in USA (with addenda)
published by Random House 1969
Third edition in USA
published by Northwestern University Press 1985

ISBN 0-8101-0720-1 (CL)
ISBN 0-8101-0662-0 (PR)

Acknowledgments for Illustrations

Accademia Carrara, Bergamo (fig. 7); Alinari (fig. 10); Goethe-Museum, Düsseldorf
(fig. 2); Mrs Jane Wade, New York (fig. 11); The Metropolitan Museum of Art, New
York (fig. 4); Mr Henry Moore (fig. 14); Spadem, Paris (fig. 16); Statens Museum for
Kunst, Copenhagen (fig. 3); Union Centrale des Arts Décoratifs, Paris (fig. 6).

Printed in Great Britain

Contents

Author's Preface to the First Edition

The great honour of being asked to give the Reith Lectures is attended by perils commensurate with it. Six talks lasting twenty-eight minutes each, concerned with a vast and cloudy subject, are apt to arouse, but not likely to satisfy, a decent appetite for information. In this book I have attempted, perhaps unwisely, to supply that want. Without changing the argument or the tone, I have expanded some of the lectures; and I have added a section of Notes and References, giving chapter and verse for even casual remarks. Although these digressions should be of use for judging the historical evidence, they are not essential for understanding the text. Some readers may prefer to ignore them.

To the directors and staff of the British Broadcasting Corporation I am indebted for many courtesies; and I am particularly grateful to my publishers for having allowed me the time to complete the book in tranquillity. From the first hasty draft to the final revision the text was read by Colin Hardie, who generously burdened himself with the Herculean task of naturalizing my exotic English. He introduced innumerable improvements affecting substance as well as style. I am also indebted to Austin Gill for his precise and germane comments; and I hope that the book shows, in a small way, what I owe to his Oxford lectures on Mallarmé. Yet even the most scrupulously critical friends cannot save an author from his faults. Whatever blemishes the text retains must be ascribed to my own obtuseness.

For a large variety of important suggestions I must thank Mrs John Hale, who was most helpful in revising the proofs; and on individual points of method I benefited much from the enlightening remarks of Mr H.A. Christie, Mr A.B. Farrell, Mr T.P. Grange, and Mr A.P. Pugh. I am obliged to the

kindness of Mr Henry Moore for the photograph reproduced in fig. 14, and to the courtesy of Dr Walther Scheidig, director of the Staatlichen Kunstsammlungen in Weimar, for tracing the original of fig. 2.

My wife's share in this (or any other) book I am not permitted to mention.

24 January 1963 E.W.

Note to the Third Edition

Addenda to the 1969 edition have here been incorporated in the Notes and dated 1968, the year of their completion. An indulgent publisher made these changes possible. The author's wishes have also been followed with regard to certain corrections and improvements in points of detail. His reflections on Mallarmé owe much to the discerning criticism of Austin Gill. To John Bayley he would have been particularly grateful for the Introduction, and to Joyce Reid for her generous scrutiny of the whole work – not least for the spirited *explications de textes* that it provoked.

24 March 1985 M.W.

Illustrations

Acknowledgments

Accademia Carrara, Bergamo (fig. 7); Alinari (fig. 10); Goethe-Museum, Düsseldorf (fig. 2); Mrs Jane Wade, New York (fig. 11); The Metropolitan Museum of Art, New York (fig. 4); Mr Henry Moore (fig. 14); Spadem, Paris (fig. 16); Statens Museum for Kunst, Copenhagen (fig. 3); Union Centrale des Arts Décoratifs, Paris (fig. 6).

Introduction

by John Bayley

It is seldom a book comes out which tells us something new about the nature of the arts. The great theoretical treatises, from Lessing and Schiller to Nietzsche and Croce, are landmarks in our general consciousness of what is involved. There are also the more purely assertive theses, such as those of Burke or Worringer, or the abbé Brémond's discourse on 'pure poetry', or Clive Bell's championing of 'significant form'. By infecting us with enthusiasm or with scepticism for their *parti pris* these can also enhance our sense of the wider issues, even though in themselves they may lack a sense of proportion, even of ordinary common sense. The great philosophers, like Hegel, usually seem more interested in diagnosing the state and condition of art than in showing us how to enjoy it; they take their examples (as did Wittgenstein) from a limited field, and distrust the hearty appetite of the amateur.

The happy amateur who is at the same time a dedicated professional: that is a combination as distinctive and desirable as it is rare, and it is one which Edgar Wind possessed in full measure. In terms of our understanding of art it makes the Reith Lectures of 1960, published as *Art and Anarchy*, a truly important event. For in terms of art the book suggests something about everything. Wind had the erudition of the specialist and the insight of the philosopher, and yet he was neither. Equally at home in literature and painting, in music and the plastic arts, he never generalized about art from the position of an expert in one of its branches. He was at home in the sense of plurality which for most scholars, and in most

contexts, would make it inhibiting to talk about 'art', as such, at all.

What gives *Art and Anarchy* a special importance today is that since it was first published theoretical criticism of the arts has undergone a further change. Wind's commentary to a large extent both anticipates that change and reveals its true nature. The change could be defined quite simply as a move away from the idea of the transcendence of art to an awareness of it as the manipulation of conventions, codes, and illusions. As consumers of art we are now expected to ask not what it is but how it has been put together. A poem is a semiotic machine, as theorists like Michael Riffaterre have claimed, to be systematically and authoritatively 'deconstructed'. True stories and real people are not created by the novelist: his fiction is a series of devices which he is proffering in his own way to the reader. A picture is a piece of painting, a flat surface covered with pigment. This kind of reductionism is in one sense obvious and unanswerable, as was Le Corbusier's statement that a house is a machine for living in. But only a computer would want to live in a machine, or to arrive at a 'correct' view of how a work of art has been made. Men are beset by fears, yearnings and ideals, and it was out of these that they made the seemingly serene and solid worlds of art by which they lived. They made its truth from the complexity and the weakness, the most basic needs, of human untruth. For modern man the need has altered, and with it the attitude to art.

This is implied in Wind's use of the word 'anarchy'. Art was a refuge, but a refuge to be reached and clung to by savage effort, amongst horrible dangers. Science, medicine, and so many other features of our modern polity, now provide an alternative kind of refuge. As Wind points out, this is shown by the change in the idea of patronage. Because the patron really needed art he once entered into the most disputatious and even violent relation with the artist, and to a good artist that relation could be extremely stimulating. The design of the Medici chapel emerged out of a prodigious clash of wills, months and years of the most energetic argument. Whenever Michelangelo submitted new designs the Cardinal Giulio de'

Medici had objections and counter-suggestions; and after he had become Pope he changed his mind again, with the great artist actually at work on the sculptures, and proposed a new plan from which emerged the titanic figures that we see today.

But so far from being angry at all this interference Michelangelo positively welcomed it. As he explained to his pupil, the new Pope had an exceptional understanding of the artistic process. His passionate and possessive interest acted as a midwife to the birth of a great work. And most true artists 'prefer patrons who fuss to patrons who do not care'. Neither government nor architects could 'spare the time', as Jean Arp put it, to bother about how the artists they had commissioned to work on the Unesco building at Paris would carry out their assignment. That was up to them. All that mattered to the modern patron was that art should be employed, that it should exist and be seen by the public as encouraged to exist. One remembers the remark of Napoleon Bonaparte: 'They say we have no literature. That is the fault of the Minister of the Interior.' Thus 'in the building devoted to the cultural work of the United Nations the arts loiter about the place without function, distracted and disunited'.

Wind presents 'the root of the matter' in a memorable sentence. 'If in the midst of their frightful troubles they [the Renaissance patrons] found the time to battle with artists and bend them to their will, it is because art was as indispensable to them as their daily food: they could not live without it.' All the wit and learning of *Art and Anarchy* implies a paradox of supreme importance: at his most worldly man can also be at his most spiritual. To undergo to the full what the prayerbook calls 'the changes and chances of this fleeting life' is most to need escape into the world of art and the spirit, the world which we enter with all our daily faculties at the fullest pitch of activity, but which is none the less wholly separated from the world of daily routine and preoccupations. The old patrons were as Yeats describes them in his poem 'Ancestral Houses'.

> Some violent bitter man, some powerful man
> Called architect and artist in, that they,
> Bitter and violent men, might rear in stone

The sweetness that all longed for night and day,
The gentleness none there had ever known ...

The exercise of power was intimate with the relief of art, and
that intimacy was reflected in the works of art themselves.
Those who exercise power today do not regard art as one of its
goals or rewards. Art has become powerless, both as regards
the producer and the consumer, and indeed has come to take a
certain pride (at least in the West) in its powerlessness. It has
become one more adjunct to the Good Life. As Wind observes,
Nietzsche foresaw modern man in his aesthetic Eden,
surrounded like an innocent Adam with the styles and arts of
every age. André Malraux made the same point when he
described modern culture as a *musée imaginaire*, where every
kind of art was accorded an equal degree of approbation and
interest. This is not the result of popularization but of the
benevolent neutrality of modern humanism. As Wind sums it
up: 'It is not the number of persons who look at art that is
alarming, it is the number of works of art they look at, and the
reduction of art to a passing show.'

The paradox that art was once both the world of power and
of escape is shown by the fact that we now live with it on the
most comfortable and trivial terms: it neither alters our days
nor offers an alternative to them. The most shocking and
sensational modern novel or picture does not change this state
of affairs: indeed by trying so hard it seems to show that it
knows it cannot do so. Lionel Trilling wondered at, and
lamented, the fact that a modern humanist education exposes
the student to works of profound power, works whose very
nature should be to awe and discompose, and yet the student
is expected – naturally enough – to study them in a spirit of
unmoved enquiry. As Wind observes, 'Plato did not foresee
that the dangers of art, which he feared so greatly, might not
affect a people who had become immune to them'. And
modern criticism aids the immunizing process by seeking to
portray the enjoyment of art as a process of collaborative
understanding in a game or technique.

Wind's art of implication is particularly illuminating
because it avoids pessimism, and any air of the *laudator temporis*

acti. It is not the decline of religion that has produced our modern situation in the arts, nor democratic popularization, nor the modern connoisseur's technique (like the great Morelli's) of 'visual dissociation'. But Wind's diagnosis shows the part played by these and other factors over the whole spectrum of the arts, and the unexpected interplay between them. T.S. Eliot, for example, made what is now a notorious critical claim that poetry after the seventeenth century underwent a 'dissociation of sensibility', that the 'feel' of it split up into form and content and ceased to have that complex natural harmony of narrative and emotion which Yeats – also looking backward – called 'blood, imagination, intellect running together'. *Art and Anarchy* reveals the obscure but highly significant connection between the point that Eliot was making and the viewing technique of a brilliant specialist in attribution. Morelli was not interested in the way a picture told a story, or the emotion it invited in the spectator, because all such banal matters could be transmitted and copied between one artist and another. What absorbed him were the involuntary signatures of form, the shape of an ear, the angle of an eye, the texture of hair or clothing – it was these, rather than any overall 'association of sensibility', that were the true revelation of individual technique in a picture, and so the most reliable way of deciding who had painted it. A highly useful and influential method for the expert, and one soon adopted by experts like Berenson and Friedländer, but, as Wind points out, we have all been encouraged to become 'unconscious Morellians' now. I remember taking part in a conference in America on literature and the arts in which one of the participants, an art instructor, gave a talk illustrated by the reproduction of a Giotto fresco of Christ bearing the Cross. He spoke of the tactile and linear values of the drapery, and its relation to other patterns of form and line in the painting. He did not mention how the painter had dealt with the subject of the picture, perhaps because he thought it might distract or even embarrass his audience, or because it seemed to him genuinely irrelevant to the quality of the painting.

In fact the more humanistic we have become, the more our art has been consciously dehumanized. But, as the saying is,

you lose something, you gain something. Public interest in and enjoyment of art, particularly the visual arts, is certainly greater today than it has ever been; and even the simplest of us try to understand every new style and kind of artefact, on the basis of its own particular technique and intent. In rejecting instinct we all achieve something of the instructed dispassion of the connoisseur. The success of Ernst Gombrich's *Art and Illusion* shows that it is salutary at times to remember that all art is a trick, that we cannot meet real people in a fiction, or look into a fictional world created upon canvas. But there is a tendency in most of us only to be able to see, as it were, either one thing or another. Lord Clark, in his excellent little study *Looking at Pictures*, describes how he used to go early to the gallery to taste in solitude the strange sensation of walking towards *Las Meninas*, Velazquez's great creation of domestic life at the Court of Spain, as if towards a living scene, and to try to catch the exact moment at which it dissolves into a map-like mastery of constituent shapes and pigments. Clark's reminiscence suggests why his accounts of art have been so deservedly popular, because he perceived for and on behalf of the viewing public the need both to 'lose oneself' in the world elsewhere which constitutes a picture, and to understand how that world has been brought into being.

Wind's understanding of this dual relation to art – and ideally, as Chekhov said about our relation to the arts and the sciences, 'we are speaking here of assets only' – is as evident as it is both acute and profound. As his thoughts on Hegel's vision of the arts of Romanticism show, he accepts that art can no longer be *dangerous*, that it can no longer be intimately and indeed hazardously bound up with our political and social life, as it was in the time of the Greek city state or in the cities of the Italian Renaissance. The state can no longer be a work of art, as Burckhardt, following Hegel, ironically described it, and when we think of the political turmoil which accompanied the great Greek and Italian experiences we may reflect that this is just as well. To every age its appropriate experience of art, and ours is no doubt the understanding that goes with a certain passivity of response. Wind distrusted the factitious violence of the Expressionist school, for instance, because he

saw that its painters were no longer concerned – and this is also the case with many modern novelists – to present truth in the guise of fiction, but to impose an emotion directly upon our consciousness. They took sincerity too much *au pied de la lettre*, and as Wind observes, you cannot blow the trumpet of the Last Judgment every day.

Distinguishing here between matters of very great ambiguity and complexity Wind stresses the essential nature and dynamic of *fiction* in art; for it is precisely by means of fiction that the great artist becomes serious and imposes his seriousness upon us in the form of feeling, of curiosity, awe, and wonder. Wind's great works of scholarship marvellously elucidate the depth of fiction in pictures like Botticelli's *Primavera*, and in so doing reveal what mystery and authority can be possessed by art's fictional content. In *Art and Anarchy* he puts this kind of revelation on a theoretic basis, further reinforced by his few but tellingly chosen illustrations. Mantegna's *Dead Christ with Angels*, placed on the opposite page to Manet's picture with the same title, shows in graphic terms the prime requirement of a fiction: that it should believe in itself and intend to be believed. Manet does not believe that anyone will take his painting seriously except as a painting. 'It was not intended,' as Wind says, 'to force anyone to his knees.'

Mantegna himself may not have had that intention either. He had no need to: the power of the fiction in which he participates does it for him. And it is here that Wind shows his greatest understanding of the tricky nature of dynamism in the arts. An artist who lives with power and is accustomed to its fictions has neither to invent his own substitute for it nor to compose as if he felt in composition the emotions he is projecting at us. Wind quotes Ruskin's words on the master craftsmen who were 'set on doing their work', and who were able 'to dwell on grievous or frightful subjects all the more forcibly because they were not themselves liable to be overpowered by any emotion of grief or terror'. The point of real importance here is that our true understanding of the arts – and this is something that does not change with history or with fashion – works or should work in much the same way.

We have, or can acquire, the artist's simultaneous belief and non-belief in the power of art's fictions. It does not matter that in the West Plato's fear of art seems as irrelevant today as a fear of refrigerators or antibiotics. It does not even matter that techniques of recording and reproduction bombard us the whole time with what Wind calls 'vast aggregations of available images', and that we live simultaneously among arts of many different kinds, responding to each according to its own canons. Tolerance is the outcome of technology, which has shaped our artistic life and given it those assumptions about exposure to all available images, just as it is technology (rather than Marxist theology) that enables us nowadays to take for granted the proprieties of 'social justice'. Art as mass technology, something that is instantly available when we want it, creates its own climate of expectation and satisfaction, so that we take for granted the arrival of what the media describe as 'exciting young new artists', and 'key figures in contemporary British poetry', as we take for granted developments in the social and welfare services.

All these things are significant, but they matter little in the scale of the truth which is at the heart of Wind's argument. What he understands and rejoices in is our continued power – despite all the critics, the men alike of violence and of abstraction, the adherents of 'the eradication of matter by form' – to reproduce in ourselves the artist's state of mind and his love for every aspect of his subject, its fiction and its reality. Art requires a dual awareness, or rather emphasizes as nothing else does the fact that our deepest and most important sensibility and powers of response *are* dual, needing fiction as truth and truth as fiction, to be both moved and unmoved, to participate in the creation of sorrow or ecstasy, the familiar and the startling, with passion but also with a neutrality of intelligent pleasure. As modern consciousness, the Hegelian *Geist*, has developed, it is possible for it to comprehend at once the ancient sense of the arts as the source of strength and turbulence together with our modern sense of them as adjuncts of interest and diversion. Indeed, reading between the lines of Wind's exposition, we sense his knowledge that the contrast between the two attitudes to art, if it ever existed, has been greatly over-simplified.

More important, and in any case shared by both, is the paramountcy of *knowledge*, the fear of which is the subject of some of Wind's sharpest and most percipient pages. No one has argued more persuasively against the recurrent notion that the intellect is in some way the enemy of the arts. Wind knows better. 'The eye focuses differently when it is intellectually guided', and one of the greatest pleasures, as well as necessities, in the appreciation of any art, – novels, poems, or pictures – is the sense of recovering, or at least the attempt to recover, 'lost modes of perception'. In guiding our eye, in a great painting like *The School of Athens*, Raphael also 'focuses our thought'. He educates our whole powers of appreciation, eclectically and synergistically. Raphael has produced a visual commentary 'of unmatched lucidity' on the complex concordance in the Renaissance of Platonic and Aristotelian doctrine. Even more important

> by following the argument in Raphael's painting we discover visual accents, modulations and correspond-ences which no one would notice who did not follow the thought. The visual articulation of the picture becomes transparent, and it reveals itself as infinitely richer than a 'pure' vision, moving along the figures without grasping their sense, could possibly perceive ... We arrive here at a theory of vision exactly the opposite of that which the young Clive Bell so confidently propounded in 1914. 'The representative element in a work of art', he wrote, 'may or may not be harmful; always it is irrelevant.' As a matter of fact it is so relevant that whenever we ignore or misunderstand a subject, we are likely to misconstrue the image by putting the accents in the wrong places. Our eye sees as our mind reads.

The 'unconscious Morellian' who concentrates on the significant detail, or the reductive artist like Rodin who fashioned his *L'homme qui marche* as a striding torso because head and arms 'are superfluous for walking', may have good reasons for simplifying the artistic vision, but as a general doctrine it is wilfully and dangerously perverse, denying their full role to our eyes and minds. Such concentration suggests

that a short cut is more 'honest'; but even in seeing its point we may well become bored by it. Economy of means leads to economy of ends. As the Roman proverb had it: 'Cinna wishes to appear poor, and succeeds.' Wind called such critics and artists 'Knights of the Razor', because in using the principle of Occam's razor they cut out everything on which intellect and imagination delight to feed. They would certainly recoil from the sweep and play of intellect and erudition which animates Wind's text and notes alike, and from the eloquence of his plea for the arts that enhance and inspire each other and their clients in a triumphant synthesis. A good artist, Wind insists, is always in the final sense a man of complete intellect. 'I have never met a significant painter or sculptor who did not speak and think exceedingly well.'

This brings us back to his cardinal emphasis on the artist's dual nature, which 'lives in two worlds' and can 'give to facts the authority of fiction, in which others can partake vicariously'.

> Our response to art will ... not be a true and full response if we fail to reproduce *in ourselves* [my italics] something of the artist's dual nature.

The client must follow the artist in his invention, be as literate, as curious, as absorbed. For Wind anarchy does not mean crudity and poverty but, on the contrary, the natural extravagance of the human mind borne foward on the summit of a civilization. Out of that effervescence great art proceeds, and not from those who try wilfully to recreate the conditions of art among primitive people who did not even 'possess an alphabet'.

> Our own art is for peoples who do have an alphabet ... Having eaten from the tree of knowledge we cannot slip backwards into paradise; the gate is locked and the angel behind us, but the garden may be open at the opposite end.

St. Catherine's College, Oxford John Bayley

1

Art and Anarchy

I hope that the word 'anarchy' in the title of these lectures does not suggest that I shall speak in defence of order. I shall not. A certain amount of turmoil and confusion is likely to call forth creative energies. As we know from the uneasy lives that were led by Dante, Michelangelo or Spenser (not to speak of Mozart or of Keats), the outward circumstances under which great art is produced are often far from reassuring. And if we look at the great patrons of art, the men of enterprise who cajoled painters and poets into production, it would seem that they were rarely distinguished by a restful temperament. Whatever the Medici, Sir Walter Raleigh and Ambroise Vollard may have had in common, it was not, I believe, a quiet existence. Dissatisfaction and discontent, far from being inimical to the arts, have often been their tutelary genius. While I should not like to be dogmatic on this point, and would hate to encourage the completely mistaken view that the best artists and patrons are those who are disgruntled, I would venture on one single generalization: If it is the highest wish of a man to live undisturbed, he might be well advised to remove art from his household.

Art is – let us face up to it – an uncomfortable business, and particularly uncomfortable for the artist himself. The forces of the imagination, from which he draws his strength, have a disruptive and capricious power which he must manage with economy. If he indulges his imagination too freely, it may run wild and destroy him and his work by excess. 'The frenzied addiction to art', wrote Baudelaire, 'is a canker that devours

1

the rest.'¹ Yet if he plagues his genius with the wrong kind of drill, and uses too many contrivances and refinements, the imagination may shrivel; it can atrophy.

On the whole, great artists do not fear atrophy, but many of them have feared excess. The notebooks of Baudelaire abound in prescriptions for a strict regimen by which he hoped to tame and regularize his inspiration: *trouver la frénésie journalière* (the word *journalière* suggesting the daily toil of a journeyman).² And when Goethe wrote his *Annalen*, a sort of annual account of his occupations, compiled when he was old and supposedly calm and Olympian, he revealed that he was nervously afraid of the wild tricks that a lively imagination might play on an otherwise cultivated man. 'What is the good', he writes, 'of curbing sensuality, shaping the intellect, securing the supremacy of reason? Imagination lies in wait as the most powerful enemy. Naturally raw, and enamoured of absurdity, it breaks out against all civilizing restraints like a savage who takes delight in grimacing idols.'³

Goethe and Baudelaire had little in common; and the discipline each imposed on himself as poet is almost the opposite of that chosen by the other: Baudelaire chastising his Muse with acid paradox, Goethe trying to soothe his demon with muted commonplaces. But both felt – and felt with the same intensity – a sacred fear of the imagination that animated their poetry.

The term 'sacred fear' is, of course, much older. It derives from Plato (*theios phobos*),⁴ from whom I shall borrow a great deal more. Although no philosopher has praised the divine madness of inspiration more eloquently than Plato, he viewed it (like Goethe and Baudelaire) with sharp suspicion. He rated the strength of man's imagination so high that he thought a man could be transformed by the things he imagined. Hence he found miming a most perilous exercise, and he devised curious laws that would prohibit the miming of extravagant or evil characters. Recitations were to change at such moments from dramatic to narrative language, so that a certain distance would be established between the speaker and what he said, as if we were to speak of evil only in the third person, not the first, for fear we might otherwise become evil.⁵

To us these regulations seem eccentric. Surely there can be no harm in impersonating a grotesque figure? A few extravagant gestures, performed for the amusement of ourselves and others, will not poison us to the root. Indeed, if Plato had his way, all children's games would have to be supervised by a magistrate.

Yet Plato had some excellent reasons for writing solemnly about play. The games of children, he thought, are a crucial instrument in the forming of character, because it is through imitation of others that we become what we are. As James Harris said in the eighteenth century, in a remark that was quoted by Sir Joshua Reynolds, we can 'feign a relish till we find a relish come, and feel that what began in fiction terminates in reality.'[6] That is exactly what Plato meant. Edmund Burke, who in the practice of oratory must have been an accomplished mimic, made this experiment on his own person. 'I have often observed', he says of himself, 'that on mimicking the looks and gestures of angry or placid or frighted or daring men, I have involuntarily found my mind turned to that passion whose appearance I endeavoured to imitate; nay, I am convinced it is hard to avoid it, though one strove to separate the passion from its corresponding gestures.'[7]

If we accept these observations as valid – and it would be difficult to deny that innocent games are not always innocent, and that fiction is apt to take root in reality – the consequences are most unpleasant: for we are forced to take art as seriously as Plato, who in the end advises us to appoint a drastic censor. We know that this is bad advice because effective censorship is a contradiction in terms. Like pruning, it gives new vigour to what it cuts back; but if it attacks the root, it destroys the plant which it is supposed to save. Yet, with all these reservations clearly in mind, we can still learn a good deal from Plato if we observe how he imagines his censor in action, how he wishes an ideal state to proceed when it officially bans a dangerous poet. 'If any such man', he says, 'were to come to us to show us his art, we should kneel down before him as a rare and holy and delightful being': but we should not permit him to stay. 'We should anoint him with myrrh and set a garland of wool upon his head, and send him away to another city.'[8]

If this ritual were to be translated into modern terms it would sound like a burlesque: it would mean that before an artist can be condemned he must receive the highest possible honour, something like the Order of Merit. Plato understood what few seem to understand today, that the really dangerous artist is the great one: 'a rare and holy and delightful being.' Plato believed – and he unmistakably said so – that great evil 'springs out of a fullness of nature' rather than from any deficiency, 'whereas weak natures are scarcely capable of any very great good or very great evil'.[9] It is obvious from this remark that Plato was spared the kind of experience which moved Jacob Burckhardt to define mediocrity as the truly diabolical force in the world.[10] Since we know the great truth of Burckhardt's dictum, it is not easy for us to follow Plato when he suggests that only the strong imagination can be destructive, while the troubles caused by the weak one are negligible. But then, Plato lived in Greece, and his own evidence and that of others suggests that the Greek forces of destruction were not mediocre. It is sufficient to think of Alcibiades.

At the risk of saying the obvious, I must here recall a fact of ancient history. Plato saw Greek art and Greek poetry reach perfection and ease at the very time when he saw the Greek state disintegrate; and he sensed, and perhaps felt in his own person, a profound connection between these two developments. If the Greeks had not been so responsive to an exquisite phrase or a beautiful gesture, they might have judged a political oration by its truth and not by the splendour with which it was delivered: but their sobriety was undermined by their imagination. If I am not mistaken, Plato found himself in much the same dilemma as an experienced physician, diagnosing an illness for which no cure is known, who in despair and out of charity for his patient prescribes a remedy that does not work. In such cases we do not say that the diagnosis was wrong because the remedy failed; and perhaps this courtesy should be extended also to Plato. His remedy – state censorship – is a desperate one, and an obvious failure. His diagnosis may nevertheless be right.

Looking at these events from afar, a modern critic of Plato might concede that the political disintegration of Greece occurred while Greek art reached its highest refinement; but if that

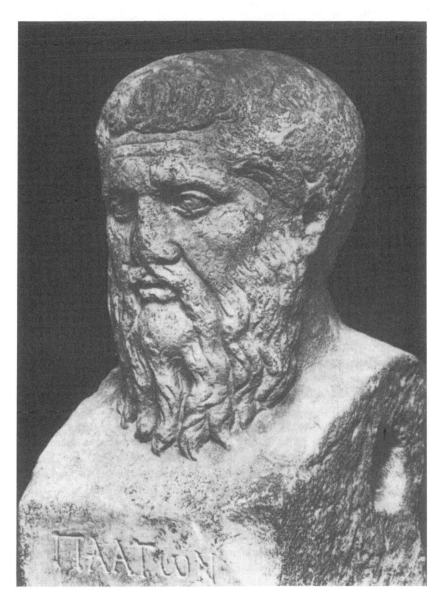

1. Bust of Plato. Staatliche Museum, Antiken-Sammlung, Berlin (East)

critic has read David Hume, he is bound to ask another question: Why claim a connection between two events merely because they happen to occur together? Could their conjunction not be an accident?

It certainly could, and it would be foolish to deny it; but it is odd that the accident should recur. In the Italian Renaissance, again, the most splendid release of artistic energies was attended by political disintegration. In Burckhardt's famous book *The Civilization of the Renaissance*, the opening chapter describes the anarchy, strife and despotism, the violent eruptions of human passion, by which the Italian city-states were lacerated; and Burckhardt gave to this, the most painful chapter of his book, an ironic title. He called it 'The State as a Work of Art' (*Der Staat als Kunstwerk*). He took that title, I think, from Hegel's *Philosophy of History*, where a comparable heading – 'The Political Work of Art' – appears over a chapter on the Greek city-states; and here the meaning is unmistakable: it signifies a state swayed by the artistic imagination. 'Even in its destruction', writes Hegel, 'the spirit of Athens appears magnificent ... Amiable and serene in the face of tragedy is the gaiety and recklessness with which the Athenians accompany their morality to its tomb.'[11]

It ought to be obvious by now that in connecting the word 'art' with the word 'anarchy' I was completely unoriginal. I merely continued to reflect on a thought which had occupied Plato, Goethe, Baudelaire and Burckhardt; and many other authors could be named, equally different from each other and equally close to the sources of art, who have made the same observation. The fact, however, that these thoughts are not new should perhaps recommend them all the more to our attention. If the release of imaginative forces is a threat to the artist, and must be controlled by him with care, then to a lesser degree the same threat is transferred to us when we share in the artist's experience. But what precautions do we take, in our busy artistic life, not to be overwhelmed by these forces, or not to choke them? How does our artistic economy avoid excess or atrophy?

I do not mean to ask this question in any narrow professional sense. We are not concerned here with the

problem, interesting though it is, of how an art critic, for example, who is obliged to visit one exhibition after another, manages to keep his sensibility fresh and his judgment sharp; or how a historian of art can survey all the medieval ivories in existence without letting his perception of them get stale. That men engaged in these tasks do occasionally lose their sense of proportion is one of the occupational risks with which any profession must reckon. My question refers to the general public, whose sense of balance is much more important: for it is essential to the well-being of a society that the whole should be less mad than the parts.

I have heard eminent and intelligent men speak on Art and Society, and on Art and the State, and the problem that preoccupied Plato all his life did not cross the threshold of their awareness. They rested their case on the generous assumption that the widest possible diffusion of art can have only a benign and civilizing effect, a view which Burckhardt, on the historical evidence, would have dismissed as silly and shallow optimism.

The late Mr. Kussevitzky used to say that we can never have too much music: the more music is performed and heard, the better for everybody. It is clear, I think, that he has had his way. More music is offered and heard today than in any age in history; and presumably the same is true of the diffusion of literature. It is certainly true of the visual arts. We are flooded with exhibitions, and glutted with picture-books; and these vast aggregates of available images are absorbed with an eagerness and, I may add, with a degree of intelligence that would have left less adaptable generations dazed. The instances are now extremely rare in which a person faced with an unfamiliar idiom of painting will dismiss it as the trick of a buffoon who cannot draw. These tantrums we are now happily spared; but the surrender to art on almost any terms seems equally alarming. It is as if the flood-gates of the imagination had been opened and the waters were streaming in without meeting resistance. The sacred fear is no longer with us.

But perhaps the fear has become superfluous. Diffusion brings with it a loss of density. We are much given to art, but it touches us lightly, and that is why we can take so much of it,

and so much of so many different kinds. If a man has the time and the means, he can see a comprehensive Picasso show in London one day, and the next a comprehensive Poussin exhibition in Paris, and – what is the most amazing thing of all – find himself exhilarated by both. When such large displays of incompatible artists are received with equal interest and appreciation, it is clear that those who visit these exhibitions have acquired a strong immunity to them. Art is so well received because it has lost its sting.

In our time many artists, I think, are aware, although not all are so unwise as to say so, that they address themselves to a public whose ever-increasing appetite for art is matched by a progressive atrophy of the receptive organs.[12] If modern art is sometimes shrill, it is not the fault of the artist alone. We all tend to raise our voices when we speak to persons who are getting deaf. Artists as different in attitude as Arp, Picasso, Rouault and Klee have all made use at one time or another of what André Gide called 'the gratuitous act',[13] to produce the cruel shock aroused by the patently absurd or the repulsive. Brecht's famous technique of 'alienation' sought to break up the inertia of empathy;[14] and it is well known how Angry Young Men have tried to shock their public into attention – but these effects have little chance of lasting. As with the unbroken colour used by *Fauve* painters[15] or the monstrous puppetry of *Ubu Roi*,[16] the shock wears off when it becomes familiar, and the device by which it was first achieved receives a place in the long gallery of modern devices where, well classified and clearly labelled, it attracts and satisfies the dispassionate pilgrim, or just arouses his curiosity.

It might be thought that Plato ought to envy the condition in which we find ourselves. The dreaded demon of the imagination, which he had tried in vain to exorcize, has finally lost the power to hurt us. Those savage masks of grimacing idols that frightened Goethe out of his wits have all been safely domesticated. We have them with us, and they give us pleasure. Isaiah's prophecy of the peaceable kingdom, where the wolf shall dwell with the lamb, and the leopard shall lie down with the kid, and the lion shall eat straw like the ox, has been fulfilled in our vision of art, but of art alone: for in no

other phase of our existence are we prepared to make the peculiar sacrifice that is required here. In Isaiah's paradise the kid and the ox remain as we know them, but the leopard and the lion are obliged to part with their teeth.

And that may possibly be the cause of our disorientation. As Plato and Baudelaire and Goethe saw clearly, the magic of art is inseparable from its risks. But however wildly our lions and leopards may jump, we know they are tame, and their antics will not frighten us.

It is fortunate that this form of apathy was explored again by a great philosopher. About a century and a half ago, when these symptoms first began to appear, they were clearly recognized by Hegel, who studied this modern malady with the same care as Plato had studied the ancient. He explained that when art is removed to a zone of safety, it may still remain very good art indeed, and also very popular art, but its effect upon our existence will vanish.[17]

It is worth listening to Hegel on this point. Whatever the weakness of his metaphysics, as an observer of the world of men he was as sharp-sighted as Montaigne. The artistic life that he saw about him resembles ours in many ways. It was the height of Romanticism, and of Berlin Romanticism at that. Imagination had been released from the restraints of convention, and it was felt that art had finally come into its own. The poetic output was so rich and miscellaneous that the young Friedrich Schlegel called it a grocery shop: folk-songs, romances of chivalry, Greek and Nordic and Christian epics, epigrams, patriotic hymns, also 'Iroquois or cannibalistic odes for amateurs of anthropophagy'.[18] In the visual arts the sombre wit of diabolical fairy tales, depicted in the impish manner of Fuseli, could be appreciated side by side with chaste, abstemious, neo-classic designs drawn in the style of Flaxman – for whom Ingres could think of no higher praise than to call him 'the English Canova' (the modern art of that time was as international as ours). And then there were the aesthetic Primitives: noble savages communing with nature, lovers of folk-art and medieval antiquities, and above all the Nazarenes, who founded their art on religious conversion.

Hegel saw it, and found it wanting;[19] interesting, to be

sure, but that in his view was not a compliment. To apply the word 'interesting' to a work of art was, in fact, a Romantic invention;[20] and in carrying on that habit today we inadvertently adopt a Romantic attitude. In Hegel's day it was new, and he saw what it meant. An 'interesting' object has an arresting quality; it arouses our attention; we take cognizance of it and then let it go. An 'interesting' experience is one that has no lasting effect.

So Hegel drew up his bill of particulars. As he saw it, the moment had arrived in the world's history when art would no longer be connected, as it had been in the past, with the central energies of man; it would move to the margin, where it would form a wide and splendidly varied horizon. The centre would be occupied by science – that is, by a relentless spirit of rational inquiry. The kind of science which Hegel foresaw bears no resemblance to the science of today: in that he was a bad prophet.[21] But the place of science in our lives he foresaw correctly, and he was equally far-sighted in the place he assigned to art. He explained that in an age of science people would continue to paint and to make sculptures, and to write poetry and compose music, and in so far as they did these things it would be desirable they should do them well. But let us not be deceived, he writes: 'however splendid the effigies of the Greek gods may look, and whatever dignity and perfection we may find in the images of God the Father, Christ, and the Virgin Mary, it is of no use: we no longer bend our knees before them'.[22] What Hegel meant was beautifully illustrated some forty years later by Manet when he painted *The Dead Christ with Angels*. Unlike Mantegna's painting of the same subject, this picture was not intended to force anyone to his knees. It was painted for an exhibition, not for a church. Manet wanted it to be admired as sheer painting.[23]

It should be clear, then, that by moving into the margin art does not lose its quality as art; it only loses its direct relevance to our existence: it becomes a splendid superfluity. An art thus detached from the realities of living does not cease to be widely and intensely enjoyed. On the contrary, nothing gives us greater pleasure than to commune with images that are so free. As Baudelaire explained with incomparable clarity, the

2. Portrait of Hegel. Contemporary lithograph by Ludwig Sebbers.
Goethe-Museum, Düsseldorf

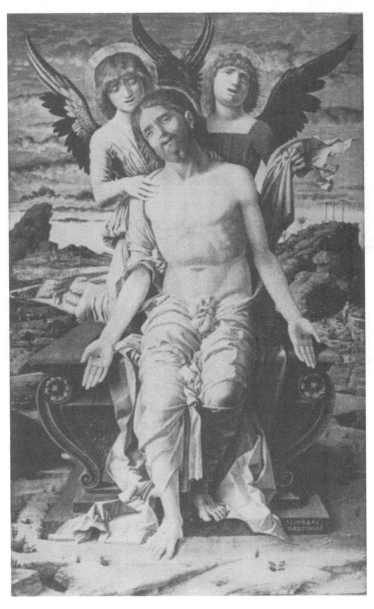

3. Mantegna. *The Dead Christ with Angels*. Statens Museum for Kunst, Copenhagen

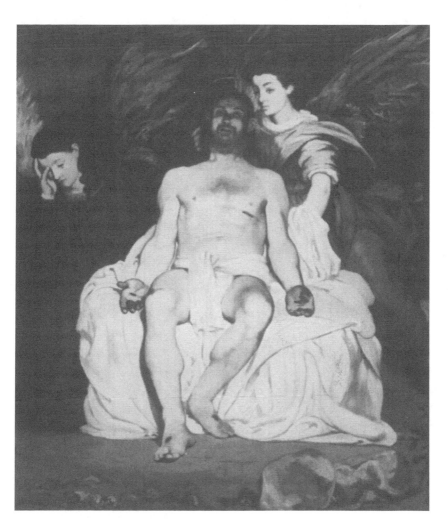

4. Manet. *The Dead Christ with Angels*. The Metropolitan Museum of Art, New York

5. Portrait of Baudelaire, by Manet. Etching

laughter aroused by a comedy of Molière, which is significant laughter because it refers to life, is both narrower and less intense than the pure, disengaged, uncontrollable laughter that may seize us before an extravagant *drôlerie* by Callot, a fantasy unrelated to our existence. According to Baudelaire, pure fantasy produces 'art for art's sake', a proud art which is no one's servant, posing all its problems from within.[24]

Although Hegel relegated this art to the margin, he was fascinated by its inherent powers. His language grows eloquent and almost poetic when he describes the plastic freedom and freshness of adventure which an artist or poet is likely to gain when he allows his imagination to roam without fear, entering lightly into diverse experiences, some familiar, others remote, without allowing himself to be caught in any. Conceived in this spirit, a love-poem will be a poem of *imagined* love, drawing its tone and form from the imagination only. In such productions, Hegel says, 'we find no personal longing, obsession or desire, but only a pure pleasure in the phenomenon'; and he describes that state of detachment as 'an inexhaustible self-abandon of the imagination, an innocent frolic, ... and with it an inward warmth and joy of sensibility ... which raises the soul, through the serenity of form, above any painful involvement in the limitations of reality'.[25]

Any modern believer in 'pure art' must admit that this description is compelling. Hegel was no stranger to that rarefied experience which Mr. Clive Bell enjoyed in what he called 'significant form',[26] but Hegel's language was more radical. He explained that the absolute freedom of art, by which art can attach itself freely to any substance it chooses in order to exercise the imagination on it, has made of the new artist a *tabula rasa*.[27] Infinitely susceptible to new shapes because no shape can be regarded as final, he is in a state of perpetual self-transformation, engaged in what Hegel quaintly calls *unendliche Herumbildung*, an infinite plasticity.[28]

It is clear that Hegel foresaw developments of which we now have the confirmation, but in spite of the brilliance of his description, in one respect his analysis is as incomplete as Plato's. Plato did not foresee that the dangers of art, which he feared so greatly, might not affect a people who had become

immune to them. Hegel, on the contrary, could not imagine that art would ever again become dangerous. Although he envisaged an art of the future which might be richer and subtler than the art he had seen, he supposed that, no matter how varied our art might become, it would always remain disengaged from reality because, as he put it, 'art has worked itself out'.[29] According to Hegel, when art becomes pure it ceases to be serious, and in that consists its final splendour.

If Hegel were right, then a state of glorious irrelevance would continue for art in perpetuity. But here it is possible that he overshot the mark and forgot some of his own reflections on method: 'The phases through which the spirit seems to have passed, it still possesses in the depths of its present.'[30] Though mysteriously worded, the thought is plain: the past is not destroyed by the present but survives in it as a latent force. On this assumption no phase of history should be treated as irrevocably finished. There is no denying that in our civilization, however lively art may seem, it has become a marginal occupation: but Hegel is much too certain in his belief that art will remain marginal for ever. 'At certain times', as Burckhardt wrote, 'the world is over-run by false scepticism ... Of the true kind there can never be enough.'[31]

2

Aesthetic Participation

In the course of the first lecture I suggested that the wide diffusion of art today, and with it the great expansion of our artistic horizon, is made possible by a facile response to art, by a certain ease we have acquired in touching the surface of many different artistic experiences without getting seriously involved in any. And I assumed a connection between this detached way of looking at art and the fact that art has become marginal in our lives, while the centre is occupied by science.

Since science has become the modern bogey, and can be used as a scapegoat for all our failings, it would be tempting to claim that art was pushed into the margin by science or, if not by science alone, then by science combined with a form of commerce that fosters wide and quick distribution. An accusation to that effect was made by André Gide, whose words must be taken with a grain of salt. In an excessively sharp attack on certain formal exercises with which he saw Matisse preoccupied in his studio, Gide claimed that when a painter cultivates painting for its own sake, and designs patterns for the sake of patterns, concerned with nothing but the formal perfection of his *métier*, he will produce an art shorn of mind, such as admirably suits 'an impatient public and speculative dealers'. Gide boldly called such an art *une peinture décérébrée*, an un-brained and dehumanized sort of painting.[32]

No doubt Gide was right, and not alone, in thinking that wide stretches of our art have become dehumanized because art has been reduced to a pure *métier*,[33] but it would be an

17

illusion to suppose that art suffered these developments as a victim. Its role has been that of an active partner. Perhaps I can illustrate this point by a parable which has the advantage of being taken from the past, so that we can look at it dispassionately.

In the sixteenth century Ariosto complained that chivalry was being destroyed by the introduction of firearms. He made that statement, which sounds plausible enough, in his mock-heroic epic, the *Orlando furioso*, where the hero, a medieval knight of splendid absurdity, finds one of these nasty unchivalrous engines and throws it, with appropriate declamation, to the bottom of the sea.[34] Now there can be no doubt that the introduction of firearms did contribute to the disappearance of medieval chivalry; and yet, if we are to name one of the strongest and most effective agents in rendering chivalry outmoded, it is Ariosto's poem, the *Orlando furioso*, where the heroes are placed in such a fantastic setting, and act such marvellously ridiculous parts, that the reader can have no doubt of their unreality. Ariosto paved the way for Don Quixote. If chivalry died, it did not die by firearms alone: it died in and through the imagination, and particularly by the force of Ariosto's poetry. The poet is an agent in those developments of which he sees himself only as a victim.

That rule applies to the marginal position of art today. Art has been displaced from the centre of our life not just by applied science, but above all by its own centrifugal impulse. For more than a century most of Western art has been produced and enjoyed on the assumption that the experience of art will be more intense if it pulls the spectator away from his ordinary habits and preoccupations. To cut us loose from our habitual moorings has become the chief task we assign to the artist. If we think, for example, of Manet, Mallarmé, Joyce or Stravinsky, it would seem that almost all the artistic triumphs of the last hundred years were in the first instance triumphs of disruption: the greatness of an artist became manifest in his power to break up our perceptual habits and disclose new ranges of sensibility. 'It is easier to paint Nature than to fight her', was one of Kandinsky's self-admonitions;[35] and he recalled his conversations with Schoenberg on 'the emancipa-

6. Matisse, Mask and Flowers. Detail from a *grande gouache découpée*.
National Gallery of Art, Washington, DC

tion of the dissonance'.[36] In literature, Remy de Gourmont –
an impressionable rambler, overpraised in T.S. Eliot's *Sacred
Wood* as 'the critical consciousness of a generation'[37] – tried to
defy the comforts of habit by seeking perpetual refreshment in
divorce: 'I have spent all my life making dissociations,
dissociations of ideas, dissociations of sentiments, and if my
work amounts to anything, it is because I have persevered in
that method.'[38] As Rimbaud wrote in his famous *Lettre du
voyant*, the modern poet comes into his own by a systematic
'derangement of all the senses'.[39]

It is indeed a psychological fact that when colours, shapes,
tones or words appear in bold disjunctions or collisions, and
thus freed from their habitual surroundings, their quality as
brute sensations is felt with a fresh intensity. Hence that
intimate and perilous connection between purism and
barbarism which Paul Valéry observed in himself. 'Nothing
leads more certainly to perfect barbarity', he wrote, 'than an
exclusive attachment to the pure spirit ... I have been
intimately acquainted with this fanaticism.'[40] Whether called
Monsieur Teste, Monsieur Croche or Stephen Dedalus (not to
speak of Balzac's Frenhofer in *Le chef-d'oeuvre inconnu*), the
portrait of the pure poet, musician or painter is always that of a
fastidious exile, studiously perched on the edge of the abyss
and savagely recording the distant overtones by which,
according to Schoenberg's *Harmonielehre*, new consonances
emerge from expressive distortion. As Mallarmé put it with
sardonic precision: 'La Destruction fut ma Béatrice.'[41]
Verlaine, in *Les poètes maudits*, celebrated this desolate state of
exaltation by the pun *bealtitudo*.[42]

It might be argued that this predicament is neither new nor
unusual; creative energy has always had the effect of
transforming or sharpening perceptual habits. Yet in the past,
when artists were still genuinely in touch with the world of
action, their innovations – no matter how exhilarating or how
upsetting – were produced in a manner almost incidental to the
vital functions that art subserved; today artistic inventiveness
is an end in itself. Art has become 'experimental'.

It is significant that this word 'experiment', which belongs
to the laboratory of the scientist, has been transferred to the

artist's studio. It is not a casual metaphor: for although artists today understand far less of science than they did in the sixteenth or seventeenth century, their imaginations seem haunted by a desire to mimic scientific procedures; often they seem to act in their studios as if they were in a laboratory, performing a series of controlled experiments in the hope of arriving at a valid scientific solution. And when these astringent exercises are exhibited, they reduce the spectator to an observer who watches the artist's latest excursion with interest, but without vital participation.[43]

It would be silly to assume that this situation can be changed by merely wishing that it were different. The cultivation of art for its own sake, which is at the root of dissociation, has had such a long and, above all, such a creative history that it cannot be dismissed with the words 'I do not believe in it' or 'I have changed my mind'. As a great sociologist once said in a moment of anger, history is not a tram from which you can alight at your convenience. Since it is a historical fact that all the arts – music and poetry no less than painting – were simultaneously seized by a centrifugal force, it would be childish to seek the cause in wilfulness, or in a friendly conspiracy of all the eccentrics: the impulse was far deeper than any individual whim. Hence it cannot be reversed by a simple decision. If art is again to play a more central part in our lives, it means that our lives will have to change, and that is a process which does not depend on artists and art critics alone; but there is no harm in making a small and very modest beginning. I thought, therefore, that it might be useful to inquire what we ourselves, in the enjoyment of art, might do, or refrain from doing, to render our participation in art more vital. And being an art historian by training, my thoughts turn first to some of the failings of my own profession: for there is no denying that we have made a contribution to the dehumanizing of artistic perception.

Historians of art are themselves part of history, and far from immune to the artistic temper of their age. The Swiss scholar Heinrich Wölfflin, for example, perhaps the greatest art historian of the last generation, was so responsive to the prevailing mood of aesthetic purism[44] that he developed a

technique of dissociation at least as extreme as that of Remy de Gourmont. His outlook is perfectly summarized in his famous remark that the essence of the Gothic style is as evident in a pointed shoe as in a cathedral. Wölfflin was not the kind of man who needed to be told that a shoe, however Gothic in style, is not the equivalent of a cathedral, and that a theory of style is incomplete if it fails to account for the difference; but he was preoccupied with a far more embarrassing and revolutionary truth. He had found that the more an object is loaded with religious emotions, the more obstacles it offers to a purely visual grasp. Gothic cathedrals excite hazier visions than Gothic shoes; and the cause lies not only in their greater formal complexity, but also in the fact that their devotional aura overwhelms us. Wölfflin insisted that the eye must be trained on forms that are emotionally less distracting. Thus he was never satisfied with tracing a master's style in the design of a human figure or head. 'In the drawing of a mere nostril', he wrote defiantly, 'the essentials of the style should be recognized.'[45] His ideal was what he called 'an art history of the smallest particles', which would trace developments of form by comparing 'hand with hand, cloud with cloud, twig with twig, down to the lines in the grain of the wood'.[46]

This sort of discipline is reassuring. By the time we have descended to the curve of the nostril, we can feel certain that we are studying the form for its own sake, and not for the sake of the object; and thence we may re-ascend to the face and the figure at large without fear of any human distractions. Even a cathedral may then become safe. And yet, a rather primitive question remains unanswered: Why should any man in his senses look for artistic safety in a cathedral? Great art never seems to be quite so clean as our aesthetic purists want to make it, since it invariably involves us in the kind of 'emotional nonsense' from which Wölfflin's method was designed to save us. In fact, a cathedral surveyed with Wölfflin's eyes is no longer a cathedral at all, but a crystalline system of visual forms. As for the drawing of a human face, the mouth and the eyes may have a range of expression for which the study of a nostril does not fully prepare us.

By ruling these illicit intruders out of court, Wölfflin reduced his artistic perception to an emotionally untainted sense of form, and this made it possible for him to move with enviable ease from Raphael to Rubens, and from Holbein to Rembrandt, without concern for the imaginative forces which their designs were intended to release. To those who protested that this radical purge of emotions deprived great artists of the power to move us, he calmly replied: 'In philology no one has ever complained that the esteem of poetic personalities is impaired by linguistic or general stylistic investigations.'[47] He admitted that he aimed to introduce into the study of art what students of letters had long accepted as a distinction between literary and linguistic studies. Historical grammar, he thought, might be secure against emotional or poetic transports.[48]

Great benefits have accrued to the study of art from this sublime disregard of human passions, which Wölfflin shared in particular with Riegl, the founder of the Vienna School. Their detachment brought freshness and breadth, and a freedom from prejudice, a willingness to explore the unfamiliar, even the repulsive, and to risk new adventures of sensibility. We owe it to them that we no longer judge one style by the canons of another. The art of the late Roman Empire or Baroque art, formerly despised as arts of decline, are now appreciated for their peculiar quality.[49] Words like 'decadent', 'primitive', 'barbaric', 'mannerist', have lost their pejorative meaning. The barrier between minor and major arts has fallen: an Egyptian lotus ornament is studied with the same care as the tomb of a Pharaoh. Michelangelo's drawings receive no less, perhaps even more, attention than his frescoes. And to return to Wölfflin's formula, a pointed shoe can instruct us about a cathedral.

If it is true, as I have suggested, that the general public has acquired a certain ease in touching the surface of many different arts without getting seriously entangled in any, there can be little doubt that this approach was encouraged by the art expert. Whether you take Wölfflin, or Riegl and the Vienna School, or Roger Fry and Clive Bell, or Bernard Berenson, they methodically developed an exquisite skill in skimming off

the top of a work of art without necessarily making contact with its imaginative forces, often even shunning that contact because it might disturb the lucid application of a fastidious technique.[50]

It was to be expected that these extreme refinements would produce a reaction of some violence. And we have that reaction with us today in a new and rather coarse philosophy of art which claims that the failings of the theory of pure art can be remedied by simply turning it upside down. In the place of an art of disengagement, which rejoiced in its separation from ordinary life, we are now to have an art which completely involves us in real life – what in France is called *art engagé*. If I am sceptical about this doctrine, it is because it seems to me to make essentially the same mistake as the theory which it opposes. Both try to escape, in opposite directions, from the plain and fundamental fact that art is an exercise of the imagination, engaging and detaching us at the same time: it makes us participate in what it presents, and yet presents it as an aesthetic fiction. From that twofold root – participation and fiction – art draws its power to enlarge our vision by carrying us beyond the actual, and to deepen our experience by compassion; but it brings with it a pertinent oscillation between actual and vicarious experience. Art lives in this realm of ambiguity and suspense, and it is art only as long as the ambiguity is sustained. However, suspense is an awkward condition to live in, and we are persistently tempted to exchange it for some narrow but positive certainties; and yet we know very well that, as soon as the artistic imagination begins to work on us, we leave the safe shore for the open sea.

We need only watch a theatrical performance to find ourselves entering willingly into dramatic situations to which we would not want to be committed even if we could be; and yet they can engage our compassion with such force that they might be difficult to endure without an ingredient of make-believe. If all the tragedies we see on the stage were to be experienced by us as *art engagé*, it is unlikely that we should survive them. Our aesthetic fundamentalists do not abide by their own rules. If they really lived their doctrine they would be dead.

Some ten years ago the same point was made much better, and more politely, in an editorial on 'Pure Art' in *The Times Literary Supplement*,[51] directed against the revival of an old error in the appreciation of Fra Angelico. It had been said that this painter is so saintly in his art that, in order to feel this quality of saintliness, the spectator must be in a good moral state. The writer replied that an understanding of goodness may well be needed to appreciate Fra Angelico, but that this does not mean that one has to be good. 'Is it then necessary', he asked, 'to be full of superstitious fears in order to be moved by Mexican sculpture, or eager for meat in order to understand the caveman's art?'

John Ruskin, who might easily be mistaken for a dogmatic prophet of artistic commitment, was struck with admiration when he observed an unexpected power of detachment in certain Northern masters of the sixteenth century who excelled in grave or terrible subjects. 'Those masters', he wrote, 'were much too good craftsmen to be heavily afflicted about anything; their minds were mainly set on doing their work, and they were able to dwell on grievous or frightful subjects all the more forcibly because they were not themselves liable to be overpowered by any emotion of grief or terror.'[52]

Some of that same freedom from affliction and fear must be ascribed also to primitive artisans. In superstitious tribes the ritual performers enjoy the benefit of particular spells which protect them against the terrors they administer. Snake-dancers do not fear the poisonous snakes they handle, and the Mexican sculptor would hardly have been able to render the terror of his gods so effectively if he had been overcome by that terror while carving the stone. The most barbaric of craftsmen thus seems in command of that curious power of self-division which Baudelaire regarded as indispensable to art: 'The artist', he writes, 'is artist only on the condition that he is double, and that he neglects no aspect of his dual nature.'[53]

It seems to me true that no theory of art is complete if it ignores the split of consciousness which enables the artist to live in two worlds: to sense what is real and to feign that he senses it, and thus to give to facts the authority of fiction, in

which others can partake vicariously.[54] It follows from this
that our response to art will, in its turn, not be a true and full
response if we fail to reproduce in ourselves something of the
artist's dual nature.

How difficult this is to accomplish I still vividly remember
from a typical error of judgment I committed as a young man,
when for the first time I saw an exhibition of German
Expressionist painting. The walls were filled with apocalyptic
pictures painted in violent colours and incongruous shapes. I
found this aggressive art singularly exciting and consumed it
with the fresh appetite and strong stomach of youth. In the
midst of these pleasures I was struck with a thought that
troubled me greatly; and it might still trouble me now, were it
not that I have become less serious. It occurred to me that if all
these intense pictures, one after the other, had been
experienced by me with the intensity they demanded, I ought
to be out of my mind, but I clearly was not. And, extending
this thought to the numerous visitors who had been exposed
with me to the same exhibition, I came to the conclusion that
something was wrong; that these painters produced an illusion
of intensity, but were not so intense as they pretended.[55]

At that time I thought that this was a valid criticism, but I
think so no longer. The aim of any artist is to produce a
persuasive figment, and if he succeeds, why call that his
failure? There is nothing wrong with an illusion of intensity,
provided the illusion is sustained. The trouble, as I can now
see in retrospect, was that the illusion was *not* sustained; and
having since seen many Expressionist paintings, I think the
causes were twofold, and played on two entirely different
levels. In the first place, that early exhibition included some
rather mediocre pictures – paintings by Heckendorf, Jäckel or
Melzer, whose names are almost forgotten today. While
mediocrity would tend in any style to weaken or destroy the
aesthetic illusion, mediocrity which claims to be intense has a
peculiarly repulsive effect. But that sort of repulsion – and this
is important – can also be caused by an aesthetically forceful
and valid picture in that style, because we may find ourselves
out of sympathy with the apocalyptic attitude of the painter.
You can blow the trumpet of the Last Judgment once; you

must not blow it every day. When the peak of excitement is produced with clockwork regularity, it cannot but be slightly strained; and by 'strained' I mean a human rather than an aesthetic failing: it entails a lack of balance, a hankering after extremes, and the complete absence of a sense of humour, each of which may contribute toward rendering the aesthetic illusion all the more compelling.

For these reasons there is much to be said for the art historian Carl Justi, who in the late nineteenth century contributed to the rediscovery of El Greco.[56] His judgment combined an acute awareness of El Greco's quality as a painter with a carefully considered rejection of his artistic character. There are many persons, including myself, who react in precisely this way to Wagner's music and Rilke's poetry, acknowledging the power of a supreme genius but recognizing it as the kind of power to which one should not surrender. And it is not impossible that much of Mexican art, both ancient and modern, might be all the more open to this form of criticism because its artistic force is undeniable. When we see with what splendour the savagery of the Aztec warriors directly issues from their superb effigies, we may well remember Plato's warning that artists of such power are 'rare and holy and delightful beings', but that we should beware of their spell. The same sort of reservation might apply to the perpetual *fortissimo* of Kokoschka or Rouault.

I have chosen these cases at random to suggest not only that we can, but that we should, react to a work of art on two levels: we should judge it aesthetically on its own terms, but we should also decide whether we find those terms acceptable. To acknowledge the force of an artistic achievement is not a sufficient ground for disregarding its human bias; and to be critical of that bias is no reason for denying its artistic merits. The advocates of *art engagé* would like to persuade us that it is not only wrong, but wicked, to praise a work of art aesthetically if we disagree with its presuppositions; whereas the adherents of pure art would like us to accept every artistic achievement on its own terms and never to question the underlying assumptions. As Croce rather brusquely put it, there is no 'double bottom' (*doppio fondo*) to the suitcase of

art.[57] And rarely has a fallacy been expressed with such gusto.

As one reads that remarkable phrase of Croce's, one feels the current of fresh air which that immensely well-read author thought he was letting into his library. All those secondary meanings, overtones, undertones, forgotten allusions, silent assumptions, which persistently obstruct our vision of art, are swept away with a magnificent gesture: art is all primary, and primary throughout. We must feel it directly, or not at all.

In fairness to Croce and Wölfflin, and also to Roger Fry, it should be said that, like most great men, they did not feel bound by their method; they had a grand way of brushing it aside. And perhaps that has been the saving grace of many propounders of pure art.[58] As a rule they were much too intelligent not to suspect that art was rarely quite so pure as they made it out to be; but they thought it was a wholesome doctrine to propound, particularly at a time when sentimentalism about art was rampant. Yet they have succeeded almost too well. I remember seeing many years ago an elegant exhibition of primitive masks and other ritual objects at the Burlington Fine Arts Club, where they were relished for their sheer formal beauty by a group of intelligent connoisseurs; and I must say that in that tasteful setting they looked as harmless and wholesome as a basket of fresh eggs. There was not a drop of poison left in them. They had all become pure art.

The temptation is great to embrace pure art because it is so refreshing. Since the imaginative forces embodied in a figure are likely to disturb our pleasure if we do not know how to respond to them, it is always encouraging to be told that they are irrelevant. Nor has such encouragement been wanting. The great spring-cleanings of art, from which art is to emerge pure and fresh, have become a regular festival;[59] and here we are again, far more than we know, both the dupes and the agents of a scientific age. For purposes of stylistic classification the treatment of art *as if it were pure* has proved a useful and economical fiction, not unlike the construction of models in science. Whoever studies the history of styles knows how helpful it is to think in morphological classes. There is no harm in moving among such abstractions as long as the model is not confused with the thing; but the theory of pure art is prone to

that error. Intent on establishing an artistic experience that is clear, tidy, and direct, it over-cleans the work of art and transforms it into an aesthetic dummy. As Le Corbusier thought of a house as a *machine à vivre*, so hedonistic connoisseurs think of a painting as a *machine à sentir*, a figment endowed with all the splendour and luminosity which Yeats, in the poem that he called 'The Circus Animals' Desertion', ascribed to the show pieces of his fancy: but those masterful puppets conceived, as he says, by 'pure mind' will not serve him any longer, because he has gone back to the 'rag-and-bone shop of the heart'.

> Players and painted stage took all my love
> And not those things that they were emblems of.

3

Critique of Connoisseurship

In speaking about connoisseurship one cannot help stumbling over the word *connoisseur*. Although English experts on art have been eminently skilful in ascribing old drawings and paintings to the right masters, the English language has not produced a native word for that kind of skill. The connoisseur is still what he was in the eighteenth century, a character set apart by virtue of certain refinements of taste for which a French word seemed the right designation.

To form an idea of an eighteenth-century connoisseur, it would be dangerous to entrust oneself unreservedly to Hogarth, who disliked anything French, also anything that sounded French. Moreover, he was engaged in a private war with a group of gentlemen whom he called 'dealers in dark pictures', which was his own way of fighting the perennial battle of the moderns against the ancients.[60] Nevertheless, Hogarth knew what he hated, and intelligent satire is always enlightening. This is shown by a vivid but nasty letter that he published in a daily newspaper over the signature 'Britophil'. In it he described how an innocent Englishman was bamboozled into paying a large sum for a 'dark' painting which he did not particularly like. His tempter persuaded him to commit this folly by addressing him in a superior way:

'Sir [he said], I find that you are no *connoisseur*; the picture, I assure you, is in Alesso Baldminetto's second and best manner, boldly painted, and truly sublime ...' – Then, spitting in an obscure place, and rubbing it with a

dirty handkerchief, [the quack] takes a skip to t'other end of the room, and screams out in raptures, – 'There's an amazing touch! A man should have this picture a twelvemonth in his collection before he can discover half its beauties!'[61]

Hogarth had a genius for catching essentials; and almost all the essentials of eighteenth-century connoisseurship are present in this little travesty. The first essential is to attach a painter's name to an anonymous picture, to make what is called 'an attribution'; and Alesso Baldminetto is a fair deviation from Alesso Baldovinetti, who had the good fortune to exist. The second essential is to be precise about it; hence we are told that the picture belongs to Baldminetto's second period. The next essential is to point to an obscure detail in the painting and blow it up into something important; and the final and perhaps the most significant touch is to make a gesture which suggests that no reasons can be given for the judgment passed by the connoisseur, because it is all a matter of perception, and hence ineffable.

Since the days of Hogarth, attention to the authenticity of ancient paintings has much increased, and the connoisseur's importance has correspondingly grown, not only for museums, collectors and the trade, but also in the more disinterested pursuits of academic art history. If an ambitious theory is proposed, for example about Rembrandt's religious opinions, the connoisseur will enquire whether the Rembrandt drawings on which the theory rests are really by the master's hand. It is not unusual for the prettiest intellectual structures to come tumbling down as soon as the connoisseur begins to tap at the foundations. But what has this useful kind of historical critic got to do with Art and Anarchy today?

He would have nothing to do with it at all if he still performed only the sort of hocus-pocus that disgusted Hogarth; but those days are more or less over. Connoisseurship of painting has become a solid craft, and being guided in its judgment by intelligible rules it willingly carries a small load of philosophy. As a skilled technician, the modern connoisseur knows by what signs to distinguish the genuine

from the counterfeit; he can demonstrate authenticity. As a philosopher (that is to say, as an aesthetician), he regards those traits which reveal authenticity as the most important parts of a painting. I shall try here to discuss both aspects of his work, the technique as well as the underlying aesthetic.

The technique of connoisseurship was rationalized in the nineteenth century by a clear-headed amateur who did his work so exceedingly well that it passed almost imperceptibly into the work of his professional successors. I mean the great Italian innovator Giovanni Morelli, to whom I shall devote much of this lecture. Himself a connoisseur of genius, and of an exceptionally wide experience, he detested the grandiloquent verbiage that always renders the study of art unnecessarily suspect. He was determined to show that there is nothing mysterious about making an attribution; that like any other skill, it requires a certain gift and regular exercise; that it rests neither on irrational nor on super-rational powers, but on a clear understanding of the particular characteristics by which the author of a painting can be recognized in his work. For this purpose he developed a well-defined method, maintaining that it transformed attributions from inspired guesses into verifiable propositions. Decried as charlatanism when it was first published, but soon adopted by Frizzoni, Berenson, Friedländer and others, and now used in all the schools of art history, Morelli's method rests on a meticulous technique of visual dissociation – an extreme case of the kind of detachment that makes our perception of art a strictly marginal experience.

We may then find that what looks at first like the professional eccentricity of a specialized method is actually a refined, precise, and therefore valuable statement of a far profounder eccentricity in which many of us share. In other words, I make bold to suggest that in certain of our habitual ways of approaching art we are something like unconscious Morellians; or to put it more precisely, that the Morellian method has carried some of our artistic prejudices to their logical conclusion. If Hogarth thought of the connoisseur as a marginal figure in the artistic life of his day, and a sort of nuisance which might be eliminated with profit, I would

7. Portrait of Giovanni Morelli, by Lenbach. Accademia Carrara, Bergamo

venture to say that the connoisseur's way of looking at art has become for us ingrained because art itself has moved to the margin. Let us then examine three questions, to see if these reflections have any truth: first, what kind of a man was Morelli; secondly, exactly what is his method; and, thirdly, what bearing has it on our current ways of responding to art.

Morelli was a native of Verona, where he was born in 1816, and by choice a citizen of Bergamo, to which he left a small and exquisite collection of paintings.[62] Trained as a physician, and an expert in comparative anatomy, he held for a short time a post in the University of Munich, but he never practised medicine. His life became absorbed in two avocations, politics and art. As a young man he moved in the circle of Bettina von Arnim, became attached to the poet Rückert, and frequented the studio of the painter Genelli, for whom he even posed – a painful thought – as Prometheus; but from 1848 to 1871 his ruling passion was that of an Italian patriot, fighting for the liberation and unification of Italy. It was only late in life, when he had acquired the dignity of Senator of the Kingdom of Italy, that he found the leisure to publish his disturbing discoveries in the field of Italian art. Perhaps in order to secure for them an unprejudiced hearing, and to satisfy a certain Romantic taste for ironic make-believe, he published them under a bizarre pseudonym and in a foreign language.

He pretended that his books were written by a Russian, Ivan Lermolieff (a Russianized anagram of Morelli), and translated into German by a writer who called himself Johannes Schwarze (which again means Giovanni Morelli). In a lively and lucid German prose, with no trace of Teutonic obscurity but many touches of Slavic wit, his Russian double plays the part of a bewildered but determined young sightseer. On a visit to Florence he encounters an anti-clerical Italian patriot who introduces him to what Berenson was to call the 'rudiments' of connoisseurship. 'As I was leaving the Palazzo Pitti one afternoon,' our Russian writes, 'I found myself descending the stairs in the company of an elderly gentleman, apparently an Italian of the better class ...' In that casual tone the revolutionary chapter on 'Principles and Method' opens.

Morelli had tactical reasons, beyond the mere fun of it, for

placing his arguments in a fictitious setting. The use of dialogue made it possible for him to contrast his own plain Socratic statements with the inflated language of his opponents.[63] On an imaginary visit to the Dresden Gallery the presumed Lermolieff becomes involved in polite conversation with an opinionated German blue-stocking of noble birth, Elise von Blasewitz, in the presence of her father. The lady is frightfully lettered, quoting Vasari and Mengs as readily as the Schlegels, but when Lermolieff tries to explain to her why *The Magdalen reading* is not a painting by Correggio, her literary reminiscences interpose themselves between the picture and her gold-rimmed spectacles. In the end she dismisses his views as 'Russian nihilism'.

As late as 1919 – that is, twenty-eight years after Morelli's death – the well-known critic Max Friedländer could still refer to him as a sort of charlatan,[64] although he added a few significant reservations. In the first place he did not question Morelli's results; he questioned only the way in which Morelli claimed to have reached them. The disputed point thus appeared to be the Morellian method, but even that is saying too much, since Friedländer did not deny that the method was useful; he applied it himself. What he meant to deny was the possibility of obtaining by that method the spectacular results that Morelli had obtained. In Friedländer's opinion, Morelli's attributions were reached by intuition, while Morelli claimed that he had produced them by science – which apparently made him a charlatan.

Undoubtedly, the new attributions were spectacular. To give just one example, Giorgione's *Sleeping Venus* is today such a familiar picture that we might imagine it was always known as a great Giorgione; but until Morelli had taken a good look at this painting it was catalogued in the Dresden Gallery as the copy of a lost Titian by Sassoferrato – which sounded so learned that it satisfied everyone; and no doubt it would have pleased Hogarth. In the Dresden Gallery alone, forty-six paintings were renamed because of Morelli's discoveries, and in other museums the upheaval was on a comparable scale. His friend Sir Henry Layard did not exaggerate when he wrote that Morelli had caused a revolution.

And now a word about the Morellian method. Like other
revolutionary devices, it is both simple and disconcerting.
Morelli explained that to recognize the hand of a master in a
given painting it is necessary to arrest, even to reverse, the
normal aesthetic reaction. In looking at a picture our natural
impulse is first to surrender to a general impression, then to
concentrate on particular features which are artistically
important: composition, proportion, colour, expression, gesture.
None of these, Morelli says, will reveal with certainty the hand
of a particular painter, because they are studio devices which
painters learn from each other. It may be true, for example,
that Raphael grouped some of his figures in the shape of a
pyramid; but pyramidal composition became a commonplace
of the school of Raphael, so that its presence does not assure us
of the hand of the master. Raphael's figures often express
devotion by raising their eyes in a sentimental way, but
Raphael had learned that trick from Perugino, and so any
painter of his own school could have learned it from him.
When we see a painting of a youthful head ascribed to
Leonardo da Vinci, we inadvertently concentrate on the smile
that is regarded as characteristic of Leonardo's figures; but we
must not forget that innumerable imitators and copyists have
concentrated on that smile before, with the result that it is
rarely absent from their paintings. What is more, since
expression and composition are artistically significant features,
the restorer will try to preserve them. It is in them that the
hand of the master is first obliterated by being reinforced;
and, of course, they also attract the forger.

Morelli drew the only possible inference from these
observations. To identify the hand of the master, and
distinguish it from the hand of a copyist, we must rely on small
idiosyncrasies which seem inessential, subordinate features
which look so irrelevant that they would not engage the
attention of any imitator, restorer or forger: the shape of a
finger-nail or the lobe of an ear. As these are inexpressive parts
of a figure, the artist himself, no less than his imitator, is likely
to relax in their execution; they are the places where he lets
himself go, and for that reason they reveal him unmistakably.
This is the core of Morelli's argument: an artist's personal

Lorenzo Costa's
shape of ear

Cosimo Tura's
shape of ear

Lorenzo Costa's
shape of hand

Cosimo Tura's
shape of hand

Fra Filippo Filippino Signorelli Bramantino

Mantegna Giovanni Bellini Bonifazio Botticelli

8. Illustrations from *The Berlin Gallery* and *The Borghese Gallery*,
by Giovanni Morelli

instinct for form will appear at its purest in the least significant parts of his work, because they are the least laboured.

To some of Morelli's critics it has seemed odd 'that personality should be found where personal effort is weakest'.[65] But on this point modern psychology would certainly support Morelli: our inadvertent little gestures reveal our character far more authentically than any formal posture that we may carefully prepare. Morelli put his case plainly: 'As most men who speak or write have verbal habits and use their favourite words or phrases involuntarily and sometimes even most inappropriately, so almost every painter has his own peculiarities which escape from him without his being aware of them ... Anyone, therefore, who wants to study a painter closely must know how to discover these material trifles and attend to them with care: a student of calligraphy would call them flourishes.'[66]

Morelli's books look different from those of any other writer on art; they are sprinkled with illustrations of fingers and ears, careful records of the characteristic trifles by which an artist gives himself away, as a criminal might be spotted by a fingerprint. Since any art gallery studied by Morelli begins to resemble a rogues' gallery, we must not be too severe in our judgment of those who at first reacted to his tests with consternation: they do offend against the idealistic spirit in which we like to approach great works of art. Morelli invites us to identify a great artist, not by the power with which he moves us, nor by the importance of what he has to say, but by the nervous twitch and the slight stammer which are just a little different from the quirks of his imitators. But let us not lose sight of Morelli's purpose: it is the *hand* of the master that he wants us to discover, and as long as that remains our well-defined aim we must not recoil from the unflattering tests by which one hand is distinguished from another. Morelli himself put it more picturesquely: 'Whoever finds my method too materialistic and unworthy of a lofty mind, let him leave the heavy ballast of my work untouched, and soar to higher spheres in the balloon of fancy.'[67]

However, behind the Morellian method lies a strong aesthetic feeling of a very particular sort. It is not just the

assignment of a name that interests the connoisseur of painting; he seeks to feel the authentic *touch*, for which the name is merely an index. If the artist's perception is conveyed by his hand, and another hand is superimposed on his work, then his original perception has been obscured, and we must search out in the ruin the few fragments where it may have remained intact. On these true relics the eye must seize for its instruction. At first glance, Morelli's concentrated study of the lobe of an ear might seem like Wölfflin's curious concern for a nostril, but the resemblance is deceptive. Whereas Wölfflin uses the small detail as a module for building up the larger structure, Morelli cherishes the authentic fragment as the trace of a 'lost original'. Whether intentionally or not, his analyses leave the reader with the perplexing impression that a great work of art must be as tough as it is fragile. While the slightest fading or re-touching or over-cleaning of a detail seems to throw the whole picture out of balance, yet despite the distortions by coarse restorers and by clumsy copyists the aura of the 'lost original' remains so potent that concentration on a genuine fragment is sufficient to evoke it. We must remember here that Morelli was born in 1816, and that his cult of the fragment as the true signature of the artist is a well-known Romantic heresy.

In a series of aphorisms which he called *Fragments*, the most fearless of the Romantics, Friedrich Schlegel, had looked with disdain on the vulgar prejudice that a thought should lead to a logical conclusion: he preferred to collect fragmentary thoughts that kept the mind in a state of fermentation. Comparing 'rough drafts of philosophy' to the sketches 'valued by connoisseurs of painting', he proposed to 'sketch philosophical worlds with a piece of chalk, or characterize the physiognomy of a thought with a few strokes of the pen'.[68] He shared these ambitions with his young friend Novalis, who said that 'fragments of this sort are literary seeds'.[69] Novalis even toyed with the idea of 'restoring mutilated fragments' to their pristine roughness,[70] an enterprise not unlike the building of artificial ruins, which were enjoyed as 'agreeably broken'. Thus, in his famous *Essay on Picturesque Beauty*, the Reverend William Gilpin seemed to take pleasure in the fact

that works of art decomposed by Nature resemble those left unfinished by the hand of man: in both cases irregular and accidental shapes convey a sense of spontaneity. To enliven a piece of Palladian architecture, and raise it to a picturesque subject, he thought that 'we must use the mallet instead of the chisel: we must beat down one half of it, deface the other, and throw the mutilated members around in heaps. In short, from a *smooth* building we must turn it into a *rough* ruin.' With the same adventurous delight he noted that in a painting or drawing 'a free, bold touch is in itself pleasing', to which he added by way of commentary: 'A stroke may be called *free* when there is no appearance of constraint. It is *bold* when a part is given for the whole, which it cannot fail of suggesting. This is the laconism of genius.'[71]

Morelli had a strain of these Romantic proclivities in him. Quite apart from questions of attribution, which would make him search for the unspoiled fragment, he distrusted the finished work as such because he disliked artistic conventions. Whatever smacked of academic rule or aesthetic commonplace he dismissed as deceptive, hackneyed and unrewarding, and withdrew from it to those minute and intimate perceptions which he felt to be the only safeguard of pure sensibility. Clear-sighted about the logic of his method, he came to regard the study of drawings as more fundamental than that of paintings. The spontaneous sketch retained in its freshness what the labours of execution tended to stale.[72] To this day, much of our approach is art is under the spell of this particular Morellian preference. We do not feel that we have seized the spirit of a painting until we have traced it back to those bold notations in which the master's hand vibrates and flickers. Intently we listen for the inspired stammer which preceded the grammatical sentence. The finished masterpiece is dead, but the inchoate sketch helps us to revive it. As Focillon said in *Vie des formes*: 'L'esquisse fait bouger le chef-d'oeuvre.'[73]

It is here that the peculiar sensibility of the connoisseur, which guides him in making an attribution, merges with a far more universal foible of the imagination in which most of us share, connoisseurs or not. In looking at paintings, we are all caught up in the pursuit of freshness. We are under the spell of

spontaneous brushwork and cherish the instantaneous sensation with which it strikes the eye.[74] How often have we not heard admirers of Hogarth and Constable repeat the insufferable cliché that only their bold sketches reveal their force as artists, whereas the meticulous labour they bestowed on their finished paintings was a deplorable aberration for which they paid dearly by loss of spontaneity? The richness of texture in a finished Constable is, indeed, less spontaneous than the first excited draft, but it is a maturer and mellower image, which must be seen with a less nervous eye, and observed at a range sufficiently close to prevent the eye from skipping over the detailed nuances.[75] In Hogarth's paintings the neat and restless cunning of his brush was meant 'to lead the eye a wanton kind of chase',[76] but our visual imagination is much too stolid to pursue the calculated intricacies of his finished designs. Instead we dote on the superbly sketched *Shrimp Girl* or the unfinished *Country Dance*, and regret that not all his paintings were left as sketchy, and hence as fresh as these two.

The same relish for vivacious first drafts is evident in a recent report on the technique of rescuing old Florentine wall paintings from decomposition. 'During the process of detaching a fresco from the wall,' the writer explains, 'it is often possible to separate it also from the *sinopia* – that is, the preliminary rough sketch in underpainting. The *sinopie* are, of course, mere adumbrations and were never intended by the artist to be seen, but to the modern eye they often have a greater vitality than the completed works and are always of considerable interest. The temptation to restore frescoes merely, or largely, to obtain the *sinopie* must be great, and many fingers, one may imagine, are itching to detach the Masaccios from the walls of the Brancacci Chapel. Who knows what masterpieces of rapid draughtsmanship might not be revealed?'[77]

Because the instantaneous sensation means more to us than the sustained imaginative pursuit, we fall into that typically Romantic predicament which Wordsworth, in 1800, called a 'degrading thirst after outrageous stimulation'.[78] Hence we put a premium on the inchoate work of art arrested at its inception for the sake of spontaneity. For the artist this

prejudice creates a debilitating atmosphere: it encourages a striving for the immediate, a peculiar sophistry of production by which each work, no matter how laboured, hopes to give the impression of being freshly improvised. Never has the *capriccio* in art, the effective arrangement of striking irregularities, held quite the commanding position it holds today.[79]

The protest against these aggressive tendencies, being as old as fragmentation itself, has produced many pointed witticisms. Anatole France, for example, accused Rodin of 'collaborating too much with catastrophe':[80] he was repelled by a plastic oratory which relied for some of its loudest effects on mutilation. Vollard jestingly claimed he had seen Rodin smashing up statues to obtain fragments,[81] a scene that might have been invented by Beerbohm, but the story has an ingredient of truth since Rodin often reduced a complete figure to a more lively torso by 'violent cuts like amputations'.[82] The sensitive Rilke approved the method and even embellished his praise of it with an evocation of Duse acting without arms in D'Annunzio's *Gioconda*. He also wrote a poem, dedicated to Rodin, on a most un-archaic torso of Apollo, glitteringly alive but headless.[83]

It is one of the oddities of this art of progressive dismemberment that, impelled by a desire for condensed expression, it leads ineluctably to a devaluation of the human face as the apex of the body. If Rodin's statue of *John the Baptist*, a solid image of the itinerant preacher, looks insipid when compared with the headless vigour of *L'homme qui marche*, this is not because (as Rodin said jocosely) a head is superfluous for walking, but because headless action suits Rodin. Thus it is essential to the rhetorical effect of *The Thinker* that his feet look more intelligent than his face. As Rilke put it: 'Sein ganzer Leib ist Schädel geworden, und alles Blut in seinen Adern Gehirn.'[84] Acephalous art is the logical consequence of the mind's absorption in the sub-rational, and this particular bias is strongly active today in stylistically very meticulous artists who have otherwise little affinity with Rodin's unflinching realism. In some of the best figures by Braque and Henry Moore the heads are vestiges that look like

9. Rodin, *L'homme qui marche*. Musée Rodin, Paris

knobs, appendages of an expression whose centre is elsewhere. Perhaps it is not irrelevant to this subject that among the many compounds of man and animal in the repertory of Greek fable – centaur, faun, siren, harpy – modern painters have shown a marked preference for the Minotaur, the only Greek one whose face is not human.[85]

It is obvious that these anti-rational impulses lie far deeper than the Morellian method, which is nothing but a refined, well-circumscribed and remarkably clear symptom of them, indicating a shift in perception that extends far beyond the visual arts. Without knowing it, the abbé Bremond, for example, was a sort of Morellian in his famous lecture *La poésie pure* (1926) in which he quoted small shreds of verse, 'quelques lambeaux de vers' – *Heureux qui comme Ulysse – ibant obscuri* – to show how these tiny and almost meaningless fragments were the most perfect samples of pure poetry. No doubt Bremond remembered from Mallarmé and Valéry (both *virtuosi* of fragmentation) that an extreme purism proceeds by destruction and that words acquire a fresh aura of sense by being torn from their established contexts.[86] Mallarmé, in a mood which he described as 'perhaps ironic', compared his collection of *Divagations* to a cloister which, 'though in ruins, might exhale its doctrine to the loiterer'.[87] Verlaine spoke of 'légèreté d'esquisse' and '*tremblé* de facture' in praising the irregularity of Rimbaud's versification; and Gide described the literary hero in *Paludes* as 'tâchant de donner à ses phrases une apparence inachevée'. Valéry's titles very often suggest a fractured or unfinished masterpiece: *Fragments du Narcisse, Ébauche d'un serpent, Fragments de poésie brute, Histoires brisées, Fragments des mémoires d'un poème*, etc.[88]

Yet another kind of *cloître brisé* was produced by Mallarmé's German disciple, Stefan George, in his translation of the *Divine Comedy*. He was content to break up the long poem into an aggregate of short ones, explaining in the preface that in these fragmentary pieces, to each of which he gave a separate title, it was possible to grasp what he called 'the Poetical: tone, movement, shape', while leaving 'the immense world-, state- and church-edifice' respectfully behind. The same urge toward intense abbreviation, even at the price of discontinuity, seized

also the music of the twentieth century, as Schoenberg recognized clearly in his old age when he reflected on the first atonal compositions: 'The foremost characteristics of these pieces *in statu nascendi*', he wrote, 'were their extreme expressiveness and their extraordinary brevity. At that time, neither I nor my pupils were conscious of the reasons for these features. Later I discovered that our sense of form was right when it forced us to counterbalance extreme emotionality with extraordinary shortness.'[89] Exactly that argument, applied to literature, encouraged the astringent belief that a poem must be short to be poetic: 'for poetry is the language of a state of crisis, and a crisis is brief. The long poem is an offence to art.'[90]

It is a curious and memorable fact that the Romantic cult of the spasm, while driving the arts into a state of crisis, has yielded for the historical study of painting a valid method of analysis. The technique of whittling down a picture almost to its vanishing point for the purpose of obtaining a pure physiognomic cipher has given a firm basis to the connoisseurship of painting, and it would be foolish to think we could do without it. No laboratory test, however helpful, can entirely replace the morphological tests of Morelli: in the end the 'hand' must be recognized by its graphic character, in whatever stratum of pigment it may appear. Hence the opinion occasionally voiced by art historians that Morellian analysis may be going out of fashion is as chimerical a thought as to suppose that palaeography might become outmoded in the study of manuscripts.

We must, however, distinguish clearly between a valid art-historical technique and the general conception of the nature of art by which the first masters of that technique were inspired. The bias in the connoisseur's appreciation of painting, and more particularly of paintings of the past, lies in his disposition to sacrifice almost anything to freshness. His test is pure sensibility, a feeling for the authentic touch, and so he cultivates the genuine fragment, turning all art into intimate chamber art. While cherishing the condensed unadulterated sensation from which the force of the original vision sprang, he tends to be impatient of the external devices by which the

vision was expanded and developed. Connoisseurs, as a rule, are over-anxious not to let the artistic experience run its full course, but to arrest it at the highest point of spontaneity. It is true that in cultivating 'the aesthetic moment' Berenson was not satisfied with pure connoisseurship and played with the psychological aesthetics of the 1870s, from which he took his ideas of empathy and tactile values, but it is fortunate that his achievement does not rest on these shaky props. No one would seriously maintain that his view of art was formed on the optical theories of Robert Vischer.[91] It was shaped by Morelli.

It has repeatedly happened in the history of scholarship that a technique outlasted the philosophy that prompted it. The differential calculus is still in use, but mathematicians are not expected to accept the metaphysics of either Leibniz or Newton. In historical grammar the old phonetic laws have retained their value although few linguists, I am told, still believe in their automatic action. No doubt, in psycho-analysis likewise, certain techniques introduced by Freud will remain effective long after his conception of the *psyche* has acquired a quaint archaeological flavour. In the study of art the Morellian method pursues authenticity by seeking out freshness; yet to make freshness the sole or supreme criterion of art is a narrow view of aesthetics. Undoubtedly, 'all that a man does is physiognomical of him',[92] and a rapid sketch may reveal an artist's character more directly than the finished artefact; but if we allow a diagnostic preoccupation to tinge the whole of our artistic sensibility, we may end by deploring any patient skill in painting as an encroachment of craftsmanship upon expression – an absurd conclusion since it is of the very essence of art to transmute expression into skill.

4

The Fear of Knowledge

When I spoke about Plato's fear of art, and suggested that he had cause to fear it, it may have sounded as if I were trying to revive a ghost, for it is certain that the sacred fear of art has left us. We have, however, another fear, which I believe was unknown to Plato – the fear that knowledge might harm the imagination, that the exercise of artistic faculties, both in the artist and in the spectator, might be weakened by the use of reason. This is a modern fear and, if I am not mistaken, unfamiliar before the Romantic period; but for more than a century and a half it has dominated our view of art with such force that we have come to look upon it as a basic truth, supported by a strong philosophical and literary tradition.

In Keats's *Lamia*, for example, the exquisite phantom of the poet's imagination is killed by the cold analytical gaze of philosophy:

> and for the sage,
> Let spear-grass and the spiteful thistle wage
> War on his temples. Do not all charms fly
> At the mere touch of cold philosophy?

The poet's vision has no place 'in the dull catalogue of common things':

> Philosophy will clip an Angel's wings, ...
> Unweave a rainbow, as it erewhile made
> The tender-person'd Lamia melt into a shade.

47

In retrospect it has seemed to some classical scholars, still under the spell of the Romantic view, that Greek tragedy died of Greek philosophy, that the primitive inspiration which the tragic poets drew from myth and ritual could not survive the destructive talk of Socrates.[93] In the *Phaedo* Plato seems to suggest that Socrates felt a scruple on that account and sang a poetic swan-song before he died, as if to recant his inveterate addiction to reasonableness. He had been visited by certain dreams which intimated that he should 'cultivate and make music': so he composed a hymn to Apollo and turned Aesop's *Fables* into verse.[94] Whether this delightful story is true or not, Plato took the opportunity to define the kind of poetry that Socrates would write: it is didactic poetry, a class of literature which every respectable treatise on modern aesthetics has taught us to despise.

Didactic poetry, we are told, is a kind of monster, a hybrid of intellect and imagination in which art is sacrificed to the interests of reason and reason betrayed by the use of art. It may well be that didactic poetry is today condemned unread. Yet a glance at the botanical verse of Erasmus Darwin, or a poem on 'The Art of Preserving Health' by John Armstrong, readily shows that the poetic schoolmaster defeats his own purpose: for his verses do not fire the reader's imagination; they merely inspire him with a sound distrust of an argument that lends itself to rhyme. Nor is the prospect more encouraging in the other arts. Except for curiosity's sake, one would hardly wish to see a ballet composed by Descartes for Christina of Sweden, in which the intellectual and moral virtues are said to have danced before the queen.[95] I myself once saw a didactic ballet, an American piece composed by Martha Graham on the Declaration of Independence, in which the text, recited by a chorus, supplied the rhythmic foundation for the dance: 'We hold these truths to be self-evident', and so forth. It was a good ballet, and I must say in its defence that the huge leaps of the dancers, their heroic gestures and rhythmic contortions, dispelled any thought that all men are created equal. Imagination here triumphed over didacticism, but I am not at all certain that this would have been the case in the more sober composition of Descartes.

As for didactic painting, that again would seem to be a discouraging subject. We think of Ingres's picture *The Apotheosis of Homer*, in which his flair as a painter deserted him because he was seized by the misguided ambitions of a pedantic pedagogue. Or we think of Kaulbach, or the once-famous Chenavard, a painter from Lyons, of whom Baudelaire said that his brain resembled his native city: it was foggy with vapours and soot from furnaces, and bristling with bell-towers and chimney stacks. While great at inventing encyclopaedic programmes which covered the history of mankind, he was remarkably bad at painting them. The gross incongruity between thought and image amused Baudelaire to such an extent that he began a critical essay which he intended to call 'Philosophical Art',[96] but he left it unfinished for an excellent reason: he changed his mind in the middle of it. The plan was to show in didactic painting how crude images result from great ideas. 'Pure, disinterested beauty', he writes, can be reached only by 'an art removed from instruction', whereas a 'desire to be philosophically clear' necessarily degrades the artistic image. But this familiar thesis is cancelled by an additional note which reads: 'There is something good in Chenavard's assumption; it is the disdain of prattle and the conviction that great painting rests on great ideas.'[97]

If Baudelaire became doubtful about the foolishness of didactic art, we might be well advised to follow his example and retrace our own steps. Admittedly, it is a little perplexing to be told first that great ideas produce bad painting, and then to learn on the same authority that great painting rests on great ideas. But there is no need to choose between these two propositions, for we may find that both are true if they are carefully qualified. The pressure of thought upon art does not follow a simple and uniform law. Great ideas have a way of either quickening or clogging the spirit of a painter, with the result that the sort of intellectual excitement which proved the undoing of Chenavard or Kaulbach was the force that made Raphael rise to his greatest height in the painting of *The School of Athens*.

We all know that a painting and an argument are two different things, and that the best argument does not produce a

good painting. Hence, if a painter becomes so enamoured of his thoughts that he allows them to overpower his vision, his pictorial imagination will be enfeebled by ideas that distract him from the art of painting. It is right, therefore, to say that flight into knowledge is an artistic weakness, because it substitutes intellect for imagination. Flight from knowledge, however, is also a weakness: it assumes that the artist's imagination has not sufficient vigour to respond actively to the pressure of thought. The insecure painter should indeed beware of distraction: his limited pictorial power may go by the board if he thinks too much; and the weak spectator might also do well not to let his thoughts roam while he looks at a painting. To that extent our habitual distrust of the intellect in art is sound. Yet there is something wrong with an aesthetics which explains why Chenavard and Kaulbach failed, but not why Raphael succeeded; which can account for the poetic weakness of Erasmus Darwin, but not for the force of Lucretius or of Dante.[98]

Since we are in the process of retracing our steps, let us face the fact that, in antiquity alone, the number of great didactic poems is disconcertingly large, far larger than it ought to be according to an aesthetics which dismisses the entire species as a contradiction in terms. In writing *On the Nature of Things*, Lucretius borrowed 'the sweet voice of song' to explain the reasonable system of Epicurus.[99] The poem taxes our intelligence; it addresses itself firmly to the understanding, but in verses of such strong feeling and fierce beauty that our imagination is fully engaged. In the *Georgics*, Virgil teaches the cultivation of the land, with exact precepts addressed to the farmer concerning the best way of planting the vine or of tending crops or bees or cattle. In enjoying the rustic poetry of these instructions, even readers unfamiliar with agriculture and animal husbandry become seized with a passion for the land and willingly participate in the farmer's cares. As for Ovid, that most forbidding of subjects, the Roman calendar, becomes a festive procession in his verses; not to speak of his eminently professional instructions on how to be skilful in the art of love. And who can forget that Horace, in writing of the poet's wish to be useful as well as to delight, does so in a great

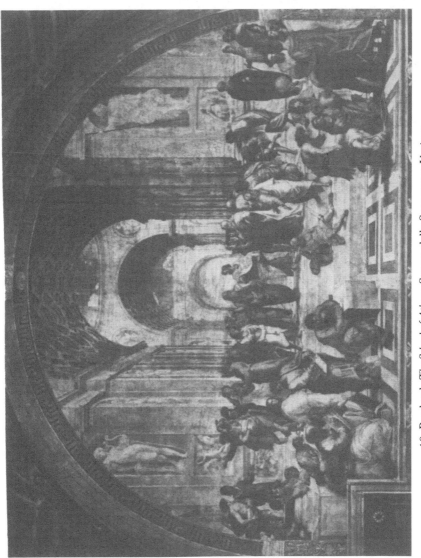

10. Raphael, *The School of Athens*. Stanze della Segnatura, Vatican

poem, and a didactic one at that? If, finally, we remember that
from the Renaissance down to the eighteenth century many
didactic poems are pleasing, even if few of them are great,[100]
we may well wonder whether the estimate is true that within
this genre the number of aesthetic failures is unusually large.
Is it really true that there are more bad didactic poems than,
say, bad poems on love, or bad patriotic or religious hymns?
Is it true that in the visual arts the aesthetic failures in
portraiture or in landscape painting are rarer than in didactic
compositions?

It is certainly *not* true before the nineteenth century. The
great religious cycles of the past were almost all didactic, the
sculptures and the coloured glass of the French cathedrals, for
example,[101] or the frescoes in the Sistine Chapel, or the
tapestries designed by Rubens of the Triumph of the
Sacrament.[102] Parts of these cycles are often enjoyed as
narratives, but they illustrate doctrine, and the doctrinal point
must be learned and understood if the visual phrase is to be
spelled out correctly, and the plastic articulation fully
mastered. An equal degree of intelligence was needed to
design the great humanist allegories.[103] If it is asked how so
much learning could be absorbed into art, the answer is far
from difficult: great artists have always been intellectually
quick. The popular belief that musicians cannot think, or that
painters have no verbal facility, is a picturesque superstition
completely disproved by the evidence of history, both past and
present. Anyone reading the letters of Titian, Michelangelo or
Rubens, or perusing the verbal jests which it pleased Leonardo
da Vinci or Mozart to invent, must be impressed not only by
their literary ease, but also by the mixture of learning, wit and
good sense which gives an individual style to their prose; and
that has remained true right down to the present day. Not only
were Cézanne and Manet well versed in literature but, if I
may speak from my own experience – which I am well aware
may be purely accidental – I have never met a significant
painter or sculptor who did not speak and think exceedingly
well. (This is not to deny that under unfavourable conditions
an artist might appear to be a fool talking professional
nonsense, but that happens to logicians as well.)[104]

Nevertheless, with the approach of the nineteenth century, didactic subjects began to repel the artistic imagination; and the causes of that aversion are clear enough. As art withdrew into itself and receded toward the margin of life where it could reign as its own master, it began to lose touch with learning, as it lost touch with other forces that shape our experience. Hence it was only the weaker painter, feeling uncertain in his seclusion, or the great painter in a moment of weakness, who accommodated himself to didactic needs. In other words, the Romantic revolt against reason was so effective in art that didactic art became a compromise. As a result it declined, and for all practical purposes it has vanished altogether – a clear sign that imagination and learning have been driven apart.

Not that artists are less knowledgeable than they used to be – quite the contrary. Their imagination is easily stirred by ideas but, compared to the artists of the past, they are at one great disadvantage. As artists they are obliged to think by themselves, their learning is essentially self-taught, they pick up new ideas wherever they can – witness the flimsy ghost of quantum mechanics in the talk of some 'action painters' and serial composers[105] – but even the most agile imagination is not at its best when it apes a science from which it is in fact cut off. The isolation, which we think of as essential to artistic creation, has been pushed to the point where artists cerebrate far too much, because they are in need of thoughts and those for whom thinking is the primary business do not supply them. Even in their intellectual lives, artists are treated as if they were untouchables: their genius must not be disturbed or distracted, and so they are forced to learn by themselves.[106]

It is evident from the writings of Paul Klee that he enjoyed looking at plant sections and all sorts of living or dead tissue through a microscope, and that he was a passionate collector of fossils. In a half-apologetic tone he asks whether these are proper occupations for an artist: microscopy and palaeontology.[107] He excuses himself by saying that they set the artist's imagination in motion. The traces of these forms are indeed unmistakable in some of Klee's fantastic designs. And yet how strange that none of the biologists who showed Klee their microscopic preparations thought of enlisting his sensitive

hand to record these structures in the interest of science, instead of letting him wander off to play with them only in fantasy. Klee's sly kind of humour is a precious bloom of Romantic irony: he made the most of being in a marginal position, and never pretended to be anywhere else, carefully avoiding the grand manner. Yet one cannot help observing that a great artistic curiosity for science was here left unused, when it could have both illustrated the precise data of science and drawn new strength from them for imaginative creation.

How odd too, but characteristic, that Picasso, who is a masterful draughtsman of animals, should have turned to Buffon – an eighteenth-century naturalist – for inspiration in an enchanting series of animal sketches.[108] Why to Buffon? Why not to a contemporary naturalist? I am not aware that George Stubbs looked for quaint graces in an outdated style of zoology before painting his splendid pictures of animals. He was passionately up-to-date, like Constable, who provided his sketches of clouds with meteorological annotations.[109] But Picasso had good reasons for reverting to Buffon, a text which is no longer science but 'literature': it gave full scope to artistic licence.

The sculptures and drawings of Henry Moore suggest that he is fascinated by geology. One would like to see him in close contact with those who professionally explore volcanic shapes and various types of stratification, but this would probably be thought sacrilege, because the artist is supposed to engage in research only for the sake of metaphor. It is known, moreover, that Moore has studied, quite on his own, in the celebrated jungle of the British Museum's ethnographic collection. No one could possibly have a better sense than he for displaying these objects to their best advantage. Would a museum ever persuade itself that a great sculptor was the right person to perform such a task? Obviously not, as long as the naïve prejudice prevails that imagination and precision do not go together. But, in fact, precision is one of the ingredients of genius. Most artists would say with Samuel Butler: 'I do not mind lying, but I hate inaccuracy.'[110]

From the past we know that if artistic imagination is harnessed to a precise and well-defined task of instruction it

11. Paul Klee, *Family Matters*. Drawing. Collection Mrs Jane Wade, New York

12. Picasso, *Ostrich*. Illustration from Buffon, *Histoire naturelle*.
Aquatint

13. Jan van Calcar, Anatomical illustration from Vesalius,
De humani corporis fabrica. Woodcut

14. Henry Moore, Two Piece Reclining Figure No. 2. Tate Gallery, London

can gain a sharp edge of refinement by responding to the pressure of thought. And what an advantage it would be to a modern naturalist if he could enlist the eye and hand of a great modern draughtsman! Some of the dreariness of scientific illustrations might vanish if they could be returned occasionally to the care of great artists, as in the Renaissance.[111] I think, in particular, of Calcar's fantastical illustrations to the *Anatomy* of Vesalius: woodcuts which combine the utmost scientific accuracy with a stylish macabre magnificence, so that the student receives his instruction in the vivid guise of pictorial figments which, no matter whether they amuse him or repel him, are bound to fascinate him at every step.[112]

We are fortunately beginning, in the study of art, to come alive again to the artistic strength revealed in such remarkable combinations of intellectual precision and pictorial fantasy. Raphael is surely the supreme master of that kind of art. In *The School of Athens* he succeeded in painting what a less intelligent and less sensitive artist might have found to be an utterly unpaintable subject: an abstract philosophical speculation of weird intricacy but rigorous logic. In the philosophical circle to which Raphael belonged, a doctrine was current that any proposition in Plato could be translated into a proposition in Aristotle, provided one took into account that Plato used the language of poetic enthusiasm, whereas Aristotle spoke in the cool tone of rational analysis. Raphael placed the two contending philosophers, who 'agree in substance while they disagree in words', in a hall dominated by the statues of Apollo and Minerva: the god of poetry and the goddess of reason preside over the amicable disputation which, concentrated in Plato and Aristotle, is enlarged and particularized in a succession of sciences; these answer each other in the same discords and concords in which Plato and Aristotle converse. The theory is abstruse, perhaps even absurd (and I may say, from personal acquaintance, that it is a rarefied form of mental torture to study it in Renaissance texts),[113] but in Raphael's figures it acquires a luminosity that overpowers the spectator – for at least three reasons.

First, as a painter Raphael makes us feel the spirit in which that curious doctrine was conceived: dialectic is reduced to

visual counterpoint; we suddenly take part in the drama of rethinking the propositions which those figures enact, with and against each other. Secondly, in guiding our eye, the artist focuses our mind. If any modern philosopher should be so perverse as to take an interest in the Renaissance concordance of Plato and Aristotle, he could learn from Raphael how to find his way through these forbidding and diffuse speculations. Raphael has produced a visual commentary on them of unmatched lucidity.

That, however, is of only historical interest. The third and artistically crucial point is that, by following the argument in Raphael's painting, we discover visual accents, modulations and correspondences which no one would notice who did not follow the thought. The visual articulation of the painting becomes transparent, and it reveals itself as infinitely richer than a 'pure' vision, moving along the figures without grasping their sense, could possibly perceive. The eye focuses differently when it is intellectually guided.

We arrive here at a theory of vision exactly the reverse of that which the young Clive Bell so confidently propounded in 1914. 'The representative element in a work of art', he wrote, 'may or may not be harmful; always it is irrelevant.'[114] As a matter of fact, it is so relevant that, whenever we ignore or misunderstand a subject, we are likely to misconstrue the image by putting the accents in the wrong places. Our eye sees as our mind reads. A large anthology could be compiled of visual errors committed by critics who thought that the right way to look at paintings is to disregard the representative element in them.[115] Misunderstanding of factual detail can cause the whole key of a painting to shift, as we know, for example, from Bellini's *Feast of the Gods*, which is not a solemn but a facetious painting, or from the famous Botticellesque painting mistakenly called *La Derelitta*, which does not represent a weeping woman shut out from a house, but the grave biblical figure of Mordecai (from the Book of Esther), dressed in sackcloth and mourning before the king's gate.[116]

It has been said that while such rediscoveries of the exact subject of a painting are historically interesting, they do not affect our aesthetic judgment. These pictures were always

regarded as great; our response was not diminished by our ignorance. That is not entirely the case. Great works of art, we must remember, are as tough as they are fragile. Though we may look rather loosely, or even complacently, at *The School of Athens*, the force of Raphael's diction somehow comes through, just as the force of Shakespeare is not completely obliterated in an eighteenth-century version which 'corrects' his style. Many of his most vivid lines are flattened, some of the images become dim and thin, horrifying scenes are timidly omitted, scenes that he never wrote are tactlessly introduced to calm the sensibilities of an eighteenth-century audience, and yet Shakespeare's greatness still makes itself felt; just as certain melodies by Mozart, vulgarized in folksongs or drinking songs, retain an echo of his spirit although all the subtle articulation has vanished. Inadvertently we trivialize the works of art of the past when we take them at their face value, and few would deny that a shallow familiarity distorts the style of great masters.

On the perpetual need to recover lost modes of perception, John Livingstone Lowes wrote with some melancholy:

> It is one of the inescapable ironies of time that creations of the imagination which are at once of no time and for all time, must nevertheless think and speak and act in terms and in ways which are as transient as they themselves are permanent. Their world – the stage on which they play their parts, and in terms of which they think – has become within a few lifetimes strange and obsolete, and must be deciphered before it can be read. For the immortal puts on mortality when great conceptions are clothed in the only garment ever possible – in terms whose import and associations are fixed by the form and pressure of an inexorably passing time. And that is the situation which we have to face.[117]

The method suggested by these remarks is burdensome. A great deal of contingent knowledge must be recaptured by the devious ways of historical learning if a work whose 'matter' has fallen into oblivion is to recover its aesthetic bloom.

Masterpieces are not so secure in their immortality as Croce imagined.[118] If a contingency can bring them to life, a contingency can also reduce them to shadows: for what must be learned can be forgotten.

It would thus be careless to underestimate the degree to which aesthetic perception is quickened by knowledge. But while pleading for a mode of vision which rests the sense of form on the sense of meaning, it is important not to forget that what quickens our vision can also clog it. The current fashion of so-called 'iconography' has produced many cumbersome interpretations, according to a pattern that C.S. Lewis has so well characterized in literary studies: 'It is impossible for the wit of man to devise a story which the wit of some other man cannot allegorize.' There is one – and only one – test for the artistic relevance of an interpretation: it must heighten our perception of the object and thereby increase our aesthetic delight. If the object looks just as it looked before, except that a burdensome superstructure has been added, the interpretation is aesthetically useless, whatever historical or other merits it may have. Nevertheless, distrust of misapplied erudition can easily slip into the error of Kant's dove: having found that the air impeded its flight, the bird decided that it would fly better without it.

Some years ago an editorial in *The Burlington Magazine* expressed impatience with learning in art. The writer suggested that 'so far as the plastic arts are concerned, a high degree of literacy would seem to be irrelevant', since 'some very fine works of art have been created by peoples who did not even possess an alphabet'. It is true that people without an alphabet have produced great art, although it would be wrong to assume that they were uninstructed: they learned orally from magicians, bards, or priests. It so happens, however, that our own art is for people who do have an alphabet; and it is known from historical evidence that great art has been produced for them by artists of the highest degree of literacy. Having eaten from the tree of knowledge, we cannot slip backwards into paradise: the gate is locked and the angel behind us, but the garden may be open at the opposite end.[119]

5

The Mechanization of Art

It might be thought that art and mechanization are mutually exclusive. An artistic performance is a creative act, unique and unrepeatable, whereas it is of the very essence of a mechanical event that it can be repeated, and often is. To say that a creative artist would not be inclined to repeat himself exactly is an understatement: he is incapable of it. If two paintings ascribed to a great master look identical, it is more than likely that at least one of them is a copy by another hand. The rule is the same as in the study of handwriting. A man's signature varies because he writes spontaneously. When two signatures are exactly the same, a suspicion of forgery arises.[120]

There are anecdotes about Mozart which illustrate the point in music, although they may well be legendary. It is said that, when asked to repeat an improvised piece, he would unfailingly improvise a variation of it. As a child of seven, while accompanying a singer extempore, he changed the accompaniment with every repetition. According to Grimm, who reported this incident in his *Correspondance littéraire* (1 December 1763), 'he would have done it twenty times over if he had not been stopped'.

It was in a similar spirit of creative exuberance that Renoir denied in a conversation with Vollard that the chemistry of pigments ever forced him to regularize and repeat his procedures: 'In painting, you know, there is not a single process that can be made into a formula. For instance, I once attempted to fix the quantity of oil that I add to the paint on my palette. I couldn't do it. Each time I have to add my oil at a

guess.'[121] The statement is the more remarkable as it comes from a meticulously trained technician who started as a painter of porcelain.

Even if we suppose that Renoir was exaggerating a little, or that Vollard embellished the statement while recording it, the bias of Renoir's remark is clear enough: he held fast to the old belief that art is degraded by mechanization. I call it an old belief because it antedates our age by at least 500 years. The invention of printing, for example, and the use of woodcuts for the illustration of books, filled the Duke of Urbino, the famous Federigo da Montefeltro, with such dismay that he would not allow a printed book to enter his library. For him the act of reading a classical text was desecrated by the contemplation of the printed page. Words that were beautifully written by a scribe seemed to address his eye and mind in a personal way which was obliterated by mechanical type; and a manuscript illuminated by hand-painted miniatures gave him a pleasure that no woodcut could equal.[122]

It would be easy to dismiss this attitude as sheer snobbery, the kind of preciousness that is sometimes found among modern collectors who have turned Veblen's principle of conspicuous waste into a policy of sound investment. That an ingredient of vanity and calculation may have entered into the Duke of Urbino's disdain of printing I would not deny:[123] but there is more to it than that. The first printed books were made to look like manuscripts, some were even doctored with hand-painted initials, or coloured washes imposed on the woodcuts, or by being printed specially on vellum, to satisfy the kind of fastidious taste which the Duke of Urbino had cultivated. Thus he cannot be entirely blamed for having regarded this new manufacture as an impertinent and vulgar cheat.

At its first appearance a newly mechanized art always looks like a fake, because it models itself on an unmechanized or less mechanized kind of art. Before the film had found its own powerful idiom, it looked like degraded theatre, just as television now often looks like degraded film. Thus, when Ruskin spoke of what he called 'vile manufacture', he did not mean to distinguish between vile and honourable manufacture. All manufacture seemed to him vile, because it was the opposite of

honourable craftsmanship in which the artisan controlled his work by his own hand; in manufacture the process of production was surrendered to a machine, an automaton that mimicked and falsified living craftsmanship and was thus nothing but its cheap, deceptive double.

Although it is obvious that Ruskin overstated his case, there is no denying that there are aspects of mechanization which justify some of his apprehensions. In the creation of monumental sculpture, for example, it is economical for the artist to confine his work to a small model and delegate the enlargement of it to a mechanical instrument which, point by point, transposes the small shapes to a huge scale. The machine treats forms as if they were indifferent to size, although every perceptive sculptor knows that they are not. The same problem in reverse arises with medals or coins, where it is expedient to make the model on a larger scale, which is then brought down to the right size by the reducing machine. As a result, the ordinary coin or medal looks as vacant as the ordinary public monument.[124] On the progressive mechanization of carving – duly upbraided by Ruskin in *Aratra Pentelici* for weakening and effacing 'the touch of the chisel as expressive of personal feeling or power' – it is worth consulting the *Encylopaedia Britannica*. Fifty years ago (1911), the article on Sculpture noted that 'in the opinion of many artists the use of the mechanical pointing-machine is responsible in a great measure for the loss of life and fire in much of modern sculpture'. In the most recent edition (1960), we read instead that 'with the help of a pointing-machine the present mechanical system of carving is easy to learn and free of responsibility because it is mathematically exact'.

If Ruskin said that 'a great sculptor uses his tool exactly as a painter his pencil, and you may recognize the decision of his thought, and glow of his temper, no less in the workmanship than the design', the same thought applies with little variation to architectural workmanship as well: its quality declines if a machine is allowed to superimpose its own habits on the artist's style. Prefabricated window-frames, for example, when inserted into otherwise conventional buildings, produce a jarring monotony of fenestration in which architecture is

victimized by mechanics. I hasten to add that these dreary cases speak not against mechanization as such, but only against bad and inflexible mechanization, an unimaginative use of machinery which the creative modern architects have triumphantly overcome. Entering as they do into the spirit of a mechanized process, feeling as intimate with it as the manual craftsman felt with the tool in his hand, they project their imagination into every part of the mechanism, and thus render mechanization itself expressive. In such cases we do not have a 'mechanization of art', but on the contrary an artistic use of machinery; and if this ideal relationship of mechanical instrument to art were universal, there would be no argument.

But even these modern achievements, as is well known, are travestied by 'vile manufacture'. The streamlined constructions required for aeroplanes and racing cars are transferred to cars not designed for such speeds but intent on suggesting them by borrowed rhetoric. Thus the stream-lined taxicab is built so low that we must double ourselves up in order to get in or out of it. The beautiful and comfortable chairs invented by Mies van der Rohe are parodied in the mass-produced, stream-lined chair constructed according to a technological idea of being seated and hence allowing no one to sit as he pleases.[125] The stream-lined knife, fork, and spoon are likely to interfere with the act of eating by making us needlessly conscious of it. The false rhetoric of mechanization persistently obliges us be wary, thus reversing the effect of those antimacassars which obliged even Ruskin to look comfortable.

It would be tempting to dismiss all this as a passing fashion that need not be taken too seriously, were it not that many cities are already disfigured by fake-modern buildings that will stand for a long time. Equipped with the newest facilities of engineering, architectural design requires of its craftsmen exceptional powers of resistance to prevent any part of the machinery usurping a function that belongs to the architect himself. The temptation to let the machine have its way increases with the perfection of machinery, every new instrument producing new routines which only a master can rescue from automatic proliferation. Perhaps this explains why modern buildings are either superb or miserable. The tension

is too great to allow for decent mediocrity. In that respect the architecture of our age is indeed like an aeroplane or a racing car. The only alternative to perfection is disaster.

A particularly destructive use of mechanization is its illicit extension to the past – as, for example, in the refacing of ancient buildings. Since no modern machinery can produce the exact double of an old façade, every stage of major repair would seem to call for fresh architectural invention. Replacements cannot be made by rote. Where complete repetitions have been attempted with machine-cut stones and the old ornaments re-carved, they look like replicas or fascimiles of the building that has vanished. Thus the refacing of Wren's Sheldonian Theatre in Oxford may be studied one day as a monumental example of the naïve obstinacy and self-delusion that bedevil a mechanical age. In the nineteenth century Viollet-le-Duc thought, because he was a skilful and vigorous engineer and had the support of an inspector of monuments as energetic as Prosper Mérimée, that he could restore French cathedrals to their original splendour. Today his name has become a byword for nineteenth-century Gothic; yet few of those who smile at Viollet-le-Duc seem to recognize his fallacy in their own confident pursuit of exact restoration. 'The Church of Vézelay', wrote Mérimée, 'is now restored in the most complete manner, and if one of its abbots of the thirteenth century were to return from the dead, no doubt he would find it just as he had left it.'[126] It is worth recalling here a remark made by Auguste Prost in 1885: 'To remake (*refaire à neuf*) an ancient monument ... is to place oneself before this dilemma: either to falsify it by failing, or to produce a pastiche by succeeding.' Prost admitted the necessity of restoring corroded parts: 'but to set oneself the task of replacing a decayed work in its entirety is ... to cause the certain loss of the object that one is dismantling.' In describing what had happened before his own eyes to the cathedral of Metz, he recorded a typical sequence of events: 'On voulait réparer d'abord; on a été conduit ensuite à vouloir restaurer, et aujourd'hui on démolit ce qui restait du vieil édifice, pour le reconstruire entièrement.'[127]

The same problems and delusions occur in the so-called 'scientific' cleaning of pictures. Conscientious restorers are

always guided by an awareness that they cannot touch a painting without interpreting it. The danger arises when the attempt is made to reduce the burden of exegesis by delegating a major part of it to a chemical solvent which, it is hoped, will safely remove superimposed layers of paint or varnish, and so lay bare the artist's original work without having altered it by the contact.[128] The belief that a painting of, say, the fifteenth century can be returned with scientific certainty to its pristine state, as if five hundred years of existence had left no trace on it, is of course a chemical as well as a historical absurdity. Even if the natural history of such an object were reversible, which it is not, the restorer's own vision cannot be wound back to a fifteenth-century optic except by an effort of historical imagination that is subject to all the hazards of learned inference. 'Does not the eye altering alter all?'[129] In an age of art-historical inquiry, which increasingly converges with studies in the history of science, it is surprising that some museum curators still fail to realize that, after a short passage of time, the 'scientific' treatment of a picture will be datable to the year. Style will be recognised in cleaning as easily as it used to be in overpainting: for no one can jump over his own historical shadow.

That these adventures of restoration are often pursued today in a reckless spirit, and on a much larger scale than should be necessary, is due to a scientific as well as an aesthetic fashion. The notion that every old picture must be cleaned is like certain outdated medical fashions that made it obligatory for every respectable person of advanced age to 'take the waters'. In the preservation of pictures these restorative ablutions are encouraged by a desire for freshness at any cost, even if it entails fragmentation. After a picture has been decomposed, the painting is 'honestly' left in a half-raw state – an artificial ruin or, to put it more charitably, a carefully prepared scientific specimen which, like any other product of technical skill, registers some of the peculiarities of the technician. Since the mechanics of stripping down a painting reverses the sequence in which it was built up, it is almost inevitable that processed pictures acquire a surface that looks machine-made, resembling the hard luminous gloss of mechanical reproductions, with brute colours in

glaring juxtaposition. The satisfaction aroused by paintings reduced to that state may probably be ascribed to the fact that vision has increasingly been trained on derivative prints, which tend to over-define an image in one direction by fixing it to a mechanical scale.

That our vision of art has been transformed by reproductions is obvious. Our eyes have been sharpened to those aspects of painting and sculpture that are brought out effectively by a camera. What is more decisive, in the artist's own vision we can observe the growth of a pictorial and sculptural imagination that is positively attuned to photography, producing works photogenic to such a degree that they seem to find a vicarious fulfilment in mechanized after-images – as if the ultimate hope of a painter or sculptor today, apart from having his works placed in a museum, would be to see them diffused in comprehensive picture-books, preferably in an illustrated *catalogue raisonné*.[130] What has optimistically been called the 'museum without walls' is, in fact, a museum on paper – a paper-world of art in which the epic oratory of Malraux proclaims, with the voice of a crier in the market-place, that all art is composed in a single key, that huge monuments and small coins have the same plastic eloquence if transferred to the scale of the printed page, that a *gouache* can equal a fresco.[131]

On these assumptions it is only logical that the colour print threatens to become the medium on which a painting must rely if it is to be remembered. That Picasso has consciously adjusted his palette to the crude requirements of the colour process I would not say, but his paintings suffer remarkably little in this singularly coarse form of reproduction. They suit it almost as well as Van Gogh. With a growing adjustment to the colour print, it is natural that the objects best suited to that medium should be preferred to works that are too intricate for it, machinery thus dictating a selection that sponsors a stylistically regressive taste. The art of the *douanier* Rousseau has thus an advantage over that of Titian, because his colour effects, being schematic and plain, can be simulated more easily by the printing press.[132]

The same forces are also active in music. Originally the gramophone record produced an echo of the live performance,

with all the peculiarities of the performer's attack. It served as a substitute for a concert, removed by one degree from the real event. For that reason musicians and amateurs of music inclined at first to despise the substitute, with much the same vigour as the Duke of Urbino displayed in his resentment of printing. However, recording – like printing – developed its own style: it became an idiom with a particular aesthetics. Marked idiosyncrasies of phrasing, for example, which may be startling and impressive in the concert hall, can grate when they are heard too often. Recording therefore tended to file them off, aiming instead at a technical finish which would allow for constantly repeated hearing. It is a well-known fact that gramophone records are now often put together piece by piece, each piece a polished unit in a musical *collage* which no living performer has played as a whole. The ear thus gets adjusted to dehumanized sounds, and there can be no doubt that the style and quality of performances have changed toward a more even mechanical proficiency, not only for the purposes of recording but retroactively in live concerts as well. In some instances, composition itself has begun to aim at the recorded tone, prescribing a style of musical performance that lends itself to *montage* and stereophonic projection,[133] just as the mechanized idiom of the film has decisively shaped certain styles of dramatic writing and acting that subordinate the range of human expression to the capabilities of the screen.[134]

The situation reminds me of a historic occasion in Washington when the National Gallery of Art was formally opened by President Roosevelt in 1941. He was expected to address the guests, and many who had often heard him speak so effectively over the wireless were curious to see in what manner he would address an audience face to face. They found that he did not address them at all. The speech was broadcast, and from the first the President's mind was concentrated on the microphone before him. It was a graceful speech addressed to the world outside, while those in his immediate presence were like eavesdroppers, listening in on a performance not intended for them. No doubt those listening to the broadcast assumed that they were getting only a reflex of his speech, a sort of echo, but they were mistaken: what

seemed like an echo was the substance.

In the enjoyment of art this curious reversal seems to me one of the fundamental dangers of mechanization. The medium of diffusion tends to take precedence over the direct experience of the object, and more often than not the object itself is conceived with this purpose in view. We are given the shadow for the thing, and in the end we live among shadows, and not only believe that things are made for the sake of their shadows, but find that this is actually the case. Not that this condition is without promise. Many a brave new world of things was made out of shadows firmly shaped by an artist, but the boldness required for that task has increased with the ease of evading it: for it is both the strength and the weakness of a mechanized medium that it can replace personal choice by automatons which, however economical in other walks of life, are artistically blank and wasteful. No mannerism is more stultifying than one caused by a machine.

An easy pride in the advances of mechanization is therefore just as unfounded as that proverbial phobia of it which was justly ridiculed by J.B.S. Haldane: 'There is no great invention, from fire to flying, which has not been hailed as an insult to some god.'[135] To assume, as Ruskin did in his weaker moments, that an art must lose its authenticity whenever it delegates part of its function to an ancillary craft is an aesthetic superstition. Ideally, on that theory, the composer should be a performer, the poet a bard, the architect a builder, mason, and bricklayer. It is true that some of the arts still survive in that uncorrupted state. The painter has not yet delegated his brush, nor the draughtsman his pencil, and there are even sculptors who have not delegated their chisels. And yet, some of the creative expansions of art – in architecture, music, and drama – could never have taken place at all if the artist had always remained his own instrument, or the only authentic instrument of his art. A prudent scepticism about mechanization, particularly when it overreaches itself, should not deny the positive part that machinery and substitution have played in artistic growth.

To my mind one of the most enlightening of anti-mechanical protests lies buried in that quizzical American book, *The*

Education of Henry Adams. Always scrupulously attentive to historical ceremony, particularly when he foresaw that it might be fatuous, Adams took a few steps of his own, in the year 1900, to inaugurate the twentieth century. He went to Paris and visited the World Exhibition, where he stood, bemused and bewildered, before the forty-foot dynamos in the Great Hall. He understood little about engineering and, perhaps for that reason, viewed its progress with misgiving. He reflected that, since 1893, 'the automobile had become a nightmare ... almost as destructive as the electric tram which was only ten years older, and threatening to become as terrible as the locomotive steam-engine itself'. To regain his balance, Adams withdrew to the cathedrals of Chartres and Amiens. Here, worshipping at the shrine of the Virgin, he meditated on the fate of those who were worshipping at the shrine of the dynamo. Adams was the kind of man who feels that on a memorable occasion it is important to make a memorable statement. Although he did not agree with Gibbon's evaluation of the Gothic style, he envied Gibbon for having dismissed all Gothic cathedrals in one single sentence by saying: 'I darted a contemptuous look on the stately monuments of superstition.'[136] Adams longed to dart just such a look on the stately monuments of engineering, but for that he was too shrewd; he knew that these forces had to be reckoned with and, although he distrusted them intensely, he prided himself on being a good judge of forces. He therefore composed for his autobiography, under the year 1900, the chapter on 'The Dynamo and the Virgin'. In it he contrasted the modern powers of steam and electricity with the force exerted by medieval faith. 'All the steam in the world', he writes, 'could not, like the Virgin, build Chartres.'

This memorable remark is worth analysing. According to it, the Virgin built Chartres – which is clearly a metaphor, and presumably means that faith in the Virgin inspired the building of the cathedral. But Chartres was not built by faith alone. Like other French Gothic cathedrals, it was built by carefully calculated engineering. The master-builders who constructed ribbed vaults and flying buttresses would have been much displeased with an admirer of their work who

discounted their mathematical and mechanical ingenuity. The antithesis between modern engineering and medieval spirituality is one of those facile and fallacious disjunctions by which we get trapped when we regard art as naturally opposed to mechanization. On the side of art Adams disregarded the mechanical energies that had been harnessed to produce an admirable building; on the side of mechanics he considered those energies in the raw, unrelated to any purposes they might subserve. Thus we get a fine antithesis between mechanization and spirit, produced by mental omissions on both sides.

A philosophical inquiry into artistic utensils would probably show that the problems we associate with mechanization lie dormant in the use of the simplest instrument. A mere pencil or piece of chalk in the hand of an artist extends his range beyond his natural self. Is not all art a form of self-extension, as in Carlyle's definition of man as 'a Tool-using Animal'?[137] Any instrument, it is true, brings with it the danger that it might enslave the man it is meant to serve. Thus the pencil dominated Meissonier, Menzel, and Muirhead Bone, and their perception became as mechanical as their skill. Yet a vision without instrument is an equivocal ghost: there is no 'Raphael without hands'.[138] As for Mozart, he may have disliked the mechanics of copying, but once he had put pen to paper, the notes could be read, recopied, distributed and played, and with the help of modern mechanization the performances in their turn can be recorded and the records replayed *ad libitum*. Repetition, however unattractive to Mozart, seems as essential to the continued existence of his music as spontaneity was to its creation. What is more, certain chances offered by mechanical repetition were explored with great spirit by Mozart himself. He composed rondos, fugues and *ritornelli* for little clockwork organs and magical music-boxes in the collection of Count Joseph Deym, whom he jestingly called 'the watchmaker'.[139] How spontaneously he enlivened automatic toys is best known from Papageno's 'Glockenspiel' in *The Magic Flute*. Mozart could thus adapt his genius to mechanization, but only as a marginal exercise. Imagine all of Mozart's music readjusted to suit the needs of 'the watchmaker'! Yet it might well be argued that, in the last

analysis, listening to a gramophone or a tape-recorder, or to any of the more advanced machines of electro-acoustical engineering, is like listening to a superior sort of musical clock.

No matter how perfect these robots may become, music would shrink if it were composed primarily for them; just as painting would shrink if it were conceived as a perfected form of print-making.[140] It remains one of the memorable facts in the history of engraving, a craft comparable with the production of musical disks, that some of the most notable contributions to that medium came from artists who were primarily painters and turned to engraving only intermittently. Strongly mechanized crafts, to remain responsive to art, will always require the kind of irregular refreshment which engraving received from the *peintre-graveur*. Otherwise a composer's skill might eventually be learned by a computer, and in that case, as has been well said, both will have wasted their time.[141]

6

Art and the Will

In reflecting on the will it is important to admit that the range of its influence is limited. Belief in the truth of a proposition, for example, cannot be changed by an act of the will. I might wish, under certain circumstances, that two and two made five, or that all men were good, or that the climate of England was dry and sunny, or that I might meet David Hume in the street, but it is beyond my power to believe any such thing; and no effort of the will can change the fact that my belief on these points is settled. I might find it prudent at certain times to disguise a belief, or to refrain from expressing it in public, and such decisions are certainly subject to my will. Even in my own private thoughts, I may occasionally refuse to face an uncomfortable fact, and prefer to think of something else. Into all of these matters the will does enter, and hence it is reasonable to appeal to the will in order to change them. A friend may say: 'Be a man and face the facts', but he could not possibly say: 'Be a man and, recognizing these facts for what they are, use your will and believe them to be different.'

Over such trivial beliefs as I have mentioned – that two and two make four, or that the climate of England is damp – no one would deny that the will is powerless. But when it comes to more vital beliefs, which are passionately held by some and incomprehensible to others – religious beliefs in the fifteenth or sixteenth century, or economic beliefs today – the charge is often made that dissent is wilful. Heretics have been persecuted not only for holding views which were not approved, but also for their pertinacity in refusing to change them, as if

their beliefs could be formed by their will. The absurdity of these proceedings was exposed in the fifteenth century with masterly skill by Pico della Mirandola, who spoke from experience: for he held some beliefs that were judged heretical for a while, and he was asked by a papal commission to change them. He explained that the intrusion of the will into matters of belief – even the highest forms of belief – is an elementary confusion, and he gave to that confusion a good Latin name: he called it *actus tyrannicus voluntatis*, a tyrannical act of the will.[142] The will assumed powers which did not belong to it, and to usurp such powers is a tyrannical act.

As is well known, tyrannical acts of the will are not confined to external pressures. Internally, too, our will intrudes into regions where it does not belong. A scientist or historian is sometimes unwilling to give up a theory to which he has become attached, even though he comes across facts that do not quite fit it. Rather than relinquish the theory, he tries to explain the facts away, ascribing them to secondary causes which might account for the facts without disturbing the theory. The will can thus obstruct a necessary revision of belief. Thinking becomes warped because it is wilful.

Nevertheless in his famous essay *The Will to Believe*,[143] William James pointed to one important province of thought where the will must remain an active force: in the approach to new and uncharted regions of experience for which rational guides are not yet available. In considering this particular problem, James cast some doubt on the common rule of scientific prudence by which we are taught to suspend our judgment until we have the evidence before us, and not to commit ourselves mentally in one way or the other for fear of being duped. According to James, this is an act of the will rather than an act of reason, and if applied to important and vital issues, an unproductive act at that: for by it we refuse to take the kind of risk that generally attends the discovery of new truths. James was surely right in suggesting that this risk has almost always been taken by productive thinkers. As Gauss remarked about mathematical exploration, his results never caused him any trouble because he knew them in advance; the real bother was how to reach them. Without this

peculiar inversion between end and means,[144] many important scientific discoveries might not have been made. The scientist acts on a hunch, for which the scientific evidence is incomplete; and his decision to act on that hunch, at the risk of being disappointed, is as certainly an act of the will as is the contrary and more common decision, namely, not to risk that disappointment, and hence to forego the chance of making a discovery.

In turning to the experience of art, we may find that here the role of the will is exactly the same as in the pursuit of knowledge. Whether we go to the theatre or not depends on our will; and whether on leaving the theatre we declare our feelings about the play, or keep them to ourselves, or decide to see the play again rather than trust our first impression, are all matters in which our will is involved. However, in the presence of the play itself, our response would not be genuine and right unless our will were temporarily suspended. Persons who can never forget what they want, and exert their own will in the presence of a work of art, are debarred from authentic artistic experience. The work of art, no less than a truth, demands a genuine and complete oblivion of the self: an attitude repugnant to many people, while others perform it with natural ease.[145]

And what is true of the spectator applies equally to the artist himself. In the moment of creation his personal will must be suspended; otherwise his work will be contrived and forced – what the French very fittingly call *voulu*, which means 'strained' or 'laboured' and is a term of aesthetic censure.[146] A tyrannical act of the will falsifies art as it falsifies belief. Only a misguided artist 'wills' his art. Hence Keats associated poetic power with what he called 'negative capability';[147] and Byron wrote of the divine raptures of the soul that

> ... 'tis in vain
> We would against them make the flesh obey –
> The spirit in the end will have its way.[148]

But this does not mean that the artist's will is not engaged when he prepares himself for these moments of rapture by

regular exercise and drill. Imagination needs a great deal of prodding and restraining to issue at the right moment in full bloom. It is also by an act of the will that the artist releases the unfinished work to the world, or withholds it, or neglects it, or whatever he may do – or refuse to do – with it. The creative act, although quite beyond the will, is thus surrounded by acts that are willed by the artist: they include questions that concern his points of departure, his choice of scale, for example, or of medium or any parts of the general framework of ideas within which he sets his imagination to work. These are questions which are raised in the forecourt of art, although it is only in the temple itself that they find their ultimate resolution.

It follows that the subject of this lecture – 'Art and the Will' – refers to the forecourt of art in relation to the temple. When we treat art as sacrosanct we clearly refer to the temple and to nothing else: there the artist is necessarily alone with his genius. But in the forecourt he should not be left alone. And yet we leave him alone there as well, because we mistakenly extend to the porch the same veneration as belongs to the sanctuary. Even in the exercise of the artist's will, we think that no pressure should be brought to bear on him, for fear that it might disturb his inspiration, and so all his preliminary decisions must be made by him *in vacuo*. For whom he will plan a new work, for what purpose or place, or from what sources he should draw his themes – these are matters rarely suggested to him by an external assignment; as a rule they are left for him to imagine, to invent. We thus place an excessive burden on the artist's personal choice because, in contrast to artistically more gifted and lively ages, no points of reference are given. For all practical purposes the forecourt is empty. The only persons to be met there are a small circle of friends and the artist's dealer, who is there on business. The patron remains modestly outside and waits.[149]

It is very unlikely that a person wishing to acquire a painting today would tell the artist what he wants him to paint; he would think it disrespectful to do so. Instead he visits an exhibition in which works of art can be purchased ready-made; and in acquiring one of them, he cherishes it as a

'find', a sort of *objet trouvé*. The heroic battles between artist
and patron that fill the annals of the Renaissance would seem
improper and wasteful to the modern amateur. He prefers not
to enter the fray. Communication with the artist is left to the
dealer, who often shoulders the kind of responsibility that the
patron and the public no longer discharge. It would be most
unfortunate if one day the dealer in his turn were to be
displaced by the auctioneer, who would neither prod the artist,
nor plan for him, nor take any risks, but merely sell him.

In the eighteenth century a lively exchange between the
artist and his public was still taken for granted. Hogarth
laughed at poets who lived in garrets and pursued their fancies;
he ridiculed musicians enraged by the popular music of the
streets. The true artist was in contact with his public.[150] The
Romantics, however, introduced the fable that the poet
dreaming in his garret, who writes only as the spirit moves
him, is an image of the true poet; and although we know that
the image is largely false, it still lingers in our imagination. We
are well aware that most poets do not live in garrets, and that
artists not only work regularly, but work harder and longer
than business men; and yet we hold fast to the belief that they
should work only as the spirit moves them, undisturbed by our
requests and unemboldened by our indifference.

On this assumption the relation of the artist to his public
resembles the ancient legend of Narcissus and Echo. The
nymph Echo loved Narcissus, but he was enamoured of his
mirror-image and would look at nothing but his own face. The
nymph might have broken the spell if her conversation had not
been quite so limited; but all that the nymph Echo could ever
do was to repeat the last words she had been hearing. To
converse with an echo is unrewarding, and we should not put
the whole blame on Narcissus. We expect the artist to mould
our imagination, but we forget that no artist can work on
materials which do not offer him a plastic resistance.

The great patrons of the Renaissance were active patrons,
and as such they had an unpleasant trait in common. Each
was to the artist what Lord Bridges – in an interesting lecture
on 'The State and the Arts' – thinks a good patron should not
be, 'an awkward and uncomfortable partner'.[151] They had

definite ideas about their patronage and did not hesitate to assert them. It is difficult to imagine, without reading the documents, what amount of bickering went into the planning and re-planning of the Medici Chapel. Michelangelo's designs for the Tombs were corrected by Cardinal Giulio de' Medici, who had commissioned them, and whenever Michelangelo submitted new designs, the Cardinal was ready with counter-suggestions. Finally, after agreement had been reached and Michelangelo was in the process of cutting the stone, the Cardinal became Pope Clement VII, whereupon he appears to have changed the project all over again, proposing a new plan, from which emerged the sublime figures that we know today.[152]

Since Michelangelo was not easily pleased with anyone, one might think that he would have felt bitter about such a disruptive patron, but quite the contrary: he explained to his pupil Condivi, apparently with considerable warmth, that Clement VII had an exceptional understanding of the artistic process.[153] It is evident that Michelangelo felt the pressure of his patron's will as beneficial, but it requires the resilience of a forceful artist to transform such an impact into art; weaker spirits might well be crushed by it.

In the large but imperfectly preserved correspondence in which Isabella d'Este pursued artists and art, there are fifty-four letters referring to a single painting by Perugino.[154] The patron who cared for art was fussy in those days; and as a rule artists prefer patrons who fuss to patrons who do not care. Perugino, it is true, was not a strong master, nor did the excessive attention of Isabella d'Este improve him, but it is characteristic of Mantegna that his art prospered under her trying commands. As for Isabella's brother, Alfonso d'Este, the courtesies he extended to Titian were equalled only by the angry threats with which he followed them up; but by this strategy of well-calculated attacks alternating with flattery he manoeuvred Titian into the inspired mood that produced the famous Bacchanals in Madrid and London.[155]

Among recent patrons, perhaps the only comparable case is that of Ambroise Vollard, the French picture dealer and publisher. This brilliant speculator in fashions of taste had a

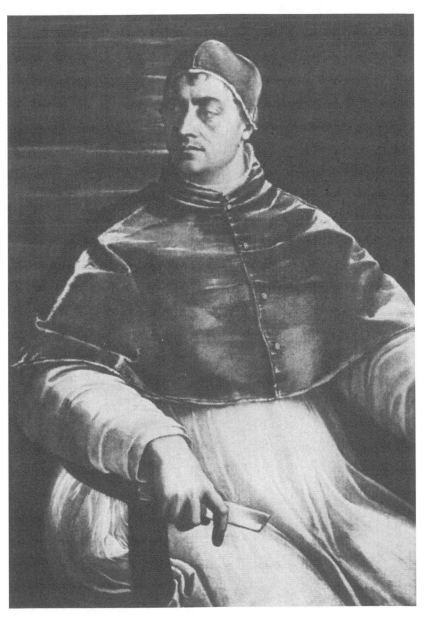

15. Portrait of Clement VII, by Sebastiano del Piombo.
Museo Nazionale, Naples

16. Renoir, Self-portrait, inscribed to Vollard. Drawing.
Formerly Collection Ambroise Vollard, Paris

singular gift for annoying, bullying, teasing, and flattering an artist until he produced the kind of work that Vollard wanted of him. How a victim responded to such treatment is shown in a rapidly sketched self-portrait by Renoir, which bears a charming dedication to his torturer. The inscription reads: *à Vollard, mon raseur sympathique.*[156] This does not refer to Renoir's shaggy beard: the word *raseur* is a colloquialism for an 'insufferable bore', and *il me rase* means 'he grinds me down'. The affectionate tone of the dedication shows the artist's gratitude to his gadfly.

That such treatment of artists has gone more or less out of fashion might be ascribed to a variety of reasons. In the first place, amateurs of art live under the impression that they do not have the time to exchange fifty-four letters about one picture; but that is an illusion. A casual glance at the lives of Renaissance patrons would reveal that they had far less time to spare than a fully occupied man of affairs today. They were haunted by daily business of an urgency and personal danger that it is difficult for us to imagine. If in the midst of these frightful troubles they found the time to battle with artists and bend them to their will, it was because art was as indispensable to them as their daily food: they could not live without it. And that, I think, is the root of the matter. If art were as indispensable to us as it was to them, we would not leave the forecourt of art so empty.

Moreover, the Renaissance patrons took far greater risks than the average modern collector would care to take. They asserted their 'will to believe' at the crucial moment, when the outcome of an artistic enterprise was still in the balance, whereas we prefer to wait until the artist has finished his work, so that we may decide whether we care for the outcome or not. Participation is thus postponed to a less critical moment: our artistic life is more sedate. No doubt William James was right in saying that the person who will not risk disappointment is in the end no safer than the one who does. The pressure of our artistic climate is lowered by the absence of an active patronage, with the result that the prudent collector, who thinks he has diminished his risks, has actually diminished his chances of getting as many significant works as he might.

Even the State has become a timid patron and holds no one responsible, least of all itself, for the bad design of bank notes and coinage.[157] Architecture, the last of the arts in which the client still continues occasionally to assert his will, has found its own no man's land in the evasive diplomacy of committee rooms, if not in the vast offices of contractors who supply architecture ready-made, conceived and designed *in vacuo*.

When he began his sculptures for the Unesco building in Paris, Jean Arp was astonished and disappointed that not even the architects could spare the time – he uses the expression 'spare the time' – 'to discuss in earnest with the painters and sculptors' how their work was to be conceived as part of the general plan.[158] Although the patron was a corporate body, and had commissioned a group of artists including Miró, Moore, Picasso and Tamayo to decorate a building with a well-defined purpose, the usual method was adopted of leaving the artist to himself, so that each might follow his individual will. Their wills were not made to clash and then to work out their harmonization. The result of this loose notion of *laissez-faire* was a visual and intellectual paradox: in this building devoted to the cultural work of the United Nations the arts loiter about the place without function, distracted and disunited.

The effect of leaving the artist far too much to himself is clearly shown in paintings by the Abstract Expressionists. These artists have carried introspection to an extreme, and nevertheless try to break out from the seclusion it imposes on them. Theirs is an art searching desperately for substance, and seeking it in two directions: by reverting to the artist's instinctive impulses and by projecting them outward on a scale that is larger than life. We generally doodle on small bits of paper, and our psycho-analytical friends tell us that this untidy habit integrates our personality. To doodle monumentally brings forces of integration into play which raise the artist above his private self. I believe, therefore, that the huge size of these paintings is not at all accidental; it is, on the contrary, their *raison d'être*. Today many artists who search for substance in their art try to find it by an increase of scale. The size is a kind of test of whether the imagination will hold its own in

such enlargements. To speak of abstractions as 'larger than life' is not as odd as it may sound: for the artist's idiom is related to the scale of man, but seems raised to a higher pitch by a *tour de force* in projection. This is splendidly shown in some of the 'action paintings' by Soulages, flawless exercises in massive calligraphy, which derive a superior authority from the fact that they are so huge. It is as if the artist himself had to invent the obstacles that are no longer supplied from without.

In twelve-tone music, to give another kind of example, the obstacle is set up as a pre-compositional tone-row (symmetrically expanded by its inversion, retrograde form and retrograde inversion)[159] which strictly limits the composer's choice of melodic variation: he thus constructs his own bed of Procrustes, like a poet committed to preconceived anagrams and acrostics. In recent years, serialization has been extended to cover musical dynamics and timbre as well, so that sequences of colour, intensity and duration are regulated as closely as sequences of pitch. Such a relentless pursuit of set patterns and their permutations has not been an uncommon occurrence in art. It is familiar in literature from the *précieuses ridicules*, and in medicine from the preciosities of the insane; but regardless of the mental level on which the mechanism plays, and whether it answers a deep or a superficial urge, it seems to be characteristic of an art insufficiently nourished from without.

Although it would be fantastic to make the artist responsible for the seclusion in which he is compelled to work, his own attitude to that condition has helped to shape it and tends to encourage its continuance. What is more, an uncanny affinity has become apparent between 'pure art' and the demands of mechanization – because pure patterns are the easiest to mechanize. No art lends itself to reproduction quite so glibly as a painting by, say, Manessier. In music, serial compositions offer the best chances to the computer. If a novelist withdraws to an inner realm of experience where all events appear as purely subjective sequences, his technique comes close to that of the film. The 'interior monologue' is a case in point. Invented as a literary device to suggest immediacy, it serves as a prop (a sort of *basso continuo*) in the comprehensive style of

film-capriccio, which – in the words of Robbe-Grillet – 'admits simultaneously, alternately and on an equal level instantaneous fragments of reality accessible to eye and ear, and fragments that are past or distant or future or altogether phantasmagoric'.[160] It is a common error in such discussions to mistake *immediacy* for *concreteness*, thus forgetting the philosophical truism that the most immediate sensations are the most abstract. Since immediacy always requires a large apparatus of exclusions, it is a construct that can be fed to a machine, and this is the ultimate irony of dissociation: while cutting the artist off from the external world, it finds outward support in mechanization because both are dehumanized procedures.

It ought therefore to cause no surprise that machine art and the sort of introspection that is encouraged by depth psychology are likely to reinforce each other. As has been shown by recent films, and also by a variety of plastic arts that rely for their effect on *bricolage*,[161] mechanical devices can release those highly irrational 'invasive experiences' which James described in his Gifford Lectures as 'uprushes into the ordinary consciousness of energies originating in the subliminal parts of the mind'.[162] What struck him as a radical innovation of psychological science and a triumph in technique – the disclosure of 'whole systems of underground life ... buried outside the primary fields of consciousness and making irruptions thereinto' – has since been accepted as a commonplace; and as such it has helped to remove some of the volitional restraints that would otherwise block the flow of the imagination. The suspension of the will is no longer reserved for the exceptional moments of artistic intuition: it has become an occurence in daily therapy, which certain artists attempt to rival in their efforts to equate the creative act with an automatic catharsis. Once art thus aspires to what Janet called *l'abaissement du niveau mental*, which is a state of mental decomposition or dissociation particularly conducive to incursions from the unconscious,[163] creative friction between artist and patron must seem superfluous and out of date. In the new forecourt of art the only challenge to the artist is supplied by managerial questions: 'Will it record well?', 'Will it

reproduce well?', 'Will it distribute well?' For wherever a vacuum is left by the will today, it is bound to be filled by mechanical forces.[164]

Although by temperament a sanguine philosopher, James wrote *The Will to Believe* in a vituperative style directed against what seemed to him a niggardly trust in salvation by machinery. In the supposedly prudent idolaters of science he detected 'a passion for conceiving the universe in the most labour-saving way'; and he accused the logicians of having spread that confusion by a misuse of what they call 'the law of parsimony'. Invented by Occam and hence called 'Occam's razor', the law of parsimony prescribes that in forming a theory we should not introduce any more hypotheses than are indispensable for its construction. Those extending this rule from a useful assumption of logic to a technique in life James called 'the knights of the razor'. And he added, not too confidently: 'The knights of the razor will never form among us more than a sect.'

This was written in 1881.[165] Today the knights of the razor are not a sect, they are the majority; and they are not – in any sense of the word – *raseurs sympathiques*. They prefer not to wrestle with the angel: it takes too long; it is uneconomical; and one is likely to get one's thigh out of joint. The avoidance of risk has become a ruling passion, and many of the forces that have been discussed in these lectures can be related to this overriding impulse: a desire to spread all manner of art so widely that its effects cancel each other out. Nietzsche saw modern man in his aesthetic Eden 'surrounded with the styles and arts of all times so that, like Adam with the beasts, he might give them a name'.[166] Classification has indeed proved a comfortable way of neutralizing the disturbing effects of art: it spares one the trouble of participation; and above all, it eliminates the will. 'These most conscientious gentlemen', as James put it, 'think they have jumped off their own feet, ... but they are deluded. They have simply chosen from among the entire set of propensities at their command those that were certain to construct, out of the materials given, the leanest result ...'[167]

In defence of diffusion it has sometimes been said that in order to give a fair account of the matter the increased number of offerings should be divided by the increased number of

recipients: we may then find that the loss of density is deceptive. I am afraid that this argument will not hold. In music, for example, diffusion affects each single listener; he hears more music than he used to hear and, thanks to mechanical means of reproduction, he often hears it in a form prepared for diffusion. To say that, if divided by the number of persons who share it, a diffused experience becomes more dense is like claiming that, if more people drink diluted milk, there is less dilution.

It would be well to keep this discussion clear of any biased views on popular education. The complaint against mass distribution of art is not that it serves too many people, but that it serves them badly. Personally, I have little patience with the supercilious belief that art for the many is a waste: self-flattery of the few is far more wasteful. If we judge the situation fairly, it is not the number of persons who look at art that is alarming, it is the number of works of art they look at, and the reduction of art to a passing show. Benevolent societies seem persistently engaged in bringing things together that are apart, and taking things apart that are together, thus fostering the perpetual mobility of art, which is destructive of genuine concentration.

To check this course will not be easy, because the forces behind it are very strong. Yet the recognition of a force for what it is itself produces a measure of resistance. The impact is broken by reflection; and if the reflection continues long enough, even the strongest impact may lose its power. Nevertheless, it would be imprudent to feel very certain that 'the spirit in the end will have its way'. The knights of the razor are astute: they do not expel the artist from the city, they receive him there on their own terms. Benevolent neutrality eliminates friction and keeps the forecourt of art safely closed to disturbance. When an experience is exceptional, it must be multiplied; and soon it will cease to be exceptional. Baudelaire foresaw that this destructive tolerance would one day be hailed as a form of 'progress': in this complacent receptacle, a friendly abyss, the anarchic energies of creation would be soaked up into nothing. 'Man's chief difference from the brutes', James said, 'lies in the exuberant excess of his subjective propensities'; and 'had his whole life not been a

quest for the superfluous, he would never have established himself as inexpugnably as he has done in the necessary ... Prune down his extravagance, sober him, and you undo him.'

Notes and References

NOTES AND REFERENCES

1. In a critical essay *L'école païenne* (1852), ostensibly directed against Théodore de Banville, Baudelaire attacked some of his own idiosyncrasies: 'Le goût immodéré de la forme pousse à des désordres monstrueux et inconnus. Absorbées par la passion féroce du beau, du drôle, du joli, du pittoresque, car il y a des degrés, les notions du juste et du vrai disparaissent. La passion frénétique de l'art est un chancre qui dévore le reste; et, comme l'absence nette du juste et du vrai dans l'art équivaut à l'absence d'art, l'homme entier s'évanouit; la spécialisation excessive d'une faculté aboutit au néant.' The essay ends with a carefully worded death sentence: '... toute littérature qui se refuse à marcher fraternellement entre la science et la philosophie est une littérature homicide et suicide.'
 A few years later (1861) Baudelaire's eulogy of Banville (*Réflexions sur quelques-uns de mes contemporains* vii) still suggests that pure art is a form of Satanism: 'Je veux dire que l'art moderne a une tendance essentiellement démoniaque.' Also: 'Aucuns y pourraient voir peut-être des symptômes de dépravation. Mais c'est là une question que je ne veux pas élucider en ce lieu' (cf. J. Pommier, 'Banville et Baudelaire', *Revue d'histoire littéraire* XXXVII, 1930, pp. 514-41). For a satirical portrait of Banville drawn by Baudelaire and inscribed by Nadar, see frontispiece to Banville's *Stalactites*, ed. E.-M.Souffrin (1942).

2. *Mon coeur mis à nu* xci: 'trouver la frénésie journalière'. Baudelaire had already touched on that theme in *Conseils aux jeunes littérateurs* vi ('Du travail journalier et de l'inspiration'). See also *Journal des Goncourt*, 17 mai 1857. The same concern in Yeats's *Autobiographies* (1956), p. 318: 'Violent energy ... is useless in the arts. Our fire must burn slowly, and we must ... be content ... to show, ... as little as the watch-mender shows, his magnifying-glass caught in his screwed-up eye.' Baudelaire did not expect his advice to be beneficial: 'Quant à moi, qui sens quelquefois en moi le ridicule d'un prophète, je sais que je n'y trouverai jamais la charité d'un médecin' (*Fusées* xxii).

3. Goethe, *Annalen oder Tag- und Jahreshefte*, for the year 1805, penultimate paragraph: 'Was hilft es, die Sinnlichkeit zu zähmen, den Verstand zu bilden, der Vernunft ihre Herrschaft zu sichern? Die Einbildungskraft

93

lauert als der mächtigste Feind, sie hat von Natur einen unwider-
stehlichen Trieb zum Absurden, der ... gegen alle Kultur die
angestammte Roheit fratzenliebender Wilden mitten in der
anständigsten Welt wieder zum Vorschein bringt.'

4. *Laws* 671D. For a more detailed account of Plato's 'sacred fear', with
some ancient and modern illustrations, see E. Wind in *Zeitschrift für
Ästhetik und allgemeine Kunstwissenschaft* XXVI (1932), pp. 349-73; and
now the English translation in *The Eloquence of Symbols*, ed. J. Anderson
(1983), pp. 1-20; also Wind in *Music and Criticism*, ed. R.F. French
(1948), pp. 53-72.

 The bust of Plato (page 5 above), although late in date (second or
third century A.D.), is the only known example that is attested by an
ancient inscription. All the others, fifteen so far, have been identified by
their resemblance to it; cf. R. Boehringer, *Platon: Bildnisse und Nachweise*
(1935), plate 3.

5. *Republic* 392D-396E. Plato's aim, to teach men how to 'rage correctly'
(*orthôs mainesthai*, cf. *Phaedrus* 244E), is likely to escape those of his
critics who judge his attitude towards *mimesis* by the tenth book of the
Republic alone, when his profoundest fear was expressed in the fourth
book, 424C: 'When modes of music change, the fundamental laws of
the State always change with them.' To say against Plato that artistic
exercise transfigures and thus renders harmless whatever it touches is
to miss the point of his argument: art has the power to intensify (not
just to purge) emotions. Some recent evidence in psychotherapy seems
to support that view. In cases of schizophrenia it is no longer regarded
as advisable to induce or allow a patient to draw, paint or model freely,
because the imaginative activity is likely to reinforce rather than
relieve the abnormal condition. See W. Mayer-Gross, E. Slater and M.
Roth, *Clinical Psychiatry* (1954), pp. 282 f.: 'While the neurotic may
relieve himself of emotional pressure and of the effects bound up with
past experiences by artistic creation, the schizophrenic tends to slip
further into his morbid fantasies ... "Art Therapy" of this kind is
contra-indicated in schizophrenics.'

 The same kind of reservation applies to music. While knowledge of
its curative effects is as old as the story of Saul and David, cases of
'musicogenic epilepsy' have been established beyond doubt (*The Times*,
30 June 1962, p. 12). For historical instances, both ancient and
modern, of mass-frenzy induced by music, see E.R. Dodds, *The Greeks
and the Irrational* (1951), pp. 270-82. Flutes and drums, 'the orgiastic
instruments *par excellence*', could cure madness, but also cause it:
Dionysus was *Bakchos* as well as *Lusios* (p. 273).

6. James Harris, *Philological Inquiries* II, xii (1781), reprinted in *Works*
(1841), p. 453; quoted by Sir Joshua Reynolds, *Discourses* XV (ed. R.R.
Wark, 1959), p. 277. See also Montesquieu, *Lettres persanes* viii: 'Je

feignis un grand attachement pour les sciences; et, à force de le feindre, il me vint réellement.' Schiller hoped, for the same reason, that in a state of moral decay the beautiful fiction of Virtue might re-awaken the moral sense: 'Truth survives in make-believe, and the original will be restored from the copy' (*Briefe über die ästhetische Erziehung des Menschen* ix). Hume was much more pessimistic. The histrionic success of some puritan fanatics, 'equally full of fraud and ardour', convinced him that religious enthusiasm may be engendered by hypocrisy: 'it is impossible to counterfeit long these holy fervours without feeling some share of the assumed warmth' (*History of England* lv). Lessing was also acquainted with this phenomenon, which is the basis of his theory of acting; see next note. [1968]

7. Edmund Burke, *A Philosophical Enquiry into the Origin of our Ideas of the Sublime and Beautiful* IV, iv. Against Remond de Sainte-Albine, who (in *Le comédien*, 1747) had naïvely assumed that in a skilled actor 'the external modifications of the body are naturally produced by the inner conditions of the soul', Lessing argued with some vehemence (*Theatralische Bibliothek*, 1754, I, iv): 'the only and true way of mastering the art of acting' is the reverse, 'to learn how to ape the outward signs of the passions and reproduce them so perfectly that the soul of its own falls into a state that corresponds to the movements, postures and sounds.' He had once thought of writing a treatise *Über die körperliche Beredsamkeit*. See also Hogarth, *Analysis of Beauty* xvii: 'Action is a sort of language which perhaps, one time or other, may come to be taught by a kind of grammar-rules.' He thus hoped to 'make acquired grace seem easy and natural'. Likewise acquired 'grandeur', as taught by Sir Joshua Reynolds, was 'to have recourse to a sort of Grammar and Dictionary, as the only means of recovering a dead language' (*Discourses* XV). It was in this context that Reynolds quoted James Harris. [1968]

8. *Republic* 398A.

9. *Republic* 491E. Whether aesthetic power mitigates or aggravates evil was brilliantly discussed by three eminent American judges (Augustus N. Hand, Clark, Frank) in the case of *Roth v. Goldman* [*Postmaster*], C.C.A.2, no. 152, 8 February 1949: '... we may suggest the curious dilemma involved in a view that the duller a book, the more its lewdness is to be excused or at least accepted' (p. 717). '... Nor will it do to say that [the book] possesses unusual artistry ... For this argument cuts just the other way: If a book is dominantly obscene, the greater the art, the greater the harmful impact ...' (p. 732). Lord Radcliffe, *Censors* (1961), p. 19, weakens this argument, it seems to me, by qualifying the 'most dangerous enemy' as 'the writer of great literary skill who is impelled by profound sincerity of purpose'. In

Goethe's *Werther*, which produced a wave of suicide, the great literary skill was an essential part of the trouble, but it would be meaningless to claim for that book a profound sincerity of purpose. If it is true that in the moment of creation the great artist is 'beyond himself', like a man possessed, it would seem to follow that 'sincerity of purpose' can be ascribed only to a minor artist, or to a great artist in one of his weaker, and hence less dangerous, moments.

10. *Weltgeschichtliche Betrachtungen*, chapter iv: 'Auf Erden ist das Unsterbliche die Gemeinheit', and many comparable passages; cf. *Reflections on History*, tr. M.D.H. (1943), pp. 153, 159: 'Mere ranters are ... powerless in times of terror. Unfortunately fools are not.'

11. In his *Ästhetische Briefe* (1795) Schiller produced a wealth of illustrations from Greek, Roman, Arab, Lombard and Florentine history to show 'that beauty establishes her rule solely upon the collapse of heroic virtues' (Letter x). The thesis derives from Rousseau, *Discours sur les arts et les sciences*: 'les vices conduits par les beaux-arts s'introduisaient ensemble dans Athènes'; also *Lettre sur les spectacles*: 'les chefs d'un peuple libre seront les créatures d'une bande d'histrions'. In Kant's *Critique of Judgment* § 42, the absence of any affinity between artistic taste and 'moral feelings' is illustrated by the empirical fact that 'vanity, capriciousness, and injurious passions' are prevalent among '*virtuosi* of taste'. Hegel's account of the collapse of the Greek city-state, from which the passage quoted above (page 6) is taken, bears traces of Schiller, if not Rousseau: see *Lectures on the Philosophy of History* II, ii, 3 (fifth section: 'Das Prinzip des Verderbens ...'). Related thoughts in *Outlines of the Philosophy of Law* § 258: 'the State is no work of art'; also §§ 279 and 356, again on the Greek state. W. Kaegi, *Jacob Burckhardt* III (1956), pp. 709 ff., associates the title 'The State as a Work of Art' with Burckhardt's notion of Renaissance despotism as a form of 'conscious artistry'. The Hegelian echo supports that view, while adding a touch of malice to the title. On Burckhardt's irritated reaction to Hegel, see Kaegi, *op. cit.* I (1947), pp. 466 ff., 484 ff.; II (1950), p. 27; also Burckhardt's later remarks in *Reflections on History*, Introduction: 'All the same, we are deeply indebted to the centaur, and it is a pleasure to come across him now and then on the fringe of the forest of historical study.' About 7 November 1870 (Letter to Carl von Gersdorff) Nietzsche heard Burckhardt lecture on Hegel's philosophy of history, 'in einer des Jubiläums durchaus würdigen Weise'. It was the centenary of Hegel's birth.

Nietzsche's very first contacts with Burckhardt in Basle revealed to him 'eine wunderbare Congruenz unsrer aesthetischen Paradoxien' (Letter to Rohde, 29 May 1869; cf. E. Salin, *Jacob Burckhardt und Nietzsche*, 1937, pp. 51, 237). In his essay *Der griechische Staat* (1871) he adopted Burckhardt's opinion that in ancient Greece and in Renaissance Italy the 'dreadful unleashing of political instincts'

confirms the 'connection between state and art'. Nietzsche's praise of violence as a necessary agent of beauty ('denn die Natur ist auch, wo sie das Schönste zu erschaffen angestrengt ist, etwas Entsetzliches') was of course unacceptable to Burckhardt. After reading *Die fröhliche Wissenschaft* (1882) he wrote to Nietzsche with his usual reserve: 'Eine Anlage zu eventueller Tyrannei, welche Sie S. 234 § 325 verraten, soll mich nicht irre machen' (Salin, *op. cit.*, p.214).

Hegel's brusque remark 'The State is no work of art' was almost certainly directed against the political aestheticism of Schelling, who had asserted, in his *Vorlesungen über die Methode des akademischen Studiums*, that the State should be treated as a work of art: 'dass der Staat ein Kunstwerk sein soll' (lecture x), a claim resumed in the concluding sentence of these lectures (no. xvi) with the reminder that in antiquity 'all actions of public life were only different branches of one universal, objective and living work of art' ('Zweige eines allgemeinen, objektiven und lebendigen Kunstwerks'). Since Burckhardt had listened to Schelling in Berlin, and distrusted his speculations as deeply as he did Hegel's (see Kaegi, *op. cit.* I, pp. 466 ff., etc.), he must have adopted the disputed term – *Der Staat als Kunstwerk* – with some malice, particularly as this helped him to define Renaissance despotism (like Renaissance warfare) as 'elegant and magnificent in its perfection', although in fact 'a bottomless pit' (*Die Kultur der Renaissance* I, viii). [1968]

12. On atrophy caused by excessive appetite in Romantic appreciations of art, see R. Payne Knight, *An Analytical Enquiry into the Principles of Taste* III, iii (1805), § 21: 'By the vicious indulgence of a prurient appetite the mind, like the body, may be reduced to a state of atrophy; in which knowledge, like food, may pass through it without adding either to its strength, its bulk, or its beauty.'

13. *L'acte gratuit*, as defined by Gide in *Le Prométhée mal enchaîné*, 1899 (*Oeuvres complètes*, ed. L. Martin-Chauffier, III, 1933, pp. 105 f.), is still the central theme of *Les faux-monnayeurs*, 1926, where it becomes *un acte monstrueux* (III, xvii: 'La confrérie des Hommes Forts'); see also *Journal des faux-monnayeurs*, in *Oeuvres complètes* XIII (1937), p. 13; also p. 52: 'What is lacking in each one of my heroes, whom I have made of my own flesh, is that small amount of common sense which keeps me from carrying their follies as far as they do.'

The most consistent and reckless exponent of gratuitous action, Alfred Jarry, said in his essay *Les monstres* (1895): 'It is common usage to call "monster" an unfamiliar concord of dissonant elements: the centaur, the chimera are thus defined for those without understanding. I call "monster" all original inexhaustible beauty' (*Oeuvres complètes*, ed. R. Massat, VIII, 1948, p. 28). Among his 'monstrous' illustrations is a fifteenth-century mnemonic woodcut (p. 52) representing the Gospel of St. Luke, but inscribed by Jarry with the gratuitous title *Figure de l'Antéchrist*. Gide's preoccupation with Jarry, both as a poet and

as a preposterous clown, dates back to *Lettres à Angèle* (*c.* 1898). In *Les faux-monnayeurs* III, viii, Jarry appears in person.

Picasso, who had known Jarry well, drew his portrait (illustrated in C. Giedion-Welcker and H. Bolliger, *Alfred Jarry*, 1960, p. 121; bibliography p. 151, nos. 52, 56) and produced from it a cover design for Jarry's manuscript of *Gestes et opinions du Docteur Faustroll* (A. Horodisch, *Picasso as a Book Artist*, 1962, fig. 65). In his painting *Peace* (1952) an *acte gratuit* is triumphantly performed by an infant juggler balancing between a bird-cage filled with swimming fish and a fishbowl in which birds are flying. As a credo this drollery is not without point: Picasso pictures the pleasures of peace as the freedom to play with absurdities.

On the whole, the history of gratuitous action, carried to extremes in the Dada movement, has confirmed a remark made by Louis Reybaud in his *Études sur les réformateurs* II (1864), p. 101: 'Le champ de l'absurde est borné et s'épuise plus promptement qu'on ne croit.' René Clair made the same observation in a commentary on his film *Les belles-de-nuit*: 'Rien de plus limité que le fantastique, alors que les thèmes les plus simples du réel se prêtent à des variations infinies' (*Comédies et commentaires*, 1959, p. 175).

14. Brecht, 'Kurze Beschreibung einer neuen Technik der Schauspielkunst, die einen Verfremdungseffekt hervorbringt', *Versuche* XI (1960), pp. 89-105. See also *Schriften zum Theater: Über eine nicht-aristotelische Dramatik* (1960), particularly pp. 74-89: 'Verfremdungseffekte in der chinesischen Schauspielkunst', which explains how the Chinese actor makes familiar behaviour look unfamiliar. Brecht qualified the doctrine, originally conceived as the opposite of empathy, in *Gespräch über die Nötigung zur Einfühling* (1953), reprinted in *Schriften zum Theater*, pp. 210 ff.

15. The word *Fauves* ('wild beasts'), as applied in the *Salon des Indépendants* of 1906 to a group of painters using shrill colours, is considerably less original than has been supposed. See A. Darmesteter, *La vie des mots* (1886), § 64: 'Voyez ce que Victor Hugo a tiré du mot *fauve*', with remarkable illustrations; see also Théophile Gautier's self-portrait in *Le château du souvenir*:

> Terreur du bourgeois glabre et chauve,
> Une chevelure à tous crins
> De roi franc ou de lion fauve
> Roule en torrent jusqu'à ses reins.

In a poem of 1862, *Contre un poète parisien*, Mallarmé pictured the true poetic spirit as an *ange à cuirasse fauve*; and in Huysmans's *À rebours*

(1884) the hero's penchant for Gustave Moreau, Odilon Redon and the late style of El Greco (chapter v) finds literary satisfaction in certain Latin barbarisms of the third century A.D.: 'ces vers tendus, sombres, *sentant le fauve*' (chapter iii, italics mine). Since the most notable painters among the so-called *Fauves*, above all Matisse and Rouault, had been pupils of Moreau, whose febrile reveries are placed in the very centre of *À rebours*, there can be little doubt that the poetic history of the word *fauve*, from Hugo to Huysmans, has some bearing on the nickname coined in 1906. On the latter see Louis Vauxcelles, *Le Fauvisme* (1958), p. 7; G. Duthuit, *Les Fauves* (1949), p. 95; A.H. Barr, Jr., *Matisse: his Art and his Public* (1951), p. 56; also Guillaume Apollinaire, *Chroniques d'art 1902-1918*, ed. L.-C. Breunig (1960), pp. 64 f.: 'Médaillon. Un Fauve' (on Matisse), with notes p. 452.

In Verlaine's little masterpiece *Louise Leclercq* the end of the story is prepared for by the unmistakably *fauve* description of a distorted Spanish crucifix, *effroyable et merveilleux*, a passage that outweighs anything written by Huysmans on Grünewald or El Greco. Needless to say, both Verlaine and Rimbaud included the word *fauve* in their poetic vocabulary. The opening verses of Verlaine's *Poèmes Saturniens* place the poet under the sign of a *fauve planète*; and Rimbaud, in *L'orgie parisienne* (1871), rhymed *coups de couteau* with *la bonté du fauve renouveau*.

The stark Spanish crucifix described in *Louise Leclercq* can still be seen in the church of Sainte-Marie des Batignolles in Paris, where it is placed against the wall of the right aisle ('à droite en entrant par le bas-côté'). Unfortunately, the sculpture is a thoroughly mediocre piece, a fact that could not have escaped Verlaine completely, since he suggested that what looked to him like an object of terrifying splendour, *effroyable et merveilleux*, had survived only as a piously restored and repainted wreck: 'quelque débris d'un couvent espagnol pillé sous le premier Empire, retrouvé chez un marchand de bric-à-brac, respectueusement restauré, repeint et réédifié contre un mur chargé d'ex-voto tout flamboyant.' The face of the Christ, pained in the mild insipid way of a popular effigy from Saint-Sulpice, shows no trace of the convulsive exaltation that Verlaine projected into it; and the head is, as he says, too large for the body, because the sculpture was originally designed for a high place: 'la tête très grosse en raison évidemment de l'élevation énorme où ce crucifix devait se trouver dans la chapelle conventuelle (*espagnole*, ne pas oublier).'

In *Mémoires d'un veuf*, to quote a less wilful example of Verlaine's predilection for something *effroyable et merveilleux*, the sketch *Mal'aria* depicts the muffled ferocity of an autumnal landscape, steeped in *jaune mélancolie* and *apathie fauve*. [1968]

16. In 1896 Yeats attended the first performance of Jarry's monstrous comedy *Ubu roi* at the Théâtre de l'Oeuvre. Although his French was deficient, there was no mistaking the tone of the play: 'The players are

supposed to be dolls, toys, marionettes, and now they are all hopping like wooden frogs, and I can see for myself that the chief personage, who is some kind of King, carries for sceptre a brush of the kind that we use to clean a closet. Feeling bound to support the most spirited party, we have shouted for the play, but that night at the Hôtel Corneille I am very sad ... After Stéphane Mallarmé, after Paul Verlaine, ... after our own verse, after all our subtle colour and nervous rhythm, ... what more is possible? After us the Savage God' (*Autobiographies*, 1956, pp. 348 f.).

Mallarmé himself applauded *Ubu Roi* as 'un personnage prodigieux', modelled in 'a rare and durable clay' by a 'dramatic sculptor' (*Propos sur la poésie*, ed. H. Mondor, 1953, p. 195); and he predicted that the figure would 'enter the repertory of *haut goût*', just as he had written to Jarry about *Les minutes de sable mémorial* that 'ce qui, chez d'autres, resterait au niveau du falot, par vous atteint, richement, l'insolite' (*ibid.*, p. 181).

For the *Almanach illustré du Père Ubu* (1901), reproduced in Jarry's *Oeuvres* VIII, pp. 61-118, Jarry collaborated with Vollard, Fagus, Claude Terrasse and, above all, with Bonnard, whose illustrations include brilliant grotesques of Ubu's colonial exploits with negroes (cf. Vollard, *Souvenirs d'un marchand de tableaux* xii, 3: 'il suffit de trois jours aux auteurs et à l'illustrateur Pierre Bonnard pour établir cet éphéméride'). Although these African fantasies by Bonnard have been little noticed, they are remarkable both for their own sake and for their influence on Rouault in his illustrations to Vollard's *Réincarnations du Père Ubu* (1933).

An ingenious bookbinding by Marcel Duchamp, shaped by the three letters UBU (Arensberg Collection), seems curiously refined for so coarse a subject, but it is just that combination of coarseness and polish which produces the *haut-goût* of barbaric regression (cf. Walter Mehring, *Die verlorene Bibliothek*, 1952, p. 127: 'en rétrogradant jusque chez les sauvages', quoted from Lautréamont, *Les chants de Maldoror* vi).

Baudelaire noticed in himself an unreasonable fondness for 'ce mot *barbarie*, qui est venu peut-être trop souvent sous ma plume'. His just reflection, that a barbaric style often shows a remarkable force of abbreviation, tempted him to suspect that, even in an observer and painter of modern life like Guys, abbreviation was a barbaric residue – 'une barbarie inévitable, synthétique, enfantine', assisting the memory by an exaggeration of contours that lent style to the dandy, the clown and the marionette (*Le peintre de la vie moderne*, v: 'L'art mnémonique'; ix: 'Le dandy'); cf. also *Morale du joujou*, with its stress on 'le joujou barbare, le joujou primitif'. On Jarry's *Conférence sur les pantins* (1902), see *Cahiers du Collège de Pataphysique*, no. 11, quoted in Giedion-Welcker, *op. cit.*, pp. 101 f., 132 note 111.

17. Hegel, *Vorlesungen über die Aesthetik* I, ed. H.G. Hotho (1835), pp. 134 f.:

'Uns gilt die Kunst nicht mehr als die höchste Weise, in welcher die Wahrheit sich Existenz verschafft', etc.

18. *Schriften und Fragmente*, ed. E. Behler (1956), pp. 119 f., written in 1795-6: 'but in vain do you collect from all climates of the earth the richest superabundance of interesting individuality. The vessel of the Danaïdes remains always empty.' Goethe passed the same sort of judgment on Achim von Arnim: 'He is like a barrel whose hoops are unfastened, and so the wine runs out everywhere' (reported by Varnhagen von Ense, *Vermischte Schriften* II, 1875, p. 346).

19. His judgment of the Nazarenes (*Aesthetik* II, p. 233) is particularly apt, through less savage than his attack on Romantic irony (*ibid.* I, pp. 84-9; II, pp. 227 f.) or on the false sentiment of the Düsseldorf painters (III, pp. 84 ff.). Reflecting on the proliferation of art in 1852, Flaubert reached a conclusion not unlike Hegel's: 'Une chose qui prouve, selon moi, que l'Art est complètement oublié, c'est la quantité d'artistes qui pullulent' (*Correspondance*, ed. Conard, II, 1926, p. 416. I owe this reference to the kindness of Austin Gill). On the veneration of Flaxman as 'the English Canova', see N. Schlenoff, *Ingres: ses sources littéraires* (1956), p. 124.

20. For the Romantic cult of the 'interesting', see Novalis in *Athenaeum* I, i (1798), pp. 80, 84, 86 f.; also (despite his irritation three years earlier – cf. above, note 18) F. Schlegel, *ibid.* I, ii, p.139: 'nichts als *interessante Individualität*' (Schlegel's italics).

'Interesting' is also the decisive word in which Uvedale Price (*Essays on the Picturesque*, ed. T.D. Lauder, 1842, first published in 1794, revised and expanded 1810) tried to sum up the 'roughness', 'sudden variation', 'singularity', 'irritation', and 'abrupt kind of intricacy' which he ascribed to the Picturesque (pp. 82, 111, 339, 510): 'And the whole way up the lane, they met with so many interesting objects, that they were a long while getting to the top of the ascent' (p. 512).

Payne Knight, *Principles of Taste* III, iii (1805), § 22, criticized 'that fluttering and fidgety curiosity, that trembling irritability of habit which cannot stoop to the tameness of reality ... but is always interesting itself in the more animated and brilliant', and he took Montesquieu to task for holding (*Essai sur le goût dans les choses de la nature et de l'art* ix) that 'surprise is the genuine principle of beauty' and that the irregular charm of the Borromean islands in Lake Maggiore depends on 'all these tricks of art' (*op. cit.* III, iii, § 13, 'Of novelty'). For a useful survey of these lively debates cf. C. Hussey, *The Picturesque* (1927), pp. 65-82; see also E.F. Carritt, *Philosophies of Beauty* (1931), p. 124 note 2, with a relevant quotation from Peacock, *Headlong Hall* (1816), on aesthetic 'unexpectedness': 'Pray, sir, by what name do you distinguish this character when a person walks round the grounds for the second time?'

Against Kant's attempt to ban the word 'interesting' from aesthetics (*Critique of Judgment* §§ 2-5), Herder argued in *Kalligone* I, 5 (1800) that Kant's strictures would be justified only if *Interesse* were narrowed down to *Eigennutz*.

21. Hegel did not understand the crucial role of experiment. His concept of logical enquiry was dialectical, which made him fancy that experimental science could be resolved into philosophical construction. It is all the more remarkable that his intellectual curiosity extended to such incurably empirical subjects as classical philology and natural history, in which his professional competence astounded some of his contemporaries; cf. Karl Rosenkranz, *Hegels Leben* (1844), p. 199; Friedrich Creuzer, *Aus dem Leben eines alten Professors* (1848), p. 124 note 1.

22. *Aesthetik* I, p. 135.

23. Manet's painting *The Dead Christ with Angels* was composed for the *Salon* of 1864, where it was exhibited under the title *Les anges au tombeau du Christ*. The biblical passage named in the inscription (John xx, 5-12) relates how the sacred linen and two angels were seen in the sepulchre of Christ. What fascinated Manet about this subject was the configuration of white linen, a wax-coloured nude, and angels with azure wings, all set against sepulchral darkness – a religious still-life in the Spanish style, by which he hoped to compete with the Old Masters. To satisfy his *goût passionné de l'obstacle*, Manet added a secular piece, also in the Spanish manner: a scene from a bull fight, with a dead toreador laid out in the foreground, exhibited as *Épisode d'un combat de taureaux*, later cut down to the main figure and renamed *L'homme mort*.

Zola, when he reviewed Manet's career in 1867, remembered that the 'Dead Christ' and the 'Dead Toreador' had been exhibited together, and he compared them with each other. Contrary to what might have been expected, he did not prefer the secular piece. The 'Dead Christ' struck him as the more profound and vigorous picture, because it revealed Manet's peculiar gift for combining realistic audacity with elegance. It was in gratitude for this appreciation that Manet gave Zola a sketch of the admired painting; but this gift (now in the Louvre) was not, as has been claimed in at least one instance, a preparatory study for the picture exhibited in 1864. It was a watercolour made after the event, and in reverse of the original composition, being a modello for the etching of a later date.

Equally untenable is the supposition (discussed in the correspondence on *Art and Anarchy* in *The Times Literary Supplement*, 2 and 9 April 1964) that Manet's image of the dead Christ, attended in his tomb by angelic ministers, has some affinity, either in style or in subject-matter, with Renan's then newly published *Vie de Jésus* (1863), from which this supernatural scene was of course omitted. Renan's

historical Christ is so steeped in cloying lyricism that the narrative exudes the kind of intimate pathos that Manet magisterially excluded. Renan was in fact satisfied that the perfect image of the modern Christ had already been found by Ary Scheffer, whose figure spoke, he thought, the common language of the heart (*Études d'histoire religieuse*, 1857, p. 432).

Of Manet's rare digressions into religious art, the four biblical subjects painted between the years 1856-65 were inspired, without exception, by his friendship with the abbé Hurel, who collected the discarded remnants of these exercises with touching fidelity; see A. Tabarant, *Manet, Histoire catalographique* (1931), nos. 16 and 102, the latter inscribed in Hurel's hand: *Cette étude est d'Édouard Manet, qui l'a coupée pour moi dans une de ses toiles. – A. Hurel.*

Manet confided to Hurel what he had in mind for the exhibition of 1864: 'Je vais faire un Christ mort, avec les anges, une variante de la scène de Madeleine au sépulcre selon Saint Jean'. (Tabarant, pp. 118 f.). The reference to the Magdalen relates to an earlier religious project that never matured – a *Madeleine au tombeau*, of which Hurel had kept a compositional sketch (see Théodore Duret, *Histoire d'Édouard Manet et de son oeuvre*, 1902, pp. 206 f., no. 59). Did Hurel, who officiated at the Madeleine, perhaps hope that Manet might produce an altarpiece? If so, he was soon disabused. In his penetrating and courageous book, *L'art religieux contemporain: étude critique* (1868), he refers to Manet only as a secular painter (pp. 237 f.), whom he defends against the small-minded intrigues that had excluded him from the *Exposition Universelle* of 1867: 'Bien peu résistent à ce vent de servitude, et on ne les trouverait guère que parmi ces ardents et fiers jeunes hommes [Manet and his friends], qui semblent ne traverser le présent que pour atteindre l'avenir ... ils auront protesté, non sans gloire, contre cet esprit de servilisme qui si souvent dessèche l'enthousiasme et tue la flamme de l'inspiration.'

This remarkable testimony seems to have escaped Manet's biographers and catalographers, who have been content to characterize Hurel (following a smart paragraph in É. Moreau-Nélaton, *Manet raconté par lui-même* II, 1926, p. 34) as a frolicsome priest of questionable humour, with a peculiar flair for modern art and himself something of an amateur painter. No mention is made of his forceful books, among them a work in two volumes on French pulpit oratory of the grand style: *Les orateurs sacrés à la cour de Louis XIV* (1872), inspired by Hurel's discontent with the flatness of contemporary preaching, in which he saw the same decline as in religious art. The chapter 'Des causes de décadence de l'art chrétien' (*L'art religieux contemporain*, pp. 236 ff.) examines the 'refroidissement réel de l'atmosphère artistique autour de nous'. Manet painted two portraits of Hurel, sixteen years apart (Tabarant, nos. 26 and 237), the second one signed *À son ami, l'abbé Hurel. – Manet, 1875*, a date which shows that the friendship continued well after the collaboration had ceased.

In conversation with Jacques-Émile Blanche (reported by Blanche in *Propos de peintre* I, 1919, p. 143; also *La pêche aux souvenirs*, 1949, p. 143), Manet declared that still-life is the true test of the painter: he challenged Blanche to paint a *brioche*. Like the *Déjeuner sur l'herbe* and the *Olympia*, the *Christ aux anges* has something of the aloof touch of the still-life painter, and this may have increased the public anger at the picture. [1968]

24. Baudelaire, *De l'essence du rire* vi. On his first visit to Gautier (reported by him in *Théophile Gautier* ii, 1859) Baudelaire directed the conversation to the virtues of the burlesque style, which he considered the touchstone of pure art: 'Je lui parlai vivement de la puissance étonnante qu'il avait montrée dans le bouffon et le grotesque.' As he said in *De l'essence du rire* v, 'le rire causé par le grotesque a en soi quelque chose de profond, d'axiomatique et de primitif qui se rapproche beaucoup plus de la vie innocente et de la joie absolue que le rire causé par le comique de moeurs. Il y a entre ces deux rires ... la même différence qu'entre l'école littéraire intéressée et l'école de l'art pour l'art.'

 The notion, so dear to Baudelaire, that fantastical or burlesque designs are the crucial test of aesthetic autonomy was adumbrated, surprisingly enough, by Kant: 'Thus English taste in gardens and baroque taste in furniture push the freedom of the imagination to the verge of the grotesque, and in this sort of divorce from all constraint of rules they afford the precise instance where taste can display its own perfection through conceits of the imagination to the fullest extent' (*Critique of Judgment*, General Conclusion following § 22). Defences for an aesthetic sansculottism built up in the ponderous language of Kant may seem even more baroque than his views on furniture: yet his belief in letting the imagination have its way is but another proof of his debt to Rousseau (whose portrait was the only picture in Kant's house). If it is true, as has been suggested by G. Lanson, R.F. Egan, J. Wilcox and others, that German philosophy forged the weapons for the French battle of *l'art pour l'art* (cf. *Journal of Aesthetics* XI, 1953, pp. 360 ff.), it should be added that France received what she had given — which may explain why the gift looked so indigenous on its return. The earliest instance found so far of the precise phrase *l'art pour l'art* (see *Smith College Studies in Modern Languages* II, iv, 1921, p. 10 note 10: observation by J.E. Spingarn) is in Benjamin Constant's diary of his visit to Weimar, cf. *Journaux intimes*, ed. A. Roulin and C. Roth (1952), p. 58, 11 February 1804: 'Dîner avec [Henry Crabb] Robinson, écolier de Schelling. Son travail sur l'esthétique de Kant. Idées très ingénieuses. L'art pour l'art, et sans but; tout but dénature l'art. Mais l'art atteint au but qu'il n'a pas.' (The last sentence is an unsuccessful attempt to render Kant's *Zweckmässigkeit ohne Zweck*.)

 Traces of Kant's terminology survive even in Baudelaire, thus in his contrast between *l'école de l'art pour l'art* and *l'école littéraire intéressée* (*loc.*

cit.), where the scornful use of the term *intéressé* corresponds exactly to Kant's sense of the words *interessiert* or *Interesse*, which figure so largely in the *Critique of Judgment*: 'Alles Interesse verdirbt das Geschmacksurteil' (§ 13), etc. Montesquieu had used the more amiable term *utilité*: '... lorsque nous trouvons du plaisir à voir une chose avec utilité pour nous, nous disons qu'elle est bonne; lorsque nous trouvons du plaisir à la voir, sans que nous y démêlions une utilité présente, nous l'appelons belle' (*Essai sur le goût*, Introduction).

25. *Aesthetik* II, pp. 239 f. The passage refers to oriental poems by Rückert and to Goethe's *Divan*, which also impressed Gautier as an exemplary escape into art for art's sake; see preface to *Émaux et camées*.

26. Clive Bell, *Art* (first published 1914: here quoted from edition of 1949, with new preface), pp. 11, 16 ff., 36 f., etc.

27. *Aesthetik* II, pp. 232 ff.

28. *Ibid.*, p. 236.

29. *Ibid.*, p. 231: '... so vollständig, ... dass alles heraus ist ...'

30. *Lectures on the Philosophy of History*, Introduction iii c.

31. *Reflections on History*, p. 20; *Weltgeschichtliche Betrachtungen*, Introduction.

32. Gide on Matisse, in *L'enseignement de Poussin*: 'We have seen Matisse working unremittingly at the elaboration of certain patterns, returning without respite to the readjustment of lines, to the learned balancing of volumes. Yet nothing governed their choice except the demands of the space they were to occupy ... In order to remain true painting, the work avoided signifying anything ... This destitution, a voluntary penury, will remain, I believe, characteristic of our age' (Preface to *Poussin*, 1945, p. 11). Gide seems to have had little patience with what Mallarmé, in his *Toast funèbre*, had called *la gloire ardente du métier*. Gide thought that the *métier* should remain a servant, but 'cette *Serva* s'est faite (ou nous l'avons faite) *Padrona*'.

33. Cf. H. Sedlmayr, *Verlust der Mitte* (1961), pp. 114 ff., anticipated by Ortega y Gasset in a brilliant essay, *The Dehumanization of Art* (Spanish 1925, English 1948). But while recognizing its centrifugal force, Ortega misjudged modern art on at least two points: he thought that it would never be popular, and he regarded it as doomed to irony, farce and waggery (pp. 46-52); its appetite for solemnity escaped him. Ortega denied, for example, that 'a cubist painting expected to be extolled as solemnly and all but religiously as a statue by Michelangelo' (p. 47). Seeing the essence of cubism in self-derision, he mistook its tone for a

sarcastic form of destructive banter. Gide's essay on *Dada* was more clear-sighted: 'C'est une grave erreur que d'assimiler Dada au Cubisme ... Le Cubisme ... c'est une école. Dada c'est une entreprise de négation' (*Oeuvres* X, pp. 18 f.).

Nevertheless, Ortega may have been right in associating some of the frenzies of modern art with a compulsive juvenility that he regarded (in the 1920s) as characteristic of modern life. In the works of Picasso and Joyce, perhaps also of Schoenberg, the calculations of an elaborate *métier* are superimposed like a mask on an adolescent emotionalism which continues unabated beneath, resurging at times in roving fits of undisguised sentimentality.

34. *L'Orlando furioso* ix, 88-91; xi, 21-28.

35. *Über das Geistige in der Kunst* (1912), p. 89 note (cf. *Concerning the Spiritual in Art*, 1955, p. 71 note 6). Although Kandinsky's artistic horizon was narrow, his arguments – like those of Schoenberg, who was his friend – have a haunting and destructive lucidity. In his famous *Blue Rider*, for example, the colour blue is meant to stand out against the rider so as to be seen as pure colour for its own sake, but Kandinsky observes that the dissociation of colour and object would fail in its purpose if it put the spectator into the mood of a fairy-tale in which blue riders are acceptable. In that case the association must be broken up again: 'The battle against *Märchenluft* is as important as the battle against nature.'

On the face of it this argument is not unreasonable, being aimed at removing what Coleridge called 'the film of familiarity' (*Biographia Literaria* xiv). Since vision is often dulled by custom, the breaking up of perceptual habits is likely to refresh it. Roger Fry, for example, held this view in *Vision and Design* (1937, p. 22). And yet the breaking up of perceptual habits can easily become a habit of its own, a facile routine, as in the case of Picasso, who tends to break up each style so quickly, and rush into a new discord with such haste, that for the sake of keeping his imagination fresh he will never allow it to settle. Those modern artists who found their idiom and stayed with it – Matisse, Braque, Klee, Bonnard, Moore – may have been narrower in range than he was, but it is possible that they struck deeper. Contemporaries are easily deceived by a show of force, particularly when it rests on a dexterous use of the pathetic fallacy. The celebrated Canova, an artist more like Picasso than it might seem, so completely captivated his age by his astounding energy of production that even Stendhal failed to notice its flimsiness.

36. 'The emancipation of the dissonance', as explained by Schoenberg and quoted by Kandinsky (*op. cit.*, 1912, p. 28; 1955, p. 35), rests on the assumption that 'dissonances are merely remote consonances in the series of overtones'; see Schoenberg, *Structural Functions of Harmony* (1954), p. 193; also *Style and Idea* (1951), pp. 104 f., and the original

statement in *Harmonielehre* (1911, here quoted from 4th edn.), pp. 18, 391, 399, 462, etc. The theory gives a positive status to so-called 'vagrant chords' and 'non-harmonic tones', whose illicit presence in classical theory Schoenberg derided with considerable zest: '... homeless apparitions roving about between the domains of tonality, incapable of standing alone, but extraordinarily adaptable; spies seeking out weaknesses and using them to cause confusion; deserters whose main object is the giving up of their own identity; troublemakers in every situation; but, above all, highly amusing fellows' (*Theory of Harmony*, tr. R.D.W. Adams, 1948, pp. 213 f.; *Harmonielehre*, pp. 309 f.; also pp. 372-416: 'harmoniefremde Töne').

In Schoenberg's revolution these former outcasts become the masters, imposing their own restrictive dominion: for just as Kandinsky prohibited representational colours and a steady *Märchenluft* because they would interfere with dissociation (see preceding note), so Schoenberg's new rules, as his translator put it, 'now avoid consonances more carefully than the classical writers of the past avoided dissonances' (*Theory of Harmony*, p. xv); cf. *Harmonielehre*, p. 505; also p. 83 note, where 'Scheu vor der Konsonanz' is defined as an inverse corollary to the creative impulse of drawing the distant overtones into the score. Strange to say, the definition of dissonance as a remote and hence unfamiliar concord, which was the cornerstone of Schoenberg's system, resembled the definition of monsters that Jarry rejected as too tame – *l'accord inaccoutumé d'éléments dissonants* (*Oeuvres* VIII, p. 28; cf. above, pages 97 f.).

37. *The Sacred Wood* (2nd edn., 1928), p. 44.

38. Remy de Gourmont, *Dissociations* (n.d.), Préface: 'J'ai passé toute ma vie à faire des dissociations, dissociations d'idées, dissociations de sentiments, et si mon oeuvre vaut quelque chose, c'est par la persévérance de cette méthode.' See also his programmatic treatise *La dissociation des idées* (1899), reprinted in *La culture des idées* (1916, pp. 67-106); also *Nouvelles dissociations d'idées* (1900-1), reprinted in *Le chemin de velours* (1928, pp. 83-206).

At the time when T.S. Eliot wrote *The Sacred Wood* (1920) he was, as he stressed in the preface to the second edition (1928), 'much stimulated and much helped by the critical writings of Remy de Gourmont' (p. viii; see also pp. 13 f., 41, 44, 46). Hence the phrase most frequently quoted from Eliot's critical writings – 'a dissociation of sensibility from which we have never recovered' (cf. *Selected Essays*, 1951, p. 288) – may be regarded as an attempt, which he later modified (*On Poetry and Poets*, 1957, pp. 152 f.), to read Remy de Gourmont into Dryden and Milton. Nevertheless, the phrase 'dissociation of sensibility' has caught the English ear, and justly: whether in Eliot's adaptation or in the French original, it defines the predicament of modern art. For Ezra Pound, writing on Remy de Gourmont in

Instigations (1920), 'Gourmont prepared our era'; and 'in a criticism of him, "criticism" being an over-violent word, in, let us say, an indication of him, one wants merely to show that one has himself made certain dissociations' (*Literary Essays of Ezra Pound*, ed. T.S. Eliot, 1960, pp. 339-58). On Eliot's debt to Gourmont, see E.R. Curtius, *Kritische Essays zur europäischen Literatur* (1950), pp. 342 f.; F.W. Bateson, 'Dissociation of Sensibility', *Essays in Criticism* I (1951), pp. 302-12; also F. Kermode, *Romantic Image* (1961), p. 150.

39. Rimbaud, *Lettre du voyant* (addressed to Paul Demény, 15 May 1871; *Oeuvres*, ed. H. Matarasso, 1956, pp. 19 ff.) 'Le Poète se fait VOYANT par un long, immense et raisonné DÉRÈGLEMENT de TOUS LES SENS' – for '... il s'agit de faire l'âme monstrueuse ... Énormité devenant norme ... Cette langue sera de l'âme pour l'âme ...' Cf. Jarry, *Les monstres* as quoted above, page 97.

40. Valéry, *Petit recueil de paroles de circonstance* (1926), p. 85: 'Rien ne mène à la parfaite barbarie plus sûrement qu'un attachement exclusif à l'esprit pur ... J'ai connu de très près ce fanatisme.' In his *'Mon Faust'* (1945) the murderous figure of the *Solitaire* is expressive of the same belief. During the terrible fits that shake him, the *Solitaire* howls like a wolf: the 'pure spirit' does not allow any finer expression; but in the intervals between those seizures he talks of them as if his dialectic had been trained on 'the One beyond Being' in Plato's *Parmenides*: 'On ne peut dire qu'ILS sont plusieurs. ILS sont UN et UN et UN ... qui ne s'additionnent pas ... Il y en a un ... qui est la présence de l'autre ... et l'un son acte; et l'un, même, l'un surtout, son absence' (pp. 202 f.). The setting of this preposterous scene, on the summit of a steep rock inhabited by the *Solitaire*, recalls the legendary 'rock of Parmenides' (cf. R. Klibansky in *Mediaeval and Renaissance Studies* I, ii, 1943, pp. 178-86) as quoted in an invective against Abélard: 'velut in altissima rupe Parmenidis sibilat inaudita' (*ibid.*, p. 185 note) – 'hissing unheard-of things on the top of Parmenides' rock'. According to Hugh of St. Victor (*Didascalicon* iii, 14, 'De studio quaerendi'), Parmenides had inhabited the rock for fifteen years; and Petrarch still remembered the story in *De vita solitaria* II, 7 (cf. Klibansky, *op. cit.*, pp. 179, 186).
 For Valéry, the *Solitaire* ('au fond, bien pire que le diable') represents 'une espèce au delà de la démence' (p. 213) – in short, a kind of Pascal. As Valéry's Faust reaches the summit and hears the howling *Solitaire* for the first time, he exclaims (p. 198): 'Quoi? ... La solitude hurle? ... Le silence éternel voudrait-il en finir avec lui-même?' The passage resumes the argument developed earlier in *Variation sur une 'Pensée': le silence éternel* ... (see *Variété* I, 1924, pp. 137-53). At that time Pascal's outcry of cosmic anguish, to which Valéry applied the word *hurler* (*ibid.*, p. 142), reminded him of 'cet aboi insupportable qu'adressent les chiens à la lune'; but in *'Mon Faust'* the dog has become a wolf, addressing his ghoulish howls to the night: 'Je hurlerai, hurlerai à la Nuit ... Il est

l'heure, il est temps que je me change en loup!' [1968]

41. The family resemblance of Valéry's *Monsieur Teste* to Debussy's *Monsieur Croche*, and of both to Frenhofer in Balzac's *Le chef-d'oeuvre inconnu*, has often been noted. On Mallarmé's *Igitur*, see A. Gill, 'Esquisse d'une explication de la "Vie d'Igitur"', in *Saggi e ricerche di letteratura francese* (1961), pp. 163-99. The phrase 'La Destruction fut ma Béatrice' occurs in a letter from Mallarmé to Eugène Lefébure, 17 May 1867 (H. Mondor, *Eugène Lefébure*, 1951, p. 349; Mallarmé, *Correspondance 1862-1871*, ed. Mondor and Richard, 1959, p. 246).

42. *Les poètes maudits* vi, conclusion.

43. In certain older attempts to ape science in poetry the dogmatism is often less marked than the paradox. In *The Sacred Wood*, for example, Eliot believed that the 'extinction of personality' is poetically desirable: 'it is in this depersonalization that art may be said to approach the condition of science' (p. 53). He proceeded to compare the poet's mind to a catalytic agent – a filament of platinum left unchanged while its presence induces oxygen and sulphur dioxide to combine into sulphuric acid. According to that simile the poet's mind would issue from the poetic act without having suffered any transformation – 'inert, neutral, and unchanged'. As a description of fact this should – perhaps not be pressed: but how very odd as an ideal!

Yeats also played with the analogue of science, but more lightly than Eliot, as if he were toying with a pleasant heresy (*Autobiographies*, pp. 325 f.): 'Science through much ridicule and some persecution has won its right to explore whatever passes before its corporeal eye, and merely because it passes ... Literature now demands the same right of exploration of all that passes before the mind's eye, and merely because it passes.' According to Yeats, this is 'not a complete defence', since he admits to 'an unscientific partiality for subjects long forbidden'. The progression of thought here clearly leads from the 'scientific' over the 'experimental' to the forbidden or 'eccentric', thus ending in poetic hilarity. Brecht used the same sort of argument: 'A technique for getting irritated by familiar, "self-understood", accepted facts was built up by science with great care and there is no reason why art should not adopt that immensely useful attitude' (*Schriften zum Theater*, p. 114).

44. The friendship of Wölfflin with the sculptor Adolf von Hildebrand, whose vigorous pamphlet *Das Problem der Form* (1893) had a far more lasting effect on Wölfflin than any of the aesthetic essays by Konrad Fiedler, began in the summer of 1889 when Wölfflin's companion, the Swiss architect Emanuel La Roche, introduced him to Hildebrand in Florence (see Wölfflin, *Kleine Schriften*, 1946, pp. 100, 251 ff., 260). The psychology of form in Wölfflin's earlier books – *Prolegomena zu einer*

Psychologie der Architektur (1886) and *Renaissance und Barock* (1888) – still relied on current theories of empathy (cf. Robert Vischer, *Über das optische Formgefühl*, 1873); but already in the delightful book on Salomon Gessner (1889), he advocated a new ideal of cleanliness: 'Gessner war von Hause aus aller Exstase abgeneigt, unzugänglich für das Unsinnliche und das verschwimmende Entzücken im Überweltlichen' (p. 14) – 'Reinlichkeit wird ein Hauptbegriff' (p. 41). Ten years later, in *Die klassische Kunst* (1899), where his debt to Hildebrand is generously acknowledged, Wölfflin made his first systematic attempt to uncover those purely visual layers of style which he thought were indifferent to emotion, *ohne Gefühlston, an sich ausdruckslos* (1914, pp. 238, 276). As he put it in *Kunstgeschichtliche Grundbegriffe* (first published in 1915): 'Our categories are merely forms, forms of perception and representation, and hence in themselves without expression' (1921, p. 245).

45. *Ibid.*, p. 3; cf. *Principles of Art History* (1932), p. 2.

46. *Italien und das deutsche Formgefühl* (1931), preface; translated as *The Sense of Form in Art* (1958), cf. p. 4. As early as 1886, in *Prolegomena zu einer Psychologie der Architektur*, reprinted in *Kleine Schriften* (1946), pp. 13-47, Wölfflin had argued that the pulse of a new style can be felt only in diminutive shapes: 'in the small decorative arts, in the lines of ornament, lettering, etc. *Here the feeling of form satisfies itself in the purest way, and, it is here that the birthplace of a new style must be sought*' (p. 46, Wölfflin's italics). The famous comparison of Gothic architecture with Gothic shoes occurs in these *Prolegomena* for the first time (pp. 44 f.). Sobriety, the purpose of the exercise, got lost in Worringer's *Formprobleme der Gotik* (1918), where the pointed shoe was replaced by an agitated *Gewandzipfel* (p. 5), a crinkle of Gothic drapery.

47. *Kunstgeschichtliche Grundbegriffe*, p. xi. If Wölfflin's categories are, as he claimed with some pride, indifferent to emotion, it is because they refer to historical averages in which emotional expressions of a fairly wide range have cancelled each other out. Thus, by reducing Bernini and Terborch to a common 'optical denominator' (*denselben optischen Nenner*), Wölfflin brought out what he called 'das Generelle der Mache', that is, the average manner of the seventeenth century, a calculable mean between a Roman Baroque façade and a landscape by Van Goyen (pp. 12, 14). It is often possible, and always useful, to trace a historical development in terms of averages, and if I am not mistaken, *Formgeschichte* as taught by Wölfflin achieved this unintentionally but well. The neutral forms which, according to his system, develop without any reference to expression, are not *basic* forms but *average* forms.

48. Admittedly, Wölfflin modelled his 'basic laws of visual change' on the

phonetic laws of historical grammar. That a linear or classical mode of vision is loosened and thus becomes baroque appeared to him as an 'inherent necessity', whereas he declared the reverse development to be against nature. Fortunately, Wölfflin was not afraid to contradict himself, and so we find him tracing the reverse development in the late style of his beloved Gessner (*Zur allgemeinen Charakteristik von Gessners Kunst*, 1930, reprinted in *Kleine Schriften*, pp. 147 f.). A hardening of style, a sort of *Verzopfung*, is in fact frequent and no less 'regular' than the softening or loosening of a given idiom. It occurs, for example, in the late works of Matisse and Kandinsky; also in the late styles of Holbein, Van Dyck or Jordaens; in the change from Early Christian to Byzantine mosaics, from Carolingian to Ottonian miniatures, from Louis XV to Louis XVI furniture, from Impressionism to Neo-Impressionism, or (to give an example from Florentine painting) in the progression from Pontormo to Bronzino. It almost looks as if Wölfflin had been deceived by a metaphor of gravitation, as if a style could *roll down* towards the baroque (*weiterwälzen*), but not *roll up* towards a new classicism (cf. *Grundbegriffe*, p. 18). He postulated plain continuity for the one kind of change, plain discontinuity for the other; whereas there can be little doubt that continuity and discontinuity are inherent in both and can be picked out by appropriate methods.

49. Cf. A. Riegl's revolutionary studies on late Roman art (*Die spätrömische Kunstindustrie*, 1901), the Italian Baroque (*Die Enstehung der Barockkunst in Rom*, 1908), the Dutch group-portrait (*Das holländische Gruppenportrait*, 1902). For the interesting origins of Riegl's method, first developed while he classified textiles at the Museum für Kunst und Industrie in Vienna, see his earliest book, *Stilfragen* (1893), devoted to the history of ornament. Like Wölfflin in *Prolegomena*, where small ornamental characteristics supplied the crucial evidence against 'mechanistic' attempts to derive style from 'the mere constraints of material, climate, practical purpose' (pp. 46 f.), Riegl argued that no given material or technique can be in itself sufficiently coercive to determine an ornamental form exactly. In his system, materials and techniques were admitted only as 'coefficients of friction' in the working of an autonomous formal impulse, which he called *Kunstwollen*, whereas Wölfflin preferred the more cautious term *Formphantasie*. Whatever the more than easy objections to a pure form evolved by a pure will (see below, note 146), it was with the help of these tenuous fictions that Riegl changed the grammar of ornament from a dogmatic to a historical subject: ornamental 'types' lost their permanent dependence on particular materials or techniques and entered, like the higher creations of art, into a continuous process of aesthetic transformation.

From these lowly beginnings – for what could be more humble than the scruples of a classifier of textiles in the Museum für Kunst und Industrie? – Riegl's theory soon rose to the lofty heights of a quasi-Hegelian philosophy of history. Changes of form, he argued,

were not caused by external forces, but by a dialectic inherent in the forms themselves. The enthusiasm with which this rarefied doctrine was greeted, and the vigour and ingenuity with which it was applied, leave no doubt that it was carried by a genuine artistic impulse of the time, a craving for visual autonomy. For a discussion of Riegl's method, see E. Heidrich, *Beiträge zur Geschichte und Methode der Kunstgeschichte* (1917), pp. 84-109; E. Panofsky, 'Der Begriff des Kunstwollens', *Zeitschrift für Ästhetik* XIV (1920), pp. 321-39; E. Wind, 'Zur Systematik der künstlerischen Probleme', *ibid.* XVIII (1925), pp. 438-86 and, for a critical reappraisal, his article, *ibid.* XXV (1931), Beilageheft, pp. 163-8 (now translated in *The Eloquence of Symbols*, pp. 121 ff.). Distant echoes of Riegl occur even in H. Focillon, *Vie des formes* (1955), pp. 18 ff., 31 ff.

50. It is significant that Berenson found it impossible to respond to the pathos of Mantegna. No one was better equipped than he to explain the peculiar twists of draughtsmanship by which an autograph drawing by Mantegna can be distinguished from a contemporary copy, but in reflecting on the artistic character of Mantegna he was capable of comparing him to Burne-Jones: see *The Italian Painters* (revised edition, 1930), p. 259. The literature of connoisseurship seems to suggest that an exquisite sensibility to the texture of painting can go with tone-deafness in the deeper registers.

51. Leading article, 13 October 1950.

52. *Catalogue of Examples*, no. 4; cf. *Works*, ed. E.T. Cook and A. Wedderburn, XXI (1906), p. 13. – In the words of Donne: 'grief brought to numbers cannot be so fierce' ('The Triple Fool').

53. *De l'essence du rire* (conclusion): 'L'artiste n'est artiste qu'à condition d'être double et de n'ignorer aucun phénomène de sa double nature.' Baudelaire developed the thought in different essays, perhaps best in *Le peintre de la vie moderne* which he conceived as 'a fine opportunity to establish a rational and historical theory of the beautiful':
 'The beautiful is always and inevitably composed of two natures, although the impression it produces is one ... The beautiful is made of an eternal, invariable element whose quantity is exceedingly difficult to determine, and of a relative, contingent element which may be regarded, either separately or altogether, as a matter of period, fashion, morality, temperament. Without this second element, which is the amusing, titillating, appetible icing, as it were, of the divine cake, the first element would be indigestible, unappreciable, unadapted and inappropriate to human nature. I defy anyone to find a sample of beauty, of whatever kind, which does not contain these two elements.' – See also *Salon de 1846*, xviii: 'Toutes les beautés contiennent ... quelque chose d'éternel et quelque chose de transitoire, – d'absolu et de particulier.'

Abstract painting is no exception. Although it tries to do away with Baudelaire's *enveloppe titillante* or *apéritive*, it cannot help making its own partial and hence perishable assumptions like any other living art, and perhaps more so: for we must face the perplexing but unavoidable circumstance that the more an art emulates music in striving for pure and immediate effects, the more it will have to rely, like music, on a large body of preparatory and ever-shifting doctrine.

As Sartre explained in *L'imaginaire* (1948), pp. 241 f., an abstract painting is an imagined object, not (as has been falsely claimed) a real one: its aesthetic life is *feigned* by the pigments, no less so than in a representational picture. The same is true of musical sounds. Every musician knows that the sound he hears is only a peg to which he attaches the sound he imagines; and however close the imagined and the embodied sound may come to each other in a perfect performance, it is only the unmusical person who gets so caught in the reality of the sounds he hears that his musical imagination ceases to function. Hence the well-known paradox that sensitive composers often play happily on a piano that is frightfully out of tune. Accustomed to extract the divine cake from the ephemeral wrapping, they automatically hear the wrong notes right.

To blur the difference between figment and fact is fatally to narrow artistic perception. If they could achieve the immediacy for which they aim, *musique concrète* and the *tableau-objet* would belong to the same class of delusion as the *trompe-l'oeil*.

Nor is it certain that these distinctions vanish on the level of primitive magic: even the caveman must have sensed a slight difference between the act of hunting an animal and the anticipatory gesture of painting it in order secure a successful hunt.

54. Goethe compared the poetic state to the double leaf of a gingko tree (*West-östlicher Divan*, 'Gingo biloba'). See also Diderot, *Paradoxe sur le comédien*, recalled by Sartre in *L'imaginaire* (1948), p. 242, and restated – a little solemnly perhaps – by M. Merleau-Ponty, *Signes* (1960), p. 76: 'On peut dire du peintre à peu près ce que Valéry disait du prêtre: qu'il mène une vie double et que la moitié de son pain est consacrée.' Even Brecht, although he disdains vicarious experience and laughs at a pain that can be exported ('ein Schmerz der transportabel ist'), concedes in *Gespräch über die Nötigung zur Einfühlung*, that aesthetic participation must combine surrender to empathy with the suspense of alienation: 'Unsere eigentliche Bewegung wird durch die Erkennung und Erfühlung des *zwiespältigen Vorgangs* entstehen' (*Schriften zum Theater*, p. 212, italics mine).

55. A significant feature of German Expressionism, and a curious comment on its solemnity, is its association with literary cabarets. One of the most strident, founded by Kurt Hiller in Berlin, called itself *Neopathetisches Cabaret*, a name rendered even more grotesque by the

heroic woodcut-lettering of Schmidt-Rottluff (reproduced in *Expressionismus: Literatur und Kunst, 1910-1923*, Schiller-National-museum, Marbach a. N., 1960, p. 23). Design and title betray an urge, which became characteristic of the entire movement, to extract monumental gestures from burlesque apostrophes. As a theatrical style this manner was anticipated by Wedekind and perfected by Brecht. The fact that as a young man Schoenberg was employed as conductor in Ernst von Wolzogen's cabaret 'Das Überbrettl' suggests that *Neopathetisches Cabaret* may have set the mood of *Pierrot lunaire* (cf. H.H. Stuckenschmidt, *Arnold Schoenberg*, tr. E.T. Roberts and Humphrey Searle, 1959, p. 21; also J. Rufer, *Das Werk Arnold Schönbergs*, 1959, p. 84).

Expressionist painting as a whole, even with such remarkable talents as Beckmann and Kirchner, became caught in that most cantankerous of genres, the serious cartoon; but that was not just a German obsession. Orozco, whose style was formed in part on the macabre caricatures of Posada, remained a cartoonist throughout his frescoes. It should also be remembered in this connection that Picasso's *Guernica* was not only designed as a monumental cartoon, but was never seen to better advantage than as a huge poster decorating the Spanish pavilion at the Paris World Exhibition in 1937. Reduced to a museum piece it looks both more *outré* and more conventional than it did in its original place where the pedimental design, balancing an enormous foot on the extreme right against an enormous hand on the extreme left, etc., had a kind of architectural justification. It would be futile to deny that a substantial part of Picasso's quick genius is that of a genuine cartoonist: has he not become our chief maker of *images d'Épinal*?

Among English artists the over-sized expressionist cartoon has found favour with Francis Bacon; occasionally with Graham Sutherland, too. The fact that the best cartoonists of our age have abandoned their medium for the grand manner, or confine themselves to weird social burlesque in the style of Thurber, may possibly account for the scarcity of talent in current political caricature. Or has modern conformism become so strong that caricature, deprived of its topical role, can display itself only as a 'fine art'?

56. Justi's essays on El Greco, first published in 1897, are reprinted in his *Miscellaneen aus drei Jahrhunderten spanischen Kunstlebens* II (1908), pp. 199-242.

57. 'Non v'è nell'arte un doppio fondo, ma un fondo solo' (*Estetica*, 1958, p. 39). The work of art is here reduced to a monad. To give a rational account of an entity so completely self-contained has proved beyond the power of any language, including French. 'Toujours nous serons tentés', writes Focillon (*Vie des formes*, p. 10), 'de chercher à la forme un autre sens qu'elle-même, et de confondre la notion de forme avec celle de signe ... Le signe signifie, alors que la forme *se* signifie' – whatever

the reflexive use of *signifier* may mean. Croce was a master of this particular sophism: 'Don Quixote is a type; but of what is he a type, save of all Don Quixotes? A type, so to speak, of himself' (*loc. cit*). It would have been less confusing to say that Don Quixote was not recognized as a type before Cervantes conceived him; but it does not follow that Cervantes's conception bears no relation to living men and their follies. Likewise A.C. Bradley was right in stressing that the meaning of a great poem is *in* the poem, arises through it, and does not rest on a pre-defined thought which the poet merely clothes in poetic language ('Poetry for Poetry's Sake', *Oxford Lectures on Poetry*, 1941, pp. 23 f.); yet his indignant refusal to discuss a poetic meaning ('What that meaning is, *I* cannot say: Virgil has said it', p. 21) drives him straight into the Crocean paradox of self-significance: 'If we insist on asking for the meaning of such a poem, we can only be answered "It means itself" ' (p. 24).

58. It is an important and perhaps inevitable paradox that attempts at rendering an artistic medium absolutely pure so often end by assimilating it to another medium. 'De la musique avant toute chose' was the opening bar of Verlaine's *Art poétique*; and according to Valéry (*Variété* I, p. 97) all the many families of 'pure poets' (*d'ailleurs ennemies entre elles*) concur with Mallarmé in their desire *de reprendre à la Musique, leur bien* (cf. *Crise de vers*, also *La musique et les lettres*). A classical discussion of the 'eradication of matter by form' appeared in Schiller's *Ästhetische Briefe* (1795), xxii: 'Darin also besteht das eigentliche Kunstgeheimnis des Meisters, *dass er den Stoff durch die Form vertilgt*' (Schiller's italics). In developing the doctrine Schiller noticed that the closer the arts approach this 'ideal of aesthetic purity', the more their increasingly evanescent media tend to converge: 'die bildende Kunst in ihrer höchsten Vollendung muss Musik werden', etc., a passage admired by Schlegel and Novalis and presumably also by Walter Pater, who ascribed the idea to 'German critics' (*The Renaissance* vii: 'The School of Giorgione').

In *La poésie pure* (1926, p. 27) the abbé Bremond improved on Pater's remark that all arts 'aspire towards the condition of music'; for Bremond 'ils aspirent tous à rejoindre la prière' – a conclusion which Roger Fry declined to draw when he suspected that his theory of pure art might land him in the depths of mysticism: 'On the edge of that gulf I stop' (*Vision and Design*, the concluding sentence). Bremond expanded the mystical argument in *Prière et poésie* (1926). However unpleasant, the assimilation of poetic incantation to prayer is perhaps less absurd than Berenson's claim that aesthetic experience can achieve the ecstatic intensity of mystic union (*Aesthetics and History*, 1948, pp. 84 f.: 'The Aesthetic Moment'). Porphyry said that Plotinus experienced the mystic union four times in his life. Are we to assume that a connoisseur of painting can marshal this exceptional force of ecstasy every time he

fully enters into the spirit of a picture? But perhaps we are faced here only with a confusion of terms. Plotinus records that in the mystical ecstasy all sense of particulars is lost. For the purpose of a connoisseur such an experience would be worthless.

59. A famous case, dated 1854, is Hanslick's diatribe against impure music, that is, music illicitly addressed to the emotions. He detected that failing not only in Wagner but in the ancient Greek theory of musical modes. 'If it needed but a few Phrygian strains', he writes, 'to animate troops with courage in the face of the enemy, or a melody in the Dorian mode to ensure the fidelity of a wife whose husband was far away, then the loss of Greek music is a melancholy thing for generals and husbands, but aestheticians and composers need not regret it.'

One can well understand why this spirited book (*Vom Musikalisch-Schönen*) was translated into French, Italian, Spanish, English and Russian. It effectively ridiculed the sentimentality to which mid-nineteenth century music was prone. The speciousness of the argument is, nevertheless, transparent; for Hanslick claims that in a song the music is so indifferent to the text that anyone who feels that they bear on each other is deceived; worse than that, that he is unmusical. Some seventy years later the same claim was made by Roger Fry who, being convinced that we would see *The Transfiguration* by Raphael better if we did not see it *as* Transfiguration, questioned in *Vison and Design* (Retrospect, 1920), and again in *Transformations* (1926), 'whether, for example, such a thing as a song really exists ... I expect that the answer will be in the negative.'

The logical consequence of this type of purism would be a rejection not only of song, but of any kind of verbal art, because the meaning of words is not accessible to pure intuition. Apparently Fry actually drew that conclusion and not only conceived of pure poetry as 'deliberate gibberish – a collection of sounds so far as possible without meaning', but thought he could illustrate the theory by sounds resembling Milton's *Ode on the Nativity* and having 'all, or almost all, the merits of the original' without any of its distracting connotations (Clive Bell, *Old Friends*, p. 76). The experiment was already well known to Payne Knight, *Principles of Taste* (1805) II, i, § 23: 'An ingenious but fanciful writer has, I know, imagined that he should have enjoyed the versification of Virgil more, if he had not understood the meaning of the words [Lord Orford]: but, probably, had he tried the experiment with any Persian or Arabian poet celebrated for the melody of his versification, he would have listened in vain for this melody.' See also Bradley's refutation of the naïve assumption 'that you can hear the sound of poetry if you read poetry which you do not in the least understand' (*op. cit.*, p. 30).

This fallacy was recently extended to calligraphy by A. Horodisch, *Picasso as a Book Artist* (1962), p. 68, where Picasso's transcription of a sonnet by Gongora is credited with a calligraphic quality 'which only

those ignorant of Latin characters could enjoy to the full. A sensitive Arab or Chinese not acquainted with the Western alphabet would judge such a page better than we do. But if we are able to look at it fixedly until the meaning of the letters is effaced and only the interplay of lines and curves remains, then the beauty of the black-and-white pattern will begin to emerge and to fascinate us irresistibly', etc.

On the periodic reiteration of the same purist arguments, despite their repeated refutation, see the justly impatient remarks by Croce, *La critica e la storia delle arti figurative: Questioni di metodo* (1934), particularly pp. 35-59 on 'the theory of art as pure visibility' and pp. 60-69 on 'the dispute of pure art and the history of aesthetics'; also pp. 30 f. on Berenson's distinction between decoration and illustration, 'essentially the same as that proposed about a century earlier by Herbart and developed in the aesthetics of his school'. It is curious that Croce did not apply this criterion to his own form of aesthetic purism – *la purezza dell'arte come pienezza d'umanità* (p. 238) – on which see below, note 118; also above, note 57.

60. Hogarth summarized his attack in two engravings, *Time smoking a Picture* and *The Bathos*, 'inscribed to the Dealers in Dark Pictures'. See also *The Analysis of Beauty*, ed. J. Burke (1955), pp. 130 note, 187: 'In authors that speak of Pictures mellowing by time always read yellowing.'

61. *St. James's Evening Post*, 7 June 1737; cf. J. Ireland, *Hogarth Illustrated* I (1791), pp. l-lv; also *The Analysis of Beauty*, ed. Burke, p. xxiii.

62. An account of Morelli's life and character, written by his friend Sir Henry Layard, is prefixed to the English edition of *Italian Painters* (1892-3), pp. [1]-[39]. On his method see also Layard's important introduction to the fifth English edition of *Kugler's Handbook of Painting: The Italian Schools* (1887), a book 'thoroughly revised and in part rewritten' by Layard under Morelli's guidance (see p. xvii). On Morelli as collector, G. Frizzoni, *Collezione di quaranta disegni scelti dalla raccolta del Senatore Giovanni Morelli* (1886) and *La Galleria Morelli in Bergamo* (1892), also A. Morassi, *La Galleria dell' Accademia Carrara in Bergamo* (1950), pp. 15-20. A useful handlist of Morelli's writings in *Italienische Malerei der Renaissance im Briefwechsel von Giovanni Morelli und Jean Paul Richter*, ed. I. and G. Richter (1960), pp. 583 f. It is disappointing that these important letters were published incompletely and without an adequate index. The preface says that 'the omissions represent more than one half of the correspondence'. In the editors' description of Morelli's method, his new criteria of authenticity are confused with ordinary characteristics of style, although Morelli was meticulous in explaining the difference (see above, pages 36 f.).

63. Morelli's style should not be judged by the English translations. The

original diction is sharp and often acid but never avuncular. Resentful descriptions of him abound in M.J. Friedländer, *Der Kunstkenner* (1919), pp. 24 ff.; also in Wilhelm von Bode, *Mein Leben* II (1930), pp. 9, 10 f., 57-64, etc. On Hermann Grimm's disapproval of Morelli see Wölfflin's whimsical account in *Kleine Schriften*, pp. 194-7 (Obituary of Grimm). Spirited letters by the young Morelli, dating back to 1837, with outrageous remarks on Görres and Friedrich Schlegel, who 'look for the Trinity in a milk jug', and a brilliant appraisal of Görres's *Die Mystik*, are quoted by Frizzoni in his posthumous edition of Lermolieff, *Kunstkritische Studien über italienische Malerei: Die Galerie zu Berlin* (1893), pp. xv, xix, etc. Genelli's *Prometheus*, with the features of Morelli, is illustrated on p. xvii. On a supposed self-portrait (reproduced as such in S. Sprigge, *Berenson*, 1960, pl. vi), which was in fact drawn by the Empress (then Crown Princess) Frederick, see *Archivio storico dell'arte* IV (1891), pp. 148, 152.

64. *Der Kunstkenner, loc. cit.* This highly instructive but malicious book lost much of its bite in later revisions (e.g. *On Art and Connoisseurship*, tr. T. Borenius, 1942, pp. 143-96).

65. *Ibid.*, p. 27.

66. Morelli, *Italian Painters* I, p. 75 (translation mine); cf. Berenson, 'Rudiments of Connoisseurship', *The Study and Criticism of Italian Art* II (1910), p. 125. The personal acquaintance of Morelli and Berenson began in January 1890, as is shown in Morelli's correspondence with Jean Paul Richter, *op. cit*, pp. 565 f., 569.

67. *Italian Masters in German Galleries* (1883), p. vii.

68. *Athenaeum* I, ii (1798), p. 82.

69. *Ibid.* I, i, p. 106.

70. *Fragmente*, ed. E. Kamnitzer (1929), no. 9: 'Herstellung verstümmelter Fragmente'. In Novalis's view, completion of a finite object would be a surrender to limitation ('Beschränkung', *ibid.*, no. 2050; *Athenaeum* I, i, p. 104), but if the finite is broken, it suggests the infinite.
 Brutal aphorisms on fragmentation abound in Grabbe, *Don Juan und Faust* (1829) I, ii: 'Aus Nichts schafft Gott, wir schaffen aus Ruinen'; or IV, iii: 'Must one tear to shreds in order to enjoy? I almost believe it ... Whole pieces are unpalatable.' A pretentious and rather histrionic Titan, Grabbe recalled ancient Dionysiac rites of fragmentation: 'There was a god, but he was dismembered – we are the pieces' (IV, iii). Some of the chunks of genius left behind by Grabbe were picked up by his spiritual cousin, Jarry, whose dramatic sketch *Les Silènes* (*Oeuvres* VI, pp. 237-53) consists of splendidly translated extracts from Grabbe's

comedy *Scherz, Satire, Ironie und tiefere Bedeutung*, a book included also among the twenty-seven *livres pairs* belonging to Dr. Faustroll (*ibid.* I, p. 205). However, the closest French parallel to Grabbe's theatre is the poetic dramas of Villiers de l'Isle-Adam, of which Verlaine said in *Les poètes maudits* that they were 'like cathedrals and revolutions', always unfinished and always begun again. The logical conclusion of these efforts to salute the Absolute in its pieces was to embrace Poe's *Poetic Principle* and *Philosophy of Composition*: 'I hold that a long poem does not exist.' 'What we term a long poem is, in fact, merely a succession of brief ones.' Consistent with this view, Mallarmé excluded long poems like *Al Aaraaf* or *Tamerlane* from his translation of Poe: 'L'oeuvre lyrique tient seule et toute dans ces pages, fermées à des poèmes narratifs ou de longue haleine' (*Les poèmes d'Edgar Poe*, 1888, p. 160).

Obviously, the same logic applies to the great English Romantic fragments; *Christabel, The Excursion, Hyperion, Don Juan*. Although planned as long poems, they consist of short ones, the poets having poured all their poetry into relatively disconnected lyrical moments. As Hegel put it (*Aesthetik* II, p. 237): 'Such an intensive concentration can only be fractional, and cannot exceed the size of a song or of a mere piece in a large whole; for if it were expanded and carried out extensively, it would have to become action and event, and entail an objective representation.' In Bradley's study on the collapse of the long poem in the age of Wordsworth (*Oxford Lectures on Poetry*, pp. 177-205), the social displacement of the poet is made responsible for the withdrawal of poetry into pure inwardness, a seclusion from which grew the defiant belief that lyricism is the only genuine form of artistic expression (cf. Croce, *Breviario di estetica*, 1958, p. 35: 'L'intuizione artistica è, dunque, sempre intuizione lirica'. For an acute analysis of this fallacy and the 'ghostly outlines' of its metaphysics, see Vincent Turner, 'The Desolation of Aesthetics', in *The Arts, Artists, and Thinkers*, ed. J.M. Todd, 1958, pp. 271-307).

Romantic painting of the grand style shared the fate of the long poem. The large cycles designed by Delacroix or Ingres do not cohere; their merit rests on splendid passages. The logical conclusion was drawn by Ingres in his painting *Tu Marcellus eris* (second version, Brussels Museum), for which he chose a fragment from a complete composition in the hope of thus heightening the intensity of the image. Romney likewise reduced his portrait-group of Flaxman modelling the bust of Hayley to a fragment more 'interesting' than the complete design (second version, National Portrait Gallery, London). On Delacroix's judgment of his own dilemma, see G.P. Mras, 'Literary Sources of Delacroix's Conception of the Sketch and the Imagination', *Art Bulletin* XLIV (1962), pp. 103-11.

By 1844 even Schopenhauer acknowledged 'dass die Skizzen grosser Meister oft mehr wirken als ihre ausgemalten Bilder'. He, too, praised the short lyric and the 'mere song', in opposition to 'large historical paintings, long epics, large operas, etc.', where calculation, technique

and routine must supply the cement for filling the lacunae left by genius (*Addenda* to *The World as Will and Idea* iii, 34). For a refutation see below, note 90.

71. *Three Essays: on Picturesque Beauty, etc.* (1794), pp. 7, 17, 50 f., 61 f. In the imaginary statutes of a Romantic Academy, drawn up by an Italian parodist in 1817, the members are enjoined to choose their emblems from rivulets, broken towers and pieces of oak bark, and to submit to a test that they can sketch (reprinted in *Discussioni e polemiche sul Romanticismo*, ed. E. Bellorini, I, 1943, pp. 208 ff., articles iii, x).

72. In the Introduction to the English translation of Morelli's *Italian Painters*, pp. [21] f., [38], Layard refers to a work left unfinished by Morelli at the time of his death: it was 'devoted to the subject of the original drawings and sketches of the Italian painters, his criticisms and suggestions with respect to which would, I am disposed to believe, have formed the most important and original part of his great work.' The materials and notes he had assembled for this volume, together with his collection of drawings, Morelli left to his pupil and friend Gustavo Frizzoni whom Layard, writing in 1891, still expected to complete and publish the work. Some of the lists, edited by E. Habich and recording observations made by Morelli in 1886, appeared in *Kunstchronik* III (1891-2) and IV (1892-3), but the plan was resumed by Berenson, *The Drawings of the Florentine Painters* (1903; revised edn., 1938).

73. *Ed. cit.*, pp. 14, 59 f. Montesquieu found (*Essai sur le goût, c.* 1755, penultimate paragraph) that Michelangelo was grand 'even in his sketches, like Virgil in his unfinished lines'. The crucial word 'even' still appears in Reynolds's *Discourses* XI (1782): 'Those who are not conversant in works of art, are often surprised at the high value set by connoisseurs on drawings which appear careless and in every respect unfinished', but in producing a general effect they indicate 'the true power of a painter, even though roughly exerted' (ed. Wark, p. 198). The reservation is dropped in Payne Knight, *Principles of Taste* II, i (1805), § 8: 'This intelligence [of the painter] is often more prominent and striking in a drawing or slight sketch than in a finished production; whence persons, who have acquired this refined or artificial taste, generally value them more; since finishing often blunts or conceals this excellence.' It is curious that the converse observation, although at least as true, is rarely mentioned: that it is only by their reference to a finished masterpiece that some famous sketches by great painters come fully to life. *Le chef-d'oeuvre fait bouger les esquisses.*

74. See, for example, P. Wescher, *La prima idea: Die Entwicklung der Ölskizze von Tintoretto bis Picasso* (1960), but also Roger Fry, *Reflections on British*

Painting (1934), pp. 36, 141. I have written against this prejudice in *Art News* (March 1947), pp. 15 ff. See also Vincent Turner, 'The Desolation of Aesthetics', *op. cit.*, p. 287.

75. That Constable intended his paintings to be seen at close range, and not at an impressionist distance, is made clear in a letter to John Fisher, 17 December 1824: '... but I will do justice to the Count [Forbin, who had first hung Constable's paintings for a distant effect at the Paris exhibition]. He is no artist, I believe, and he thought "as the colours were rough, they must be seen at a distance". They found their mistake as they then acknowledged the richness of the texture and the attention to the surface of objects in these pictures' (R. B. Beckett, *Constable and the Fishers*, 1952, p. 199. I have not retained Constable's punctuation and spelling).

 In Constable's Lectures on Landscape Painting, reprinted in C.R. Leslie, *Memoirs of the Life of John Constable*, ed. J. Mayne (1951), pp. 305 f., Reynolds is criticized for his disdain of detail. 'Reynolds has censured Count Algarotti [in the eleventh Discourse] for admiring the minute discrimination of the leaves and plants in the foreground [of Titian's *Peter Martyr*], but Sir Joshua was swayed by his own practice of generalising to such a degree that we often find in his foregrounds rich masses of colour, of light and shade, which, when examined, mean nothing. In Titian there is equal breadth, equal subordination of the parts to the whole, but the spectator finds, on approaching the picture, that every touch is the representative of a reality; and as this carries on the illusion, it cannot surely detract from the merit of the work.' How closely Constable examined details is shown by his own description of Titian's *Peter Martyr* (*ibid.*, p. 294): 'The choice of a low horizon greatly aids the grandeur of the composition; and magnificent as the larger objects and masses of the picture are, the minute plants in the foreground are finished with an exquisite but not obtrusive touch, and even a bird's nest with its callow brood may be discovered among the branches of one of the trees.' Reynolds's belief that the 'curiosity' of the 'naturalist' is incompatible with pictorial imagination (*Discourses* XI, ed. Wark, p. 199) was unacceptable to Constable, whose character as a naturalist was beautifully caught in one of John Fisher's letters to him: 'I am reading for the third time White's history of Selborne. It is a book that should delight you and be highly instructive to you in your art ... I am quite earnest and anxious for you to get it, because it is in your own way of close natural observation: and has in it that quality that to me constitutes the great pleasure of your society' (6 March 1821, Beckett, *op. cit.*, p. 67). Constable's affection for visual detail pervades also his instructions to his engraver: 'Dear Lucas. All who have seen your large print like it exceedingly; it will be, with all its grandeur, full of detail. Avoid the soot-bag, and you are safe ... Be careful how you etch it, that you do not hurt the detail' (Leslie, *op. cit.*, pp. 226 f.).

76. *The Analysis of Beauty* v, *ed. cit.*, p. 42.

77. *The Times*, 10 December 1958. An illustrated survey of this work has since been published by U. Procacci, *Sinopie e affreschi* (1961).

The *mystique* of the sketch has produced its own literature. Although Max Liebermann never tired of explaining why 'the rapid sketch is often more complete than the finished picture' (*Gesammelte Schriften*, 1922, pp. 55, 260, etc.), he noticed with surprise, but without modifying his aesthetics, that among the several revisions of Manet's painting *The Execution of the Emperor Maximilian*, 'the last version is by far the most perfect, whereas usually a work not only suffers in the course of painstaking labours but often loses its character entirely' (*ibid.*, p. 153: 'Ein Beitrag zur Arbeitsweise Manets').

The fact that Michelangelo, throughout his life, blocked out more statues than he could finish, used to be ascribed to the impetuosity of his temperament, which entered into the conduct of all his affairs, artistic and otherwise; but in recent years this natural explanation has given way to a profounder one, a theory of the *unfinishable* in his work: see H. von Einem, 'Unvollendetes und Unvollendbares im Werk Michelangelos' in *Das Unvollendete als künstlerische Form*, ed. J.A. Schmoll gen. Eisenwerth (1959), pp. 69-82. It is here claimed that among Michelangelo's unfinished statues a particular type can be singled out – exemplifed by the *Pietà Rondanini* – which is so bold and arresting in its blocked-out state that it could not be imagined completed. Unfortunately this sort of delusion, by which an unfinished work is declared unfinishable, and therefore unfinished in a Pickwickian sense, has now been encouraged also by Henry Moore (see *Henry Moore on Sculpture*, ed. Philip James, 1966, pp. 183, 186), who not only finds, with perfect justice, that the unfinished *Slaves* in the Academy in Florence represent a more powerful phase of Michelangelo's art than the earlier and more finished *Slaves* in the Louvre, but also that they are wrongly called 'unfinished', because they were not meant to be carried further. But in fact, as everyone knows, these *Slaves* were intended for the Tomb of Julius II, and the degree and kind of finish they would have received may be seen in the superb figures of Leah and Rachel, in the final version at S. Pietro in Vincoli.

In an account of Michelangelo's artistic remains, written immediately after his death in Rome by the Florentine envoy, it is reported (see J.A. Symonds, *The Life of Michelangelo Buonarroti* II, 1893, p. 321) that 'as far as drawings are concerned, they say that he burned what he had by him before he died' – a sign (according to Vasari, ed. Milanesi, VII, p. 270) that he did not wish posterity to dwell on adumbrations: 'io so che, innanzi che morissi di poco, abruciò gran numero di disegni, schizzi, e cartoni fatti di man sua, acciò nessuno vedessi le fatiche durate da lui ed i modi di tentare l'ingegno suo, per non apparire se non perfetto ...' Posterity is entitled to ignore that wish,

but not without recognizing its existence.

Curiously enough, in the second printing (also 1893) of his *Life of Michelangelo*, Symonds felt the need to include among his *Replies to Criticism* a note *On Michelangelo's Unfinished Statues*. At that time it was not so much the *Pietà Rondanini*, or the unfinished *Slaves*, as the statues of *Day* and *Evening* in the Medici Chapel that were admired for the evocativeness of 'their blocked-out forms', which Michelangelo would not have wanted to spoil by finishing. Symonds replied, with his usual terseness, that this was 'sentimental, not scientific criticism', inasmuch as the finished parts of the cycle of decorations in the Medici Chapel left no doubt that Michelangelo had 'intended to work the whole series of monumental figures up to the highest pitch of completeness'. It was also clear to Symonds that a high state of finish was characteristic of Michelangelo's style in all its periods: compare the *David* with the *Rachel* and *Leah*, or the *Moses* with the Medici *Dukes*. [1968]

78. Preface to the second edition of *Lyrical Ballads*.

79. To make it clear that the word *capriccio* is not used here in a derogatory sense, it may suffice to recall the superb capriccios of Goya or Piranesi, or such a brilliant modern capriccio as Picasso's *Songe et mensonge de Franco*. In that extravagant and light style of improvisation, it is possible to say effectively things that a more literal and weighty language might render gross or downright silly.

In the past the capriccio was cultivated as a typically marginal exercise, whereas for Picasso and the majority of modern painters it has become the predominant form. Obvious cases are Klee, Miró, Chagall, Ernst, less obvious ones Léger and Braque, also Lipchitz and occasionally Henry Moore. It is true that some critics have extolled Cubism as a puritanical sort of discipline, to which they even misapply the words *mathematical* and *Platonic*, but in fact Cubist art has always displayed the vigour and licence of the capriccio. An artistic discipline underlies it, certainly, but the intended effect is that of improvisation. What could be more 'capricious' than a Cubist *collage* at its best?

While the powers of this genre are great, its limitations become apparent when the capriccio is raised to a heroic scale and charged with tragic or didactic substance, as Picasso tried to do in *War and Peace* and in the *Charnel House*. Of these paintings I would uphold the view that, like Picasso's monumental capriccio for Unesco, they are gigantic artistic failures, comparable in scale (though, of course, not in kind) to Michelangelo's *Risen Christ* in the church of S. Maria sopra Minerva in Rome, which – owing perhaps to its tangible bathos – was one of his most popular works in its day. On the more particular case of *Guernica*, see above, page 114. Just because Picasso, as he himself explained, builds up his compositions by progressive destruction, catastrophe is an unsuitable subject for him. His method of breaking up natural forms

becomes literal-minded when he applies it to forms that are actually broken. Thus the kind of cubist splinters that fill the centre of *Guernica* can be rich in fantasy if they depict a still-life, a guitarist, or a seated woman; but when they represent a scene of destruction, they are what they are and nothing else. Tautology is an aesthetic weakness.

80. See Guillaume Apollinaire, *Chroniques d'art*, p. 437.

81. Vollard, *Souvenirs* x.

82. Schmoll gen. Eisenwerth, 'Zur Genesis des Torso-Motivs und zur Deutung des fragmentarischen Stils bei Rodin', in a timely symposium, *Das Unvollendete als künstlerische Form* (see above, note 77), p. 117. The volume includes a study by E. Zinn (with Novalis's title 'Fragment über Fragmente', pp. 161-9) on the origin and history of *fragment* as a literary term; also contributions by von Einem, J. Gantner, A. Chastel and others on various 'forms of the unfinished'.

83. *Archäischer Torso Apollos*. For the reference to Duse, see Rilke, *Rodin* (1913), p. 31.

84. *Ibid.*, p. 42. The same, in reverse, can be said of the detached hands or heads which Rodin modelled as if they were torsos: a device that gave nervous force to his portrait busts. Significantly, some of the heads of the *Burghers of Calais* appear less trivial when cast separately; and this applies also to the monument of Victor Hugo, and in fact to all portrait statues by Rodin except the *Balzac*, where the sculptural sketch as such is raised to a monumental scale.

85. Although the Romantics were much preoccupied with facial expression, they also cultivated a form of portraiture which deliberately ignored the face. Painters like Kersting and Caspar David Friedrich (following Tischbein) enjoyed portraying their subjects from the back; Friedrich himself was portrayed by Kersting in this way (drawing in the Staatliche Museen, East Berlin; reproduced in E. Schilling, *Deutsche Romantikerzeichnungen*, 1935, pl. 7). For a brilliant parody see the frontispiece to Southey's *The Doctor*, representing the anonymous and hence faceless author, drawn by E. Nash. The form survives in a jocose self-portrait by Schoenberg (reproduced in Stuckenschmidt, *op. cit.*, p. 49), which was shown in the first exhibition of the Blue Rider Group in 1911 (cf. W. Grohmann, *Kandinsky*, 1959, p. 67; also Rufer, *Das Werk Arnold Schönbergs*, p. 177).

86. Cf. Mallarmé's 'lambeaux maudits d'une phrase absurde' in *Le démon de l'analogie*.

87. Preface to *Divagations* (1897); cf. *Oeuvres complètes*, ed. H. Mondor and G. Jean-Aubry (1956), p. 1538.

88. Verlaine, *Les poètes maudits* ii; Gide, *Paludes (Oeuvres complètes* I, p. 375); M. Bémol, 'L'inachevé et l'achevé dans l'esthétique de Paul Valéry', in *Das Unvollendete als künstlerische Form, op. cit.*, p. 157.

89. Schoenberg, *Style and Idea* (1951), p. 105. The aphoristic structure of these dense compositions, produced by Schoenberg, Webern and Berg between 1911 and 1913, is discussed by Stuckenschmidt (*op. cit.*, pp. 58 f.), in connection with Schoenberg's piano pieces, op. 19, of which the longest consists of eighteen bars, the shortest of nine; see also H.F. Redlich, *Alban Berg: Versuch einer Würdigung* (1957), pp. 76-86, on Webern's orchestral piece, op. 10, no. 1, which comprises twelve bars, and Berg's *Orchesterlieder*, op. 4, set for large orchestra to the text of Peter Altenberg's little poems scribbled on picture postcards, of which the shortest (no. 2) has eleven bars. Significantly, Berg felt attracted to the fragments of Büchner's unfinished *Woyzeck*, a sequence of thirty-two extremely short and evocative sketches which Berg condensed into fifteen operatic episodes (cf. his lecture on the construction of *Wozzeck*, published in Redlich, *op. cit*, pp. 311-27). Needless to say, all these works antedate the theory of the tone-row (on which see above, page 85).

Recently A. Hodeir, *Since Debussy* (1961), revealed a notable paradox in the strongly fragmented music of the young French composer Jean Barraqué. Apparently much of it is 'work in progress' for an oratorio-like mystery *La mort de Virgile* (based on the diffusive prose of Hermann Broch) which, when completed, should be 'much longer than *The St. Matthew Passion* and *Parsifal* combined' (p. 200). Such vast and absurd phantasmagorias (cf. the plans for Schoenberg's *Jakobsleiter* or for Rodin's *Gates of Hell*) are the typically Romantic illusion from which the spirit of fragmentation springs. In Hodeir's words: 'With its starts and stops, its sudden breaks, its irrepressible flights into silence, Barraqué's music thrives on the same temptation of the absolute' (p. 201). The phraseology belongs to the age of Novalis and Grabbe; but the irony is missing.

90. Bradley, *Oxford Lectures on Poetry*, pp. 203 f., summarizing Poe's *Poetic Principle* (cf. above, note 70) and providing a cogent refutation of it: 'in fact [this theory] would condemn not only the long poem, but the middle-sized one, and indeed all sizes but the smallest ... Naturally, in any poem not quite short, there must be many variations and grades of poetic intensity; but to represent the differences of these numerous grades as a simple antithesis between pure poetry and mere prose is like saying that, because the eyes are the most expressive part of the face, the rest of the face expresses nothing. To hold, again, that this variation of intensity is a defect is like holding that a face would be

more beautiful if it were all eyes ... a symphony better if it consisted of one movement, and if that were all crisis.' It is interesting to compare this remark with the passage quoted above, page 45, from Schoenberg. In expressionist literature, a form of drama consisting of mere screams of one or two syllables (*Schreidrama*) for a time occupied Stramm, Hasenclever and others.

The phrase 'poetry is the language of a state of crisis', which Bradley employs to such effect in reviewing the polemics against the long poem (*loc. cit.*, 1909), was not, as might be thought, his own invention, but borrowed from Arthur Symons, *The Symbolist Movement in Literature* (1899), p. 125, where it is mistakenly ascribed to Mallarmé: ' "Poetry", says Mallarmé, "is the language of a state of crisis." ' The source of this error can be traced back to a discussion on contemporary versification in which Mallarmé had in fact explained that the grand resonant periods of the French alexandrine – 'les grandes orgues du mètre officiel' – could no longer be used consecutively, but should be reserved for exceptional moments: 'Le vers officiel ne doit servir que dans des moments de crise de l'âme' (*Oeuvres complètes*, pp. 866 ff.). This did not mean that the whole of poetry was to arise from these high moments of tension, but rather the reverse: 'créer une sorte d'interrègne du grand vers', a relaxation from the 'national cadence, whose use, like that of the flag, should remain exceptional' (p. 362).

Since Mallarmé agreed with Poe that long narrative poems are not strictly poetic, Symons's confusion, however regrettable, was not altogether unfair to Mallarmé, even though he substituted a much too sweeping and popular statement about the nature of the poetic act for a keen technical remark on the state of French prosody from which Mallarmé departed, as he explained with reference to *L'après-midi d'un faune*: 'J'y essayais, en effet, de mettre, à côté de l'alexandrin dans toute sa tenue, une sorte de jeu courant pianoté autour, comme qui dirait d'un accompagnement musical fait par le poète lui-même et ne permettant au vers officiel de sortir que dans les grandes occasions' (p. 870). That the same development had occurred in contemporary music, where the intermittent use of 'vagrant chords' and 'non-harmonic tones' (see above, page 107) foreshadowed what Schoenberg and Stravinsky were to call 'the emancipation of the dissonance', did not escape Mallarmé's attention: 'D'ailleurs, en musique, la même transformation s'est produite: aux mélodies d'autrefois très dessinées succède une infinité de mélodies brisées qui enrichissent le tissu' (p. 867). In Mallarmé's view, these bold deviations from the classical norm were not meant to displace it completely: 'Je dirai que la réminiscence du vers strict hante ces jeux à côté et leur confère un profit' (p. 362) – a clean disavowal of pure atonality or of self-sufficient fragmentation. However much given to 'savantes dissonances' or 'infractions volontaires', he remained committed to 'la tradition solennelle, dont la prépondérance relève du génie classique' (p. 363). A single-minded revolutionary like

Kandinsky, associated with Schoenberg in the fight for atonality (*Über das Geistige in der Kunst*, p. 28), complained that in the music of Debussy he felt thrown back and forth 'like a tennis ball' between bold innovation and conventional beauty. Had French poetry occupied him as much as French music, he might have found the same characteristic in Mallarmé's verse, a firm but mitigated radicalism.

To the very end Mallarmé entertained the dream that his meticulous poems were at most the grace-notes of a majestic plainsong. If published as a collection, they would compose a scrap-book or album, not a book: 'ces lambeaux ... je ne les collerai sur des pages que comme on fait une collection de chiffons d'étoffes séculaires ou précieuses.' He still hoped to write a fragment, or some portions, of the great Ode itself, and so to show what it was as he knew it and as it therefore existed, in its perfection, though his life-time would not suffice for him to execute the whole. 'Voilà l'aveu de mon vice, mis à nu, cher ami ...' (letter to Verlaine, 16 November 1885, *Correspondance* II, ed. H. Mondor and L.J. Austin, 1965, p. 302).

In introducing the second part of his autobiography, Yeats wrote in the preface of 1922: 'I have found in an old diary a saying from Stéphane Mallarmé, that his epoch was troubled by the trembling of the veil in the Temple. As these words were still true during the years of my life described in this book, I have chosen *The Trembling of the Veil* for its title.' Mallarmé's words may be read in *Crise de vers* (*Oeuvres complètes*, p. 360), but Yeats could have seen them in *The National Observer* (1892), where they first appeared in an article 'Vers et musique en France': '... on assiste, comme finale d'un siècle, pas ainsi que ce fut dans le dernier, à des bouleversements; mais, hors de la place publique, à une inquiétude du voile dans le temple avec des plis significatifs et un peu sa déchirure.' [1968]

91. Robert Vischer's *Über das optische Formgefühl*, first published in 1873, reprinted in *Drei Schriften zum ästhetischen Formproblem* (1927), is both the earliest and the most eloquent statement of the aesthetics of 'tactile values' and 'ideated sensations' which Berenson popularized in English. *Einfühlung* (empathy) as a term in aesthetic theory occurs here for the first time. Vischer's aesthetic psychology (developed from the aesthetics of his father, Friedrich Theodor Vischer) had a wide currency among art historians of his generation, perhaps because he was an art historian in his own right. His *Studien zur Kunstgeschichte* (1886) were highly esteemed, and he competed with Wölfflin for the chair in Berlin (cf. Wölfflin, *Kleine Schriften*, p. 258). It is nevertheless astonishing that Berenson remained so content with an aesthetic psychology that had been abandoned by Wölfflin in 1889 for a more exigent type of formalism (see above, note 44). Even more surprising is that Geoffrey Scott, who had studied Wölfflin with much care, found it possible in 1914 to introduce empathy as a revolutionary aesthetic (*The Architecture of Humanism* viii), mistakenly ascribing its invention to Lipps,

who was in fact its systematizer. The popularity of Worringer's *Abstraktion und Einfühlung* (1908, 3rd edn. 1910) shows how far opposition to Lipps had meanwhile progressed in his own country. The formula that aesthetic enjoyment is 'objectified self-enjoyment' (Lipps, *Ästhetik* II, i, 4) was found 'inapplicable to wide areas of the history of art' (Worringer, *op. cit.*, p. 3; supported by Wölfflin, *Die Bamberger Apokalypse*, 1918, pp. 1 ff., also 'Indische Baukunst', *Kleine Schriften*, pp. 220 ff.: 'Das "Ich" wird nicht gestärkt, sondern negiert'). Lipps thought he had disposed of such objections (*op. cit.* I, iii, 3): 'The cutting of trees into geometric shapes, a sphere, a pyramid, etc., this would be stylization after the heart of such aestheticians.' He dismissed it as 'unkünstlerische Barbarei', but this sounded hollow to a generation that had begun to admire barbaric art.

92. Carlyle on Shakespeare, from 'The Hero as Poet'; cf. *Shakespeare Criticism*, ed. D. Nicol Smith (1944), p. 407.

93. Burckhardt, *Griechische Kulturgeschichte*, ed. J. Oeri, III (1900), pp. 251-60; Rohde, *Psyche*, pp. 539 ff.; Nietzsche, *The Birth of Tragedy* xii: 'This is the new enmity, between the Dionysiac spirit and the Socratic, and the art of Greek tragedy died of it.' On Socrates and Euripides see Dodds, *The Greeks and the Irrational*, pp. 186 f.

94. *Phaedo* 60C-61B.

95. A. Baillet, *Vie de Monsieur Descartes* II (1691), p. 395; see also *Oeuvres de Descartes*, ed. C. Adam and P. Tannery, V (1903). pp. 457 ff.

96. *L'art philosophique*, cf. *Oeuvres*, ed. Y.-G. Le Dantec, II (1938), pp. 367-74.

97. *Ibid.*, p. 375. For some illustrations of Chenavard's work, including a drawing of Baudelaire, see J.C. Sloane, 'Baudelaire, Chenavard, and Philosophic Art', *Journal of Aesthetics* XIII (1955), pp. 285-99.

98. According to Valéry, 'attention to the sequence of thought' necessarily interferes with 'attention to the sequence of song'. Didactic poetry reminded him of attempts at squaring the circle; see *Variété* I (1924), p. 93; also *Variété* V (1945), p. 158: 'Poésie et pensée abstraite'. The same argument recurs in Bremond, *La poésie pure*, p. 22; but where Valéry spoke of 'squaring the circle', which is a genuine but insoluble mathematical problem, Bremond thought of 'a square circle', which poses no mathematical problem at all. Surely the assumption that rational discourse and art are *incompatible* is as false as to suppose that they are *identical*.

99. *De rerum natura* I, 944 f.

100. Burckhardt, *The Civilization of the Renaissance* (tr. S.G.C. Middlemore) III, x, on didactic art: 'One thing is certain, that epochs far above our own in the sense of beauty – the Renaissance and the Greco-Roman world – could not dispense with this form of poetry.' An 'abundant sense of style', if Burckhardt is right, coloured anything about which Renaissance men felt strongly, and since they cared passionately for knowledge they could not help turning it into verse: which contradicts the popular notion that didactic poetry is necessarily frigid. Politian's *Silvae* are in fact as vivacious as Ovid's *Fasti* or Pope's *Essay on Man*.

101. É. Mâle, *L'art religieux du XII^e siècle en France* (1928), p. iii: 'Dès qu'il apparaît, l'art du moyen âge se montre façonné par la pensée. C'est ce travail de la pensée sur l'art que j'étudie.'

102. The tapestries were commissioned for the monastery of the Descalzas Reales in Madrid, where they are still to be seen today.

103. For far-fetched erudition nothing exceeds the images of the Indian decans of Abū Ma'shar in the astrological frescoes of the Palazzo Schifanoia in Ferrara (identified by A. Warburg, *Die Erneuerung der heidnischen Antike*, 1932, p. 468); yet these very figures are aesthetically among the most vivid and forceful parts of the cycle (for example, fig. 111).

A delightful survey of allegories in all ages can be found in a lecture by Burckhardt of 1887, 'Die Allegorie in den Künsten' (reprinted in *Kulturgeschichtliche Vorträge*), with brilliant remarks on the Greek capacity for picturing an abstraction: 'To give shape to generalizations, which we find troublesome, was with them a common gift, and there was no need for literary people to talk the populace into an acceptance of allegories.' Although the same applies to the Renaissance populace, allegory flourished at that period in such magnificent ways because literary people talked a great deal (see E. Wind, *Pagan Mysteries in the Renaissance*, 1968, pp. 14 f.).

104. On painters as judges of literature Vollard made an amusing experiment (see *Recollections of a Picture Dealer*, 1936, pp. 243 f.; somewhat shortened in *Souvenirs* xv). For a new kind of literary prize he appointed a jury consisting only of painters, but including Academicians as well as *Fauves*: 'I must admit I was not without a certain anxiety as to the choice that so unusual a jury would make. To everyone's surprise, these artists of such diverse tendencies showed the most discriminating, and at the same time the boldest taste: their almost unanimous choice fell upon Paul Valéry, who had not as yet been elected to the Académie Française.' It would, nevertheless, be unwise to generalize. Rouault would doubtless have voted for a

mediocrity like André Suarès.

105. Since Heisenberg's principle of indeterminacy refers to sub-molecular magnitudes only, it is demonstrably false to speak of 'chance effects' in music or painting (*The Times*, 15 September 1960, p. 4) as if they corresponded to Heisenberg's principle. Neither the gliding perspectives of a Calder 'mobile', nor the somnambulist strokes of an 'action painter', nor the choice between musical sequences 'left open' by Stockhausen or Boulez, have anything to do with a quantum jump. The attempt to sanction these forms of spontaneous variation as 'analogues' to modern science confirms a general observation made by C.P. Snow in *The Two Cultures and the Scientific Revolution* (1959), p. 16: 'It is bizarre how very little of twentieth-century science has been assimilated into twentieth-century art. Now and then one used to find poets conscientiously using scientific expressions, and getting them wrong – there was a time when 'refraction' kept cropping up in verse in a mystifying fashion, and when 'polarized light' was used as though writers were under the illusion that it was a specially admirable kind of light. Of course, that isn't the way that science could be any good to art. It has got to be assimilated along with, and as part and parcel of, the whole of our mental experience, and used as naturally as the rest.'

In the Preface to *Lyrical Ballads*, Wordsworth described the same predicament: 'The remotest discoveries of the Chemist, the Botanist, or Mineralogist, will be as proper objects of the Poet's art as any upon which it can be employed, if the time should ever come when these things shall be familiar to us, and the relations under which they are contemplated by the followers of these respective sciences shall be manifestly and palpably material to us as enjoying and suffering beings. If the time should ever come when what is now called science, thus familiarized to men, shall be ready to put on, as it were, a form of flesh and blood, the Poet will lend his divine spirit to aid the transfiguration ...'

It is characteristic of the present disjunction that if artists seek contact with science at all, they are likely to choose what seems to them the most advanced and adventurous kind of science, but what is in fact the least profitable to them. Neither quantum mechanics at the one extreme, nor psycho-analysis at the other, can be of serious use to a painter, whereas he might draw real inspiration from the morphological sciences which he neglects. As for the place of the accidental in art, it seems hardly necessary to underpin it by a set of false scientific analogues, since a cautious admission of the unexpected has long been part of artistic discipline: *Un coup de dés jamais n'abolira le hasard* (Mallarmé); and see Reynolds, *Discourses* XII (ed. Wark, p. 223): 'Accident in the hands of an artist who knows how to take the advantage of its hints, will often produce bold and capricious beauties of handling and facility, such as he would not have thought of, or ventured, with his pencil, under the regular restraint of his hand'; also

Stravinsky, *Poetics of Music* (1947), p. 55: 'If his finger slips, he will notice it; on occasion, he may draw profit from something unforeseen that a momentary lapse reveals to him.' Reflections like these are spoiled by calculation, and particularly by deliberate manoeuvres to bring 'the laws of chance' into play.

106. Zola has often been ridiculed for modelling his treatise *Le roman expérimental* on Claude Bernard's *Introduction à la médicine expérimentale* because the relation of science to art is not that of a simple analogue. Nevertheless, Zola was right in complaining that scientists are far too inclined to cherish art as an escape from their own exact way of thinking: 'After their accurate labours they seem to feel the need for a holiday of illusion *(une récréation de mensonge)* ... They allow us to play them an air on the flute.' For a strong vindication of Zola, see J.-F. Revel, *Sur Proust* (1960), pp. 239 ff.

107. Paul Klee, *Über die moderne Kunst* (1945), p. 45: 'Also befasst sich denn der Künstler mit Mikroskopie? Historie? Palaeontologie? Nur vergleichsweise, nur im Sinne der Beweglichkeit.' Cf. *On Modern Art*, tr. P. Findlay (1948), p. 49.

108. Originally designed for Vollard, Picasso's thirty-one aquatint illustrations – *Eaux-fortes originales pour des textes de Buffon* – were published after Vollard's death by Fabiani in 1942. See A.H. Barr, Jr., *Picasso: Fifty Years of his Art* (1946), pp. 210, 278. Picasso studied and partly paraphrased the original illustrations by Jacques de Sève and others for Buffon's *Histoire naturelle* (1749-1804), on which see G. Heilbrun, 'Essai de bibliographie' in *Buffon*, ed. R. Heim (1952), pp. 236 f.

109. K. Badt, *John Constable's Clouds* (1950); and *Wolkenbilder und Wolkengedichte der Romantik* (1960), pp. 57 ff. On Stubbs's zoological paintings for John and William Hunter, see Basil Taylor, *George Stubbs*, Exhibition Catalogue, Whitechapel Art Gallery, London (1957), nos. 49, 53 f., 76; also the catalogue of *Rediscovered Anatomical Drawings* from the Free Public Library, Worcester (Mass.), The Arts Council of Great Britain (1958), pp. 6-18.

110. *Samuel Butler's Notebooks*, ed. G. Keynes and B. Hill (1951), p. 314.

111. H.M. Cundy and A.P. Rollett define the purpose of their book *Mathematical Models* (1956) by a quotation from Coleridge: 'To assist reason by the stimulus of the imagination is the design of the following production' (p. 5). In the light of this claim, their illustrations of Archimedean solids should be compared with Leonardo's designs of the same solids in Luca Pacioli, *De divina proportione* (1509). The lack of eloquence in the modern diagrams is not the price paid for greater

precision: in the representation of the icosihexahedron, for example (Pacioli, pl. xxxvi, Cundy and Rollett, p. 99), all oblong figures are foreshortened squares – which can be *seen* in Leonardo's perspective, whereas in Cundy and Rollett it must be *inferred*. Not that modern scientific illustration could, or should, return to the graphic methods of the sixteenth century. All that the comparison is meant to suggest is that the modern illustrator of a scientific book might penetrate the machinery at his disposal with some of the imaginative force and persuasive elegance that Leonardo applied to the more unwieldy mechanics of his time.

112. On the plates to Vesalius's *De humani corporis fabrica*, first published in 1543, second edition 1555, see J.B. de C.M. Saunders and C.D. O'Malley, *The Illustrations from the Works of Andreas Vesalius of Brussels* (1950). Our illustration (page 57 above) is taken from Book II, plate 4; cf. Saunders and O'Malley, pp. 98 f.

113. For some years I have been preparing a book on the philosophical sources of *The School of Athens*. As I have often said in lectures, the painting represents a particular doctrine, the *Concordia Platonis et Aristotelis* (cf. Pico della Mirandola, *Opera*, 1557, pp. 83, 241, 249, 326, etc.), which supplies the key to the entire cycle of frescoes in the Stanza della Segnatura.

114. First stated in *Art* (1914, here quoted from the edition of 1949, p. 25); later in *Since Cézanne* (1922), pp. 195 f., where 'subject' and 'attack', although 'conditioned by an artist's opinions and attitude to life', are defined as 'irrelevant to his work's final significance'; also *Enjoying Pictures* (1934), p. 69: 'how easily you can go off the rails once you begin to allow the cognitive element in a picture to guide your appreciation of the design.' Even in the critical memoir of Roger Fry (*Old Friends: Personal Recollections*, 1956, pp. 62-91), which qualifies the notion of pure art by some important reservations (pp. 73, 76), Bell stuck to the view that the *sine qua non* of a work of art is the presence of 'a combination of lines and colours, or of notes, or of words, in itself moving, i.e. moving *without reference to the outside world*' (p. 72, italics mine). However, a clear and important modification of this view is contained in a recent letter to *The Listener* (5 January 1961, p. 34), in which Bell agreed that the cognitive element in a picture might guide the appreciation of the design: 'Also, I should like to say that it was while studying – soon after the first war – the windows of Chartres and Bourges, that I came to realize that, only by attempting to unravel the intricacies of the subjects, could one hope to appreciate thoroughly and in detail the beauties of form and colour.'

115. Even Wölfflin's eye sometimes failed him; for example in *Die klassische Kunst* (1914), pp. 94 f. (tr. *Classic Art* 1952, pp. 94 f., fig. 63), where a

detail from *The School of Athens* is interpreted as a symmetrical group (a philosopher standing between two seated scribes), whereas the argument defines these figures as part of a series progressing in a crescendo from right to left. It is clear from the cut of Wölfflin's illustration (p. 95) that, misled by an arbitrary choice of focus, his eye seized on a subordinate clause as principal.

116. For the interpretation of these two paintings see E. Wind, *Bellini's Feast of the Gods* (1948) and 'The Subject of Botticelli's *Derelitta*', *Journal of the Warburg and Courtauld Institutes* IV (1940), pp. 114 ff.

117. *Geoffrey Chaucer* (1934), pp. 6 f.

118. Croce agreed with De Sanctis that in a genuine work of art the contingent elements are irrelevant to the aesthetic effect, which survives by its own force: 'The gods of Homer are dead; the *Iliad* remains. Italy may die and, with her, every memory of Guelf and Ghibelline; the *Divine Comedy* will remain. The content is subject to all the hazards of history; it is born and it dies; the form is immortal' (*Estetica*, pp. 409 f.). No doubt, these are fine and familiar sentiments ('Tout passe – l'art robuste seul a l'éternité'), but suppose the gods of Homer are so dead that their characters have become utterly strange, their actions incomprehensible; or that we have forgotten all that Dante meant by such terms as Purgatory and Paradise, or by angels, spheres, and departed souls, or by names like Farinata and Ugolino: do the *Iliad* and the *Divine Comedy* remain?

In Croce this faith is an aesthetic variant of the Hegelian belief that when 'substance' is perfectly resolved into 'spirit' all external relations become internal (cf. *Phänomenologie des Geistes*, 1832, pp. 14 f., 569: 'Dies aber ist die Substanz, insofern sie in ihrer Accidentalität eben so in sich reflektiert ... Subjekt oder Selbst ist.'). Schiller fortunately left no doubt that the 'eradication of matter by form' (see above, note 58) was not a descriptive statement but alluded to an infinite task; it meant the unobtainable: 'Since no purely aesthetic experience exists', he writes, 'the excellence of a work of art can reside only in its greater approximation to that ideal of aesthetic purity.' While it is more than questionable whether valid aesthetic judgments can be built on approximations to a transcendent ideal, at least Schiller does not impute to great works of art a perfect immunity to contingencies.

119. Cf. Kleist, *Über das Marionettentheater* (1810); see also *The Burlington Magazine* LXXXIX (1947), p. 29.

For a criticism of the Romantic view of the savage as a being without access to objective information, see below, note 163.

120. Friedländer, *Der Kunstkenner*, p. 33. Against this view F. Winkler has claimed (I think, mistakenly) that Van Eyck, the Master of Flémalle,

Dürer, Holbein, Baldung Grien, Mabuse, and also Terborch produced exact duplicates of some of their pictures (*Berliner Museen: Berichte* VII, 1957, pp. 37 ff.). He was right, however, in suggesting that the subject deserves a more systematic study than it has so far received. See also B. Nicolson, 'Terbrugghen repeating himself', *Miscellanea D. Roggen* (1957), pp. 193-203.

121. Vollard, *Recollections* (translated by V.M. Macdonald), p. 266; cf. *Souvenirs* xii, 2: 'En peinture voyez-vous il n'y a pas un seul procédé qui s'accommode d'être mis en formule. J'ai essayé de doser l'huile que j'ajoute à la couleur sur ma palette. Eh bien, je n'ai pas pu y arriver. Je dois, à chaque fois, mettre mon huile au jugé.'

122. Vespasiano da Bisticci, *Vite di uomini illustri del secolo xv*, ed. A. Mai and A. Bartoli (1859), p. 99: '... tutti iscritti a penna, e non v'è ignuno a stampa, che se ne sarebbe vergognato.' Pope Alexander VII acquired these manuscripts for the Vatican Library where they now form the famous *Codices Urbinates*.

In their original setting, described by Castiglione in *Il Cortegiano* I, ii, Federigo da Montefeltro's collection of manuscripts looked like treasures, fitted out in gold and silver: 'eccellentissimi e rarissimi libri greci, latini, et ebraici, quali tutti ornò d'oro e d'argento'; on this see also Vespasiano da Bisticci (*op. cit.*, pp. 98 f.), who added that they were 'tutti miniati elegantissimamente, e non v'è ignuno che non sia iscritto in cavretto'.

It is important to see this precious collection of manuscripts against the background of the mass production of printed books by which the market was glutted at that very period (as shown by V. Scholderer, *Catalogue of Printed Books in the XVth Century now in the British Museum* VII, 1935, introduction; also *Vom italienischen Frühdruck*, 1932, pp. 13 ff.). Between 1469 and 1472 Venice alone produced 154 editions, of which 94 were of classical subjects; and by 1480 the Venetian output had risen to a total of 600, of which 206 were classical. Disdain for this manufacture was not confined to Urbino (Federigo survived until 1482), but shared at that time by the Medici (*ibid.*, p. 16). To dismiss Vespasiano's testimony as unreliable because he was a professional vendor of manuscripts who found his trade threatened by the invention of printing is to simplify the historical evidence. [1968]

[Though Federigo's main library was undoubtedly composed only of manuscripts, it now appears that he did in fact have a small collection of printed books, perhaps entirely donated. See C.H. Clough, 'Federigo da Montefeltro's Patronage of the Arts', *Journal of the Warburg and Courtauld Institutes*, XXXVI (1973), p. 138.]

123. Had the Duke of Urbino been consistent in his prejudices, he might have extended his disdain for manufacture from printed books to his hand-written library. The scribe who copied one manuscript from

another, was he not a degraded mechanic compared with the rhapsodes who had recited the *Iliad* live? At the time of the rhapsodes, no doubt, there must have been critics who fastidiously regretted the better days when the poets themselves recited their songs and had not yet delegated that function to a tribe of menial substitutes, etc.

124. Ruskin attacked the mechanization of sculpture in *Aratra Pentelici* (1872), § 178; *Works*, ed. Cook and Wedderburn, XX (1905), p. 326.
 On the pitfalls of mechanical enlargement, the debate on Graham Sutherland's tapestry for Coventry Cathedral revealed some illuminating details: according to the Chairman of the Edinburgh Tapestry Company (letter to *The Sunday Times*, 10 June 1962, p. 12), the artist supplied the weaver with only a small design, which was photographically enlarged by one hundred.
 The technique and history of the reducing machine are clearly set forth by Sir John Craig, *The Mint* (1953), pp. 299, 321, 341 f., 358 f. The final result is worth noting: 'By repetition of the process at different positions along the bar, reductions are obtained to different scales ... All identical patterns, such as portraits, on a series of coins from a crown-piece to a Maundy are thus reproduced from a single original' (p. 359). For the ill effect on the art of the medallist, see C.H.V. Sutherland, 'The Art of the Modern Medal', *Journal of the Royal Society of Arts* CIII (1955), pp. 545 ff.; also Sir George Hill, *The Medal: its Place in Art* (British Academy, 1941), p. 6.

125. Chairs designed by Mies van der Rohe – the MR chairs (1926), the Barcelona chair (1929), the Tugendhat and Brno chairs (1930), and conchoidal chairs for manufacture in plastics (1946) – are illustrated in Philip Johnson's monograph on Mies van der Rohe (1947), pp. 54, 56 f., 172 f. Many of the hackneyed tubular chairs that have become standard office furniture ape the elegant MR chairs.

126. Article in *Le moniteur universel*, 30 December 1854, reprinted in *Lettres à Viollet-le-Duc* (1927), pp. 215 f.

127. A. Prost, *La cathédrale de Metz* (1885), pp. 271 ff. On the destruction of Saint-Front in Périgueux by restorers, see Le Corbusier, *Quand les cathédrales étaient blanches* (1937). As for washing the stone, however preferable to refacing, Le Corbusier anticipated the problem in a memorable sentence: *Les cathédrales étaient blanches parce qu'elles étaient neuves.* The pleasure is dubious of seeing a wrinkled old face restored by artifice to the colour of youth. The colour does not suit the wrinkles. It is a delusion to claim that such buildings look new; they look just what they are – old buildings washed. The blunted edge of the stone, combined with the luminous surface, recalls the paper and print of 'washed books' or 'washed engravings'. Whether the life of these

buildings will be shortened by the increased porosity of the stone is another question.

128. For a concise account of the technical problems set by the stratification of paintings, see A.E. Werner, 'Scientific Techniques in Art and Archaeology', *Proceedings of the Royal Institution of Great Britain* **XXXVIII** (1960), pp. 211-33, with further literature. At a conference held in Rome, September 1961, an important debate took place between Stolow, Keck, Ruhemann and others on the effect of solvents such as acetone on varnish and paint (reported in *Studies in Conservation* VI, 1961, pp. 123 ff.). Stolow remarked: 'once solvent has been allowed to come into contact with a paint film, an irreversible change takes place – that of leaching.'

 The official inquiry of 1853, by a Select Committee of the House of Commons, into methods of picture-cleaning at the National Gallery produced a Report that is still worth consulting (cf. C. Holmes and C.H. Collins Baker, *The Making of the National Gallery*, 1924, pp. 24 f.). The question was then, as it is now, whether 'glazings' and other final touches by the Old Masters were being removed (cf. *The Burlington Magazine* CIV, 1962, nos. 707, 716). The Gallery's case is painstakingly argued in the Director's Report, the National Gallery (1962), pp. 67-87 ('Renewal of the Controversy over Cleaning'), but the reasoning is not faultless. On p. 77, for example, it is suggested that because the Gallery's restorers do not regard themselves as infallible 'they are reluctant to add their own interpretations to what is revealed when the additions made by less scrupulous restorers have been removed' – which seems to imply that the technique of removal is infallible and that judgments on 'less scrupulous restorers' can be completely free of interpretation. Yet the very next sentence proposes that 'by general consent Titian was one of the most original and adventurous of all painters', and for that reason the bold colours laid bare by recent cleaning are unlikely to deviate from his original vision. Whatever the historical validity of this particular interpretation of Titian's style, the denial that it *is* an interpretation would be absurd. The stubborn claim *hypotheses non fingo* is a basic misapprehension of method. No restoration is well-directed if it does not make stylistic assumptions, which are of course open to debate. The belief that in any phase of his work the restorer can divest himself of this uncertainty is not only illogical: it is dangerous.

129. Yeats, *Essays and Introductions* (1961), p. 159.

130. Some of the best catalogues of modern art have perhaps unwittingly helped to shape the working habits of younger artists. Paintings brought forth in rows and classes look irresistibly like illustrations for the artist's future *catalogue raisonné*. Is it possible that, in the place of the patron, it is now the cataloguer who looks over the artist's shoulder?

As is well known, the cataloguer's excusable love of order has occasionally obscured the art of the past by forcing its profuse growth into linear sequences. Today, linear sequences seem to dominate growth. The catalogue has become an aesthetic force.

131. Although it is difficult to conceive, Malraux seriously holds in *Le musée imaginaire* that it is through the levelling effect of reproduction that supra-personal forces are discovered in art: 'La reproduction, et elle seule, a fait entrer dans l'art ces sur-artistes imaginaires ... qui s'appellent des styles' (p. 52) – as if a common style emerged from the obliteration of differences. Merleau-Ponty recalled in *Signes* (p. 57) how a documentary film, by slowing down the motion of Matisse's hand, made the painter's brush stroke appear as a long premeditated action. If such an enlargement were juxtaposed with a real gesture of deliberation, the difference between them would vanish. As Merleau-Ponty rightly says, Malraux's 'spirit of painting' works too much 'behind the painter's back', *une Peinture qui travaille derrière le dos du peintre* (p. 81), a failing here explained by Malraux's reckless individualism: 'Quand on a enfermé l'art au plus secret de l'individu, la convergence des oeuvres ne peut s'expliquer que par quelque destin qui les domine.'

132. Since the ordinary photographic plate is sensitive to a larger range of shades than can be recorded in colour, the best black-and-white reproduction of Titian, Veronese or Renoir is comparable to a conscientious piano transcription of an orchestral score, whereas the colour print, with rare exceptions, is like a reduced orchestra with all the instruments out of tune. Colour photographs and colour prints have indeed fostered a coarseness of vision in art that is likely to be increased by colour television. It would be tempting to reply that colour distortion is a technical imperfection that is bound to be overcome with the progress of science, but this is an evasion of the actual problem: for it is precisely during the time-lag that vision is mechanically shaped and coarsened.

133. See *The Times*, 20 July 1961, p. 8: 'The composer's demand that [the choruses] be pre-recorded on tape and stereophonically reproduced in the theatre not only produced beautiful and exciting effects but made it possible for the chorus to get them right piece by piece, and the pieces to be assembled.' Scherchen used pre-recorded choruses in Schoenberg's *Moses and Aaron*, Bruno Maderna in Nono's *Intolleranza 1960*. In such composite arrangements for the stage, which are becoming increasingly frequent in modern opera, live voices and a live orchestra are placed against recorded sounds; and since the records are set and hence inflexible, the living sounds must abide by the dead ones.

134. In the art of the film, mechanization has achieved the peculiar triumph

of reducing the aesthetic experience to an instantaneous response. The full effect of a film must be manifest at first sight; otherwise it is not a good film. Hence only a few of the great films increase in depth at a second viewing; but as they were not designed for that purpose, this is hardly a valid criterion for judging their quality as films. It is nevertheless well worth analysing exactly what kind of pleasure we get from a good film when we see it for the second or third time. It is often not so much a pleasure of spontaneous response as one of reflective recognition, an appreciative awareness of how the instantaneous effect, designed for a single viewing, was originally achieved. As the by-product of an avowedly popular art, the film has thus inadvertently engendered (much like jazz) a particularly finicky sort of critical *expertise.*

That films have lasting moments of genuine lyricism and produce great exhibitions of the actor's art, which are worth re-experiencing for their own sake, is undeniable; but even here the fact remains that the actor in a film adjusts his capability to that of the screen, where sequences are built up out of episodic 'shots', and the necessity of thus concentrating his performance on relatively short, discontinuous pieces may gradually disable him for the living stage.

135. J.B.S. Haldane, *Daedalus* (1924), p. 44.

136. *The Autobiographies of Edward Gibbon,* ed. John Murray (1896), p. 263; also *Memoirs of my Life and Writings,* ed. G. Birkbeck Hill (1900), p. 309 note.

137. *Sartor Resartus* I, v.

138. Lessing, *Emilia Galotti* I, iv (speech of Conti the painter): 'Why do we not paint directly with our eyes! So much gets lost on the long way from the eye through the arm to the paint brush! Yet the fact that I know what got lost here, and how it got lost, and why it had to get lost, makes me proud, and prouder than I am of all that I managed to save … Or do you think that Raphael would not have been the greatest pictorial genius if by mischance he had been born without hands?'

139. Mozart's compositions for mechanical instruments: K. 594, 608, 616; cf. A. Einstein, *Mozart* (1945), pp. 153, 268 f.

140. The same argument may help to define the artistic merits and limitations of photography. What precludes photography, as Croce put it, from becoming 'entirely art', although it may have 'something artistic about it' (*Estetica* I, ii, *ed. cit.,* p. 20), is the crucial surrender of the pictorial act to an optical or chemical agency which, however carefully set up and controlled by the photographer, must remain automatic in its operation. If the photographer's skill and taste become

obtrusive to the point of obliterating the automatism, the photograph looks contrived: there is not enough genuine photography in it. It follows that an aesthetics of photography would have to stress the importance of an agent outside the photographer's control, a partly unpredictable component which, in a successful photograph, plays in with the photographer's intentions. The term *photogenic* refers to an adventitious felicity which the photographer must catch in an object but not devise. In that respect his skill and tact are inseparable from *reportage* (as in Cartier-Bresson). According to S. Kracauer, *Nature of Film* (1961), the aesthetics of the cinema rests on the same principle: he rejects High-Art photography as incompatible with genuine filming.

For a detailed criticism of deliberately artistic photographs, see H. and A. Gernsheim, *The History of Photography* (1955), pp. 176 ff.; also H. Gernsheim, *Creative Photography: Aesthetic Trends 1839-1960* (1962), pp. 13, 73 ff. While it is now generally acknowledged that the Victorian aberrations of Rejlander (cf. Beaumont Newhall, *Photography, a Short Critical History*, 1938, pl. 36) are pseudo-photographic as well as pseudo-pictorial, this genre is as illicit in its modern form, even if indulged in by Steichen or Man Ray (*ibid.*, pls. 50, 72); cf. Kracauer, *op. cit.*, p. 10.

141. P. Laird, 'Composers or Computers?', *The Listener* LXV (1961), pp. 785 f. The increasing emphasis on pre-compositional thought and construction, to which this article draws attention in contemporary music ('the composer's interest has shifted from the music to the method by which it is written'), was observed in poetry by Valéry. He suggested in 1920, while reflecting on the heritage of Mallarmé, that pure poetry, like pure philosophy, is defined *par son appareil, et non par son objet*: 'It seems that constructive thought, which used to enter into verse, ... has now withdrawn to the phase of its preparation' (*Variété* I, pp. 100 f.). It is easy to see the same shift of emphasis in the theoretical preliminaries of abstract painting. As Lévi-Strauss put it sarcastically: 'C'est une école de peinture académique, où chaque artiste s'évertue à représenter la manière dont il exécuterait ses tableaux si d'aventure il en peignait' (*La pensée sauvage*, 1962, p. 43 note). Pure art has this feature in common with mechanization, where it is self-evident that constructive thought is withdrawn from the event as such into its preparation: the event is then released automatically. Aesthetic automatism as a consequence of pure art is discussed in the last lecture (above, page 86).

142. Pico della Mirandola, *Apologia* viii (*Opera*, 1557, pp. 227 f.): 'actus tyrannicus voluntatis'. The condemnation of Pico's *Apologia*, issued in 1487, was revoked by a papal brief of 18 June 1493.

143. First published in 1897, dedicated to C. S. Peirce.

144. Letter from Gauss to Olbers, 3 September 1805, *Werke* X, i (1917), p. 24; also P. Stäckel, 'Allgemeines über die Arbeitsweise von Gauss', *ibid.* X,

ii, 4 (1922), pp. 6-16. Bergson, in *La pensée et le mouvant* 229, noticed a comparable trait in Claude Bernard's physiological methods: 'We are in the presence of a man of genius who, having first made great discoveries, inquired afterwards how one should go about making them: an apparently paradoxical sequence of events and yet the only natural one, since the inverse way of proceeding has been tried much more often and has never succeeded.'

145. Aesthetic theory has shown a remarkable unanimity in excluding the will from the aesthetic experience: see Kant, *Critique of Judgment* §§ 2-5; Schopenhauer, *The World as Will and Idea* §§ 35-38; Coleridge, *On the Principles of Genial Criticism* § 3; F. Schlegel, in *Athenaeum* I, ii, p. 26; Bergson, *Essai sur les données immédiates de la conscience* i ('les sentiments esthétiques'); Croce, *Estetica* I, vi; Sartre, *L'imaginaire*, p. 242; Wölfflin, *Kleine Schriften*, p. 20 ('Die ästhetische Anschauung verlangt eben diese Willenlosigkeit, dieses Aufgeben des Selbstgefühls'); also Clive Bell, *Old Friends*, p. 79: 'Could he have believed ... that style could be imposed? A horrid fancy: that way lie art guilds and gowns, sandals, homespun and welfare-work, and at the end yawns an old English tea-room.'

146. It is only to designate an aesthetic audacity that *voulu* is occasionally used as a term of praise; for example by Jarry, *Conférence sur les pantins*: 'ces vers voulus mirlitonesques' (cf. Giedion-Welcker, *op. cit.*, p. 102). Even Riegl, who coined the provocative term *schöpferisches Kunstwollen* (on which see above, page 111), did not assume that a genuine style can be freely chosen: he thought of *Kunstwollen* as an 'irresistible impulse' (*Stilfragen*, 1923, p. 187: 'unwiderstehlicher Drang'), a description which did not strike him as self-contradictory, because he relied for his vocabulary on an antiquated psychology which classified all impulses as volitions; cf. 'Phantasiewille' and 'künstlerisches Wollen' in Robert Vischer, *op. cit.*, p. 32; also Lipps, *op. cit.* II, i, 4. The same archaism recurs in Worringer's books. Even in Bergson, *L'évolution créatrice* 225, the words *vital* and *voulu* are used interchangeably: both serve to combat a mechanistic theory of evolution. These distant echoes of biological debate, although quite audible in Riegl's *Stilfragen* (p. vi: 'Darwinismus und Kunstmaterialismus'), have had no lasting effect on the language of criticism. Like the French *voulu*, the German *gewollt* has remained a term of aesthetic censure, comparable to the English *wilful* (= 'contrived').

A rather special case, perhaps inspired by Poe, is Baudelaire's use of the term *beauté voulue*, which he applied to the chiselled verses of Leconte de Lisle (*Réflexions sur quelques-uns de mes contemporains* ix, penultimate paragraph) and also to Poe's own poetic diction: 'Une traduction de poésies aussi voulues, aussi concentrées, peut être un rêve caressant, mais ne peut être qu'un rêve' (quoted by Mallarmé – *pour*

notre peur – in his translation *Les poèmes d'Edgar Poe*, 1888, p. 160). Yet despite Poe's *Philosophy of Composition* (1846; translated by Baudelaire as *Genèse d'un poème*), in which all the poetic tricks of *The Raven* are ascribed to deliberate, cold contrivance, Poe had written in the preface to *The Raven and Other Poems* (1845): 'With me poetry has been not a purpose but a passion, and the passions should be held in reverence: they must not – they cannot at will be excited …' Mallarmé may have said the final word on what is only superficially a self-contradiction: 'L'éternel coup d'aile n'exclut pas un regard lucide scrutant l'espace dévoré par son vol' (*Les poèmes d'Edgar Poe*, p. 163).

147. *The Letters of John Keats*, ed. M. Buxton Forman (1935), no. 32.

148. *Don Juan* V, cx. Yeats went so far as to condemn volitional forms of language as anti-poetic: 'We would cast out of serious poetry those energetic rhythms, as of a man running, which are the invention of the will with its eyes always on something to be done or undone' (*Essays and Introductions*, p. 163).

149. For the notion of a 'forecourt' of art, see Goethe's preface to *Propyläen*. Goethe still believed in setting subjects for painters, whereas C.L. Fernow, an aesthetician who had lived in Rome and was brought to Weimar by Goethe, censured the practice as useless interference: he demanded that painters be left alone to find the subject that would suit their genius. See his essay *Über die Begeisterung des Künstlers* (*Römische Studien* I, ii, 1806, p. 269), which anticipates the modern view. An ardent classicist and Kantian, Fernow was a revolutionary in politics (cf. *Römische Briefe*, 1944, pp. 52 f., 73 ff.).

150. Hogarth's engravings *The Distressed Poet* and *The Enraged Musician* ridicule the type of artist that seeks refuge from reality either in sordid solitude or in pretentious refinement. His sympathies are with the intruding populace. The mood changes already in Rowlandson, whose harassed painters or poets are represented as victims. In Spitzweg's complacent picture *The Poor Poet* (1839) the garret has become an idyllic place, the only right setting for an artist, as in Murger's *Scènes de la vie de Bohème* (1851).

151. Romanes Lecture, Oxford (1958), pp. 4 f. A characteristic example of Renaissance partnership appears in a letter from the humanist Konrad Celtis: 'See to it that the figures are rendered by the painter in philosophic and poetic attitudes [corresponding to the inscriptions proposed by Celtis] so that, when I come to you, I can pass judgment as to what should be added or left out' (H. Rupprich, *Der Briefwechsel des Konrad Celtis*, 1934, no. 87); or Isabella d'Este's peremptory command to Perugino: 'You are not to add anything of your own' (document

published by W. Braghirolli in *Giornale di erudizione artistica* II, 1873, pp. 163-6).

152. The documents on the Medici Chapel – in particular Cambi's contemporary chronicle, supported by Michelangelo's correspondence – leave no doubt that Cardinal Giulio's own tomb was included in the original plan, in addition to the four tombs he had ordered for his relatives. When the cardinal became pope, the plan had to be reduced from five tombs to four because the Pope expected to be buried in Rome. Michelangelo achieved the reduction by a simple reversal: in the place of two double tombs and one single tomb, he provided for two single tombs and one double tomb, with the result that some of the statues originally designed for two sarcophagi were readjusted to fit one. The statue of *Day* still shows the traces of the different type of sarcophagus for which it was originally cut. (These observations, first presented in a lecture to the Pierpont Morgan Library, New York, 16 January 1943, differ from the accounts given in the current literature on Michelangelo, but they agree with at least one remark made independently by F. Kriegbaum, 'Michelangelo und die Antike', *Münchener Jahrbuch* III-IV, 1952-3, p. 16, namely, that the statues of *Day* and *Night* were originally planned for a pair of sarcophagi. See also W. Gramberg in *Mitteilungen des kunsthistorischen Institutes in Florenz* VII, ii, 1955, p. 153.)

It is well known that a little later the Pope again changed his mind. It struck his fancy that if the two Medici popes – Leo X and himself – were buried in the family chapel, the latter would become a glorious Medici mausoleum comprising *magnifici*, dukes and popes. He proposed that Michelangelo should now again expand the plan from four tombs to six, but although Michelangelo toyed with the idea for a while, it did not come to much, and the plan was abandoned.

153. Ascanio Condivi, *Life of Michelangelo*, tr. C. Holroyd (1911), pp. 50 f., 56, 60.

154. E. Wind, *Bellini's Feast of the Gods*, p. 19 note 41.

155. *Ibid.*, pp. 56-63; Crowe and Cavalcaselle, *Life and Times of Titian* I (1881), pp. 184, 225 f.

156. Vollard, *La vie et l'oeuvre de Pierre-Auguste Renoir* (1919), p. 8; also *Auguste Renoir* (1920), frontispiece. Rouault's homage to Vollard, in the preface to *Miserere*, ed. Monroe Wheeler (1952), has more self-pity and pathos in it: '... it would have taken three centuries to bring to perfection the various works and paintings with which, in utter disregard of earthly limitations, he wished to burden the pilgrim.' Translated into the Boston vernacular of 1901, the conditions exploited by Vollard's business acumen were neatly described in *The Education of Henry Adams*,

chapter xxvii: 'New York or Paris might be whatever one pleased – venal, sordid, vulgar – but society nursed there, in the rottenness of its decay, certain anarchistic ferments, and thought them proof of art. Perhaps they were.'

157. Lord Bridges, as quoted above, page 79, does not wish the State to be 'an awkward and uncomfortable partner in its relationship with the arts.' Yet it is doubtful whether a patronage so self-effacing can be effective, since it practically abrogates any responsibility for artistic decisions. That a responsible Minister would have a depressive effect on art is generally regarded as axiomatic, although historical evidence speaks against it: witness Colbert or Antonin Proust. However, to say that an institution works well does not necessarily mean that it works smoothly. Malraux, for example, has shown himself an annoyingly enterprising minister, and artistic life in France has reacted to him with commendable irritation. No doubt an uncomfortable partnership, but preferable to the comforts of the void. As long as State patronage is so timid as to confine itself to the avoidance of trouble, the State will receive the vacant art that it inadvertently sponsors.

158. *Daedalus*, Journal of the American Academy of Arts and Sciences, Winter 1960, p. 117.

159. Schoenberg, *Style and Idea*, pp. 102-43: 'Composition with Twelve Tones'; systematized in J. Rufer, *Composition with Twelve Notes related only to one another* (1961), pp. 79-111.

160. Preface to *L'année dernière à Marienbad* (1961), p. 16. For Robbe-Grillet this studied aggregate represents 'le film total de notre esprit'.

161. The word *bricolage*, originally used in billiards or tennis for the skill of causing a ball to rebound, is now applied in France more generally to any unexpected use made of ready-made objects, particularly when taken from the sort of stock that is likely to collect in an attic. Persons habitually reassembling such pieces for a new use are called *bricoleurs*. Recent French art shows many examples of more or less tasteful *bricolage artistique*. (Lévi-Strauss, *op. cit.*, p. 26, expanded the notion to *bricolage intellectuel*.) The fascination exercised by such 'heteroclite compositions' is a fusion of estrangement with recognition. It is the old Dada-trick in a more elegant form.

162. *The Varieties of Religious Experience* (Gifford Lectures, 1901-1902), Lecture X. James's enthusiastic account of 'the wonderful explorations by Binet, Janet, Breuer, Freud, Mason, Prince, and others' is particularly moving today, when it is known how right he was in his judgment: 'These clinical records sound like fairy-tales when one first reads them, yet it is impossible to doubt their accuracy.' He was well

aware that the human material available for demonstration had 'so far been rather limited and, in part at least, eccentric, consisting of unusually suggestible hypnotic subjects, and of hysteric patients'; yet he was confident in his belief that 'the elementary mechanisms of our life are presumably so uniform that what is shown to be true in a marked degree of some persons is probably true in some degree of all, and may in a few be true in an extraordinarily high degree.'

163. Pierre Janet, *Les obsessions et la psychasthénie* (1903) I, ii, pp. 443 ff.; II, i, pp. 1 ff.; also L. Laurent, *Des états seconds, variations pathologiques du champ de la conscience* (1892), showing that a 'retraction of the field of consciousness' releases sudden and acute impulses of an elementary kind. Jung's psychology of myths relies on this class of phenomena: 'Reduced intensity of consciousness and absence of concentration and attention, Janet's *abaissement du niveau mental*, correspond pretty exactly to the primitive state of consciousness in which, we must suppose, myths were originally formed' (C.G. Jung and C. Kerényi, *Essays on a Science of Mythology*, 1949, p. 103). But this inference is not conclusive. If a lowering of mental attention is necessary to decompose the upper strata of a rational intelligence because these interfere with the myth-making impulse, it does not follow at all that in a more primitive state, where the myth-making impulse is unobstructed, it has any of the haziness caused by an *abaissement du niveau mental*. Keen outward observation seems, on the contrary, an essential ingredient of primitive myths: see Lévi-Strauss, *La pensée sauvage*, pp. 25, 48 ff., who remarks that 'the appetite for objective information constitutes one of the most neglected aspects of the so-called primitive mind' (p. 5). The meticulous botanical and zoological observations made by certain pygmies and other aboriginal tribes (*ibid.*, pp. 7-15) are difficult to reconcile with Jung's suggestion that 'the primitive' suffers from a 'chronic twilight state of his consciousness' (*op. cit.*, p. 101). This may well be a Romantic view of the savage.

While the pioneers of depth psychology (Janet, Breuer, Freud, etc.), entertained no illusions about the quality of some of the psychic material thrown up from the unconscious, in the school of Jung it has become an article of faith that the subterranean 'archaic' stuff of the soul contains ore that is particularly precious. What Jung has written on the *mysterium coniunctionis*, for example, would seem to imply that the symbol of the Hermaphrodite is not only a subliminal projection of exceptional energy, but must be one of the great themes of artistic creation. Yet this is demonstrably not the case. Whether treated solemnly or as an eccentric jest, the androgynous sculptures of the Hellenistic period are as contrived and ostentatious as Balzac's *Séraphita*, Schlegel's *Lucinde*, Gautier's *Mademoiselle de Maupin*: the image never quite shakes off the pedantry of the *Rebis*-figure in alchemical picture-books, although the literary efforts have been numberless. Among modern examples it is enough to name *Les mamelles*

de Tirésias by Apollinaire and *La dragonne* by Jarry, both saved by an Aristophanic style of masquerade from the sultry platitudes that pervade Péladan's *L'androgyne* or Hermann Hesse's *Demian*. Schoenberg and Berg, and more lately Mircea Éliade (*Méphistophélès et l'androgyne*, 1962, p. 122), reserve an exceptional place for *Séraphita* as 'the last great work of European literature to treat the myth of the androgyne as its central theme' – to which one may reply with Gibbon: 'The reader, according to the measure of his faith, will determine this profound question.'

Although it is now generally understood that the methods of depth psychology were designed to uncover pre-conceptual types of emotional life, it is not always realized that these types are also pre-artistic. It is no reproach to the psycho-analytical method that, when applied to artistic creation, it tends to wipe out the difference between great art and mawkish art: reduced to the diffuse level of the subliminal, refinements of perception are likely to vanish. On the other hand, if it were clearly stated that it is precisely an infra-artistic kind of impulse that is to be anatomized in psycho-analytical studies, their genuine contribution to artistic psychology might be better defined than it is at present.

In reflections on the Oedipus myth, for example, it has become customary to suppose that it is by the evocation of a latent memory that 'what is otherwise merely a revolting story' becomes invested with 'that mysterious quality which would make it worthy to be chosen as a tragic theme' (F.M. Cornford, *The Unwritten Philosophy and Other Essays*, 1950, p. 9). It is difficult, however, to see why a revolting story should become less revolting by the fact that it is latently remembered. By that token any sordid jest, provided it is sufficiently coarse to disturb our dreams, would become dignified and poetic. Far from being an ideal subject of art, the tough sort of symbol that survives in the unconscious and comes to light with an *abaissement du niveau mental* is artistically the most obtuse. If the Oedipus legend is in itself monstrous (and I do not see how that can be denied), and if, as the psycho-analytical evidence suggests, it is one of those monstrous tales that are deeply embedded in our unconscious life, then it must be as difficult to make a great drama out of this subject as to write a good novel about 'the blest Hermaphrodite'. The way in which Sophocles succeeded was not by collusion with the unconscious but, on the contrary, by forestalling any incursions from that region. As has often been noticed, in the construction of this tragedy the sheer artistry of unravelling the crime of Oedipus transfigures the fierceness of the conclusion. The frightful revelations are so carefully prepared that the final effect on the spectator is the very opposite of an uprush from the unconscious. In Stravinsky's opera of Oedipus the *repoussoir*-effects are even more numerous. Not only does the Narrator interrupt the confusions and excitements by which he comments, but the dramatic parts are cast in liturgical Latin, which helps to arrest the events at a

hieratic distance. It is precisely because of the absence of any such filter to relieve the robust tangibility of his phantoms that Balzac seems to fail in *Séraphita*. Psychodynamic schematism, if left in the raw, produces documents, but not art. One might as well read Swedenborg directly.

From the point of view of aesthetic theory, it is interesting that Schoenberg gave up his attempt to write a musical *Bühnenwerk* on *Séraphita*. According to a letter from Berg to Webern, it was to occupy three evenings (Redlich, *Alban Berg*, p. 88). The homage paid in the preface of *Harmonielehre* to Maeterlinck, Strindberg and Weininger (!) leaves little doubt that the use of Balzac as mystagogue would have brought forth plenty of 'archaic material'. It is fair to add that what has been published or exhibited of Schoenberg's paintings, on which he apparently set great store, falls within the style and category of the psycho-claustral images studied by Jung; cf. Rufer, *Das Werk Arnold Schönbergs*, pp. 175 ff. (illustrations).

164. Science fiction was not slow to seize on the combination of depth psychology and mechanization. In Villiers de l'Isle-Adam's *Ève future* (1885), Edison is an expert in both.

165. 'Reflex Action and Theism', first published in *Unitarian Review* (October 1881), reprinted in *The Will to Believe* (1897).

166. Nietzsche, *The Birth of Tragedy*, §18.

167. *Loc. cit.* (shortened). Although James described 'the knights of the razor' as a mere sect, he saw 'their fraternity increasing in numbers and their negations acquiring prestige'. Carlyle compared these 'sandblind pedants' to 'a Pair of Spectacles behind which there is no Eye' (*Sartor Resartus* I, x). The phenomena here discussed bear an unpleasant resemblance to the 'evolution by atrophy' in highly organized insect societies, a development that secures strong social cohesion at the expense of variability: see William Morton Wheeler, *The Social Insects* (1928), pp. 303, 307 ff.; also *Essays in Philosophical Biology* (1939), pp. 143-69. More recent biologists have become wary of transferring Darwinian categories to cultural history: they recognize (cf. P.B. Medawar, *The Future of Man*, 1960, pp. 97 ff.) that while man's genetical evolution has followed consistently a Darwinian pattern, the transmission of his technological and cultural inheritance is 'obviously Lamarckian' but non-genetical. A clear distinction between these two orders of events does not imply that they are sealed off from each other: an environment evolved by a cultural tradition acts, however imperceptibly and slowly, as a selective force on genetical traits (cf. H. Kalmus, *Variation and Heredity*, 1957, p. 206). Moreover, the historical growth of a tradition, although removed by several degrees from the genetical order of causation, depends on a psychological mechanism of

such complexity that it may well produce an 'evolution by atrophy' in its own sphere. A master-builder like Pier Luigi Nervi, for example, has paid the price for concentrating all his faculties on architectural engineering by a complete asthenia in domestic architecture. The question is whether or not cases of this sort will remain exceptional; but even if the answer in the negative should have the weight of economy on its side, according to James it would be a mistake to accept that argument as final. Our irrepressible wants 'form too dense a stubble to be mown by any scientific Occam's razor that has yet been forged.'

Another aspect of 'evolution by atrophy' is discussed by Jean Revol, 'Art et aliénation', *Nouvelle revue française* XI (1963), pp. 128 ff. The fastidious attention to diagrammatic detail that characterizes a certain class of psychopathological drawings (cf. above, pages 85 f.) is here seen against its clinical background. The author suggests that, while a patient's contact with reality is progressively lost, his pursuit of intricate formal patterns becomes a surrogate for experience. In literature the ceremonious letters written by Hölderlin during his madness (*Gesammelte Briefe*, ed. E. Bertram, *c.* 1936, pp. 405 ff.) show the same finical elaboration of a ghostly syntax. These desperate utterances literally achieve what some aestheticians have proposed as the ideal of art – the 'eradication of matter by form'.

Index